Henry Moore
Textiles

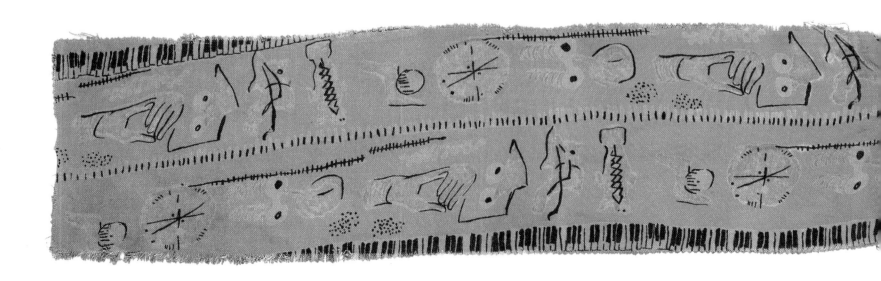

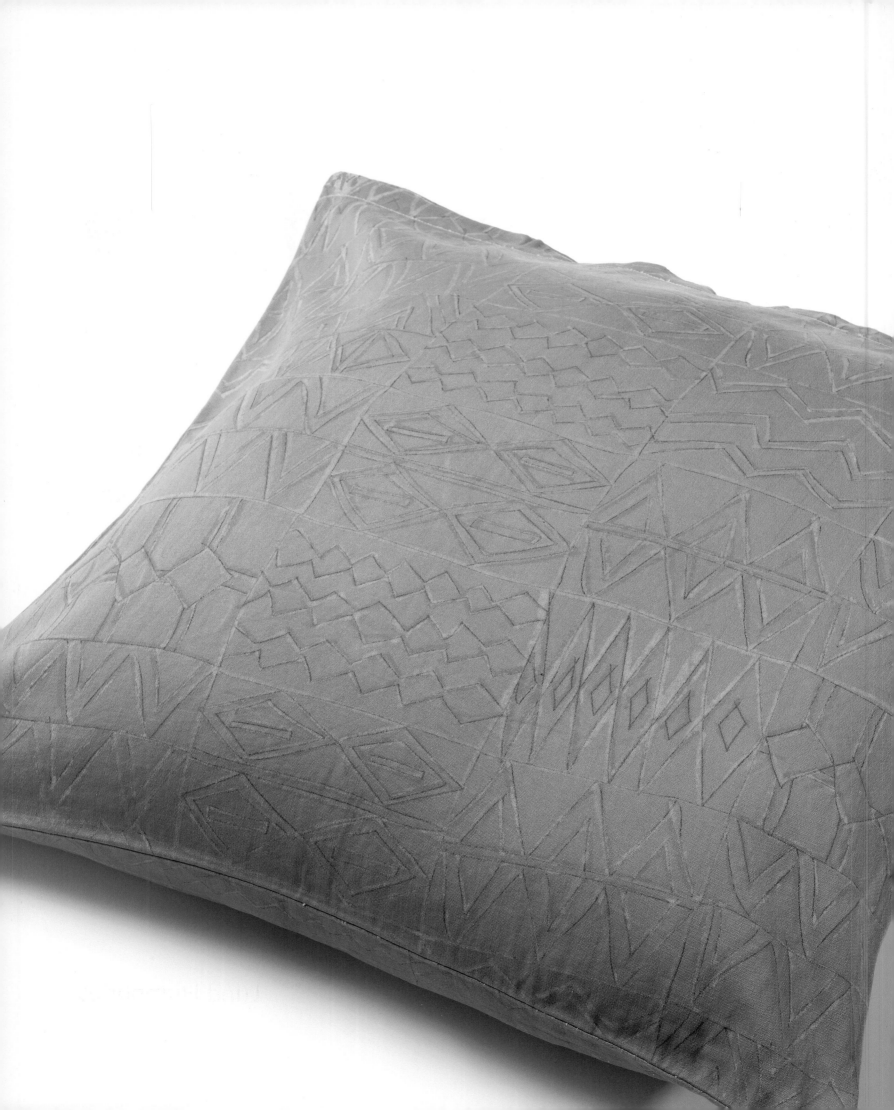

Henry Moore
Textiles

Edited by Anita Feldman
Introduction by Sue Prichard

Lund Humphries

First published in 2008 by
Lund Humphries
Wey Court East, Union Road, Farnham,
Surrey GU9 7PT

Reprinted in 2009

Henry Moore Textiles
British Library Cataloguing in
Publication Data

Henry Moore Textiles
 1. Moore, Henry, 1898–1986
 I. Feldman, Anita
 746'.092

ISBN 978-1-84822-052-2

Library of Congress Control Number
2007940993

Text edited by Angela Dyer
Designed by Tim Harvey

Origination by Altaimage, UK
Printed by Graphicom, Italy

(half-title page)
Piano 1947 (TEX 5.5)

(title page)
Zigzag 1954; TEX 23.2; serigraphy in four
colours; rayon cushion cover; 540 × 530mm;
Printed by David Whitehead Fabrics;
Private collection, UK

(right)
Group of scarves designed by Moore

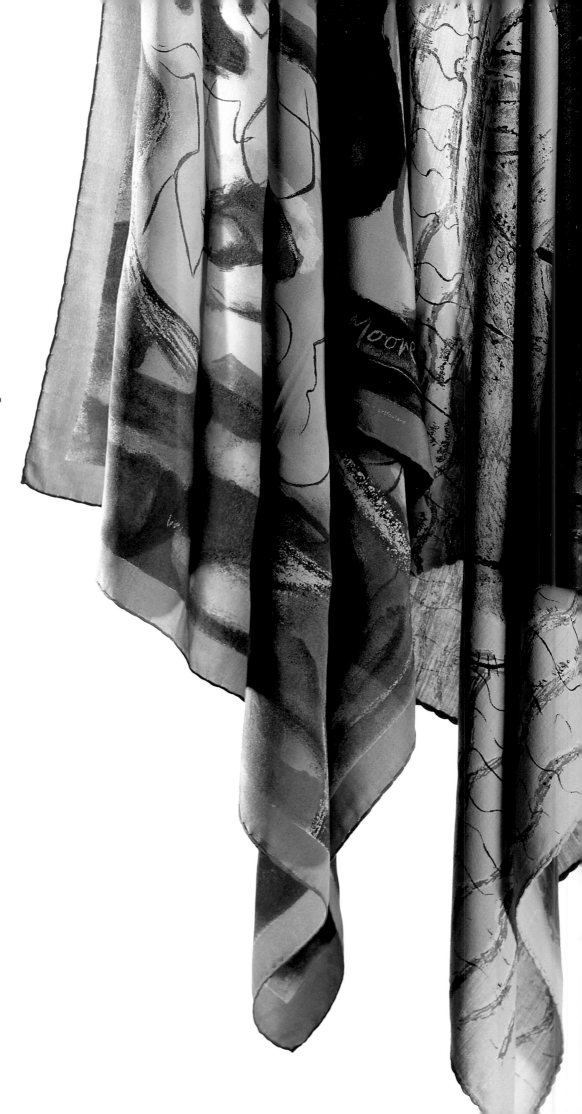

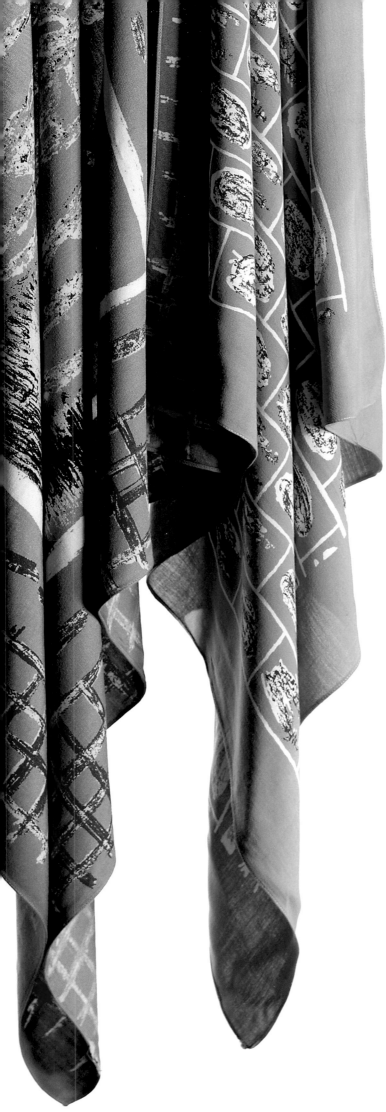

Contents

Moore's works are referred to by their archive reference numbers:
LH (Lund Humphries) for sculptures; HMF (Henry Moore Foundation) for
drawings; CGM (Cramer, Grant, Mitchinson) for graphics; TEX for textiles

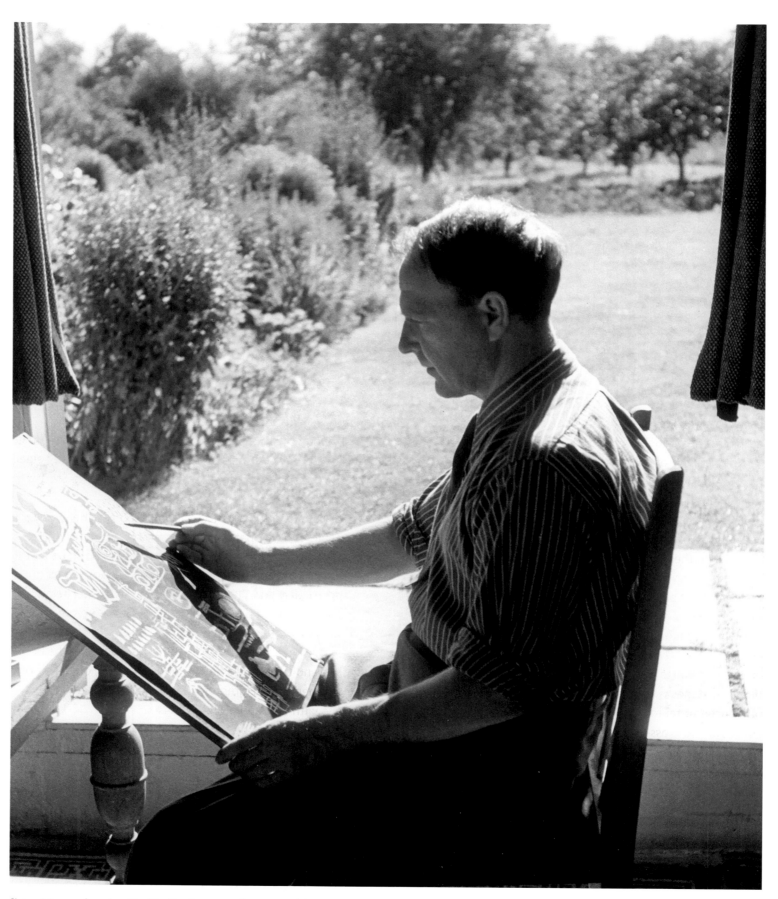

fig.1 Moore drawing **Textile Design** 1943 (HMF 2155) in Perry Green. The drawing was separated – the upper half containing the name 'Ascher' has disappeared and the lower half is now in the Foundation's collection (see p.54).

Preface

David Mitchinson Head of Collections and Exhibitions
The Henry Moore Foundation, Perry Green

Henry Moore was requested to produce ideas for fabric designs in late 1942 or early 1943. Twenty-five were later worked up as samples in different colourways and materials, from which a few went into production: four as head scarves, four as wall hangings and seventeen as ideas for fashion and furnishing fabrics. All were made at the instigation of Zika Ascher, a Czech textile manufacturer who had been living and working in London since 1939. Later, in the mid-1950s, two further designs were produced for David Whitehead Fabrics, and later still a drawing of 1981 was used in 1983 as the basis for a silk scarf produced by art*foulard*, Vienna. This book details the story of the textiles' creation, examines the sources Moore went to for inspiration, illustrates all his known patterns, and puts his work into the context of British fabric design of the period.

Moore's use of colour in his two-dimensional work has often surprised the viewer. In his war-time drawings of sleepers in the Underground, layers of coloured crayon built up on a sketch of pencilled lines and areas of white wax were covered with watercolour washes, pen and ink and touches of gouache. In the textile designs that followed the black, sombre colours of the Coalmining sketchbooks of 1942, Moore brightened his palette: vivid red, green, purple and orange used in the sketches were carefully translated in printing inks for the fabric samples.

When the third volume of the catalogue raisonné of Moore's drawings was published in 2001, seventy-eight textile design sketches were described, with twenty-one cross-referenced to textiles in the Henry Moore Foundation's collection – a cross-referencing that made little sense as no pictorial images of the textiles corresponding to the numbers had been published. During the past few years further research has identified another nineteen sketches, including a previously unknown sketchbook, thereby greatly adding to an understanding of Moore's imagery and working techniques. The publication of this book has provided the opportunity for the newly discovered works to be catalogued and illustrated. Further designs, and possibly textiles, may exist, but all known examples in the main collections of this material have been studied, collated and used for the preparation of this book.

The Victoria and Albert Museum, London, as custodian of one of the world's finest fabric collections, holds a substantial group of Moore's textiles, as does Zika Ascher's son, Peter, who now runs Ascher Studio from New York. Further examples in private collections and in the Henry Moore Family Collection have been studied and the resulting information has been entered on to the Foundation's database, which is now available for further research.

The database has been meticulously put together by Jenny Harwood, Archive Assistant at the Henry Moore Foundation. She worked closely with the Foundation's Curator, Anita Feldman, who was responsible for selecting the works to be illustrated and for writing the text and individual entries, and the Victoria and Albert Museum's Curator of Contemporary Textiles, Sue Prichard, who has contributed the introductory essay. Others at the Foundation who have helped with the book's preparation are Martin Davis, Emma Stower and Michael Phipps.

The Foundation would like to thank Peter Ascher and his wife, Robin, for their patience in answering endless questions and for allowing items in their personal collection to be lent for photography, and Juliet Bareau, John Farnham, James Holland-Hibbert and Steven Gabriel who have been helpful in locating works in private collections. The book's editor, Angela Dyer, photographer, Matt Pia, and designer, Tim Harvey have worked quickly and with their usual expertise to put the book together, and Lucy Myers and Miranda Harrison, on behalf of the publishers Lund Humphries, have kept everyone on schedule with tact and professionalism.

Since the book is being published to coincide with an exhibition on the subject at the Henry Moore Foundation – and many items illustrated have been lent for the exhibition – I would like, on behalf of the Foundation, to thank all those who have helped with its preparation, particularly Suzanne Eustace and Charlotte Booth, and those who lent anonymously from their collections, as well as the Trustees of the Victoria and Albert Museum; the Ascher Collection; the Henry Moore Family Collection; Paul and Karen Rennie; the Sherwin Collection; John Robert Wiltgen, IIDA; Museum of Domestic Design & Architecture, Middlesex University; and Tate.

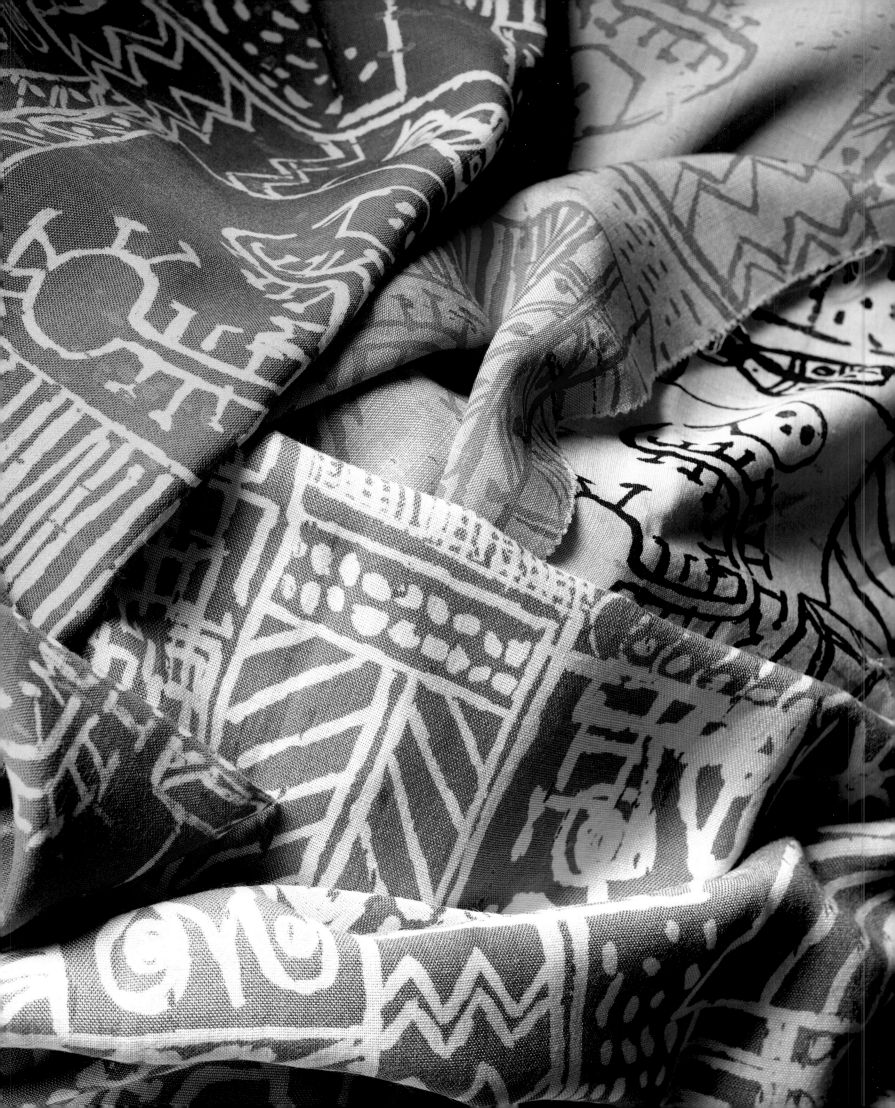

Introduction
British Textile Design: The Quest for a New Aesthetic

Sue Prichard Curator, Contemporary Textiles
Victoria and Albert Museum, London

Henry Moore produced four sketchbooks of textile designs in 1943, during one of the most troubled periods of the century. There is no documentary evidence to suggest why Moore became interested in textile design – his collaboration with the textile entrepreneur Zika Ascher and later participation in Hans Juda's *Painting into Textiles* exhibition in 1953 receive scant attention in official biographies. Writing in 1970, however, Zika Ascher considered Moore's textile designs as significant then as they were in 1943: 'I have . . . been thinking a lot over the week-end of what I mentioned to you, but I felt that I did not express myself very clearly. I feel that some of the non-figurative designs show the real strength of your art. I am so sure that I am right that I was thinking that this should be revealed in an exhibition.'[1]

A solo exhibition of Moore's textile designs never took place, although Ascher's contribution to the textile and fashion industry was celebrated in a major exhibition at the Victoria and Albert Museum in 1987. The monumental tapestries designed by Moore and woven at West Dean are perhaps better known, the focus of both a publication and an exhibition held in 1980, also at the Victoria and Albert Museum. Despite the widespread media coverage accorded to both the 'Ascher project' (see p.16) and the *Painting into Textiles* exhibition, Moore's textile designs remained little known outside the field. However, his engagement with this most democratic of art forms can be placed firmly within the context of the debate regarding design reform and continuing concern as to the lack of a truly modern British style.

Design reform

The last decades of the nineteenth century witnessed a flurry of debate regarding the role of art and design as a 'force for good'. Against a background of momentous changes in technology, social mobility and public taste, enlightened individuals in the textile industry battled to develop a

(opposite)
Selection of colourways of Moore's design, **Caterpillar and Insect Wings** (TEX 10).

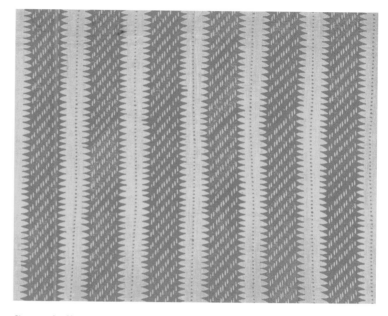

fig.2 Phyllis Barron, *Pointed Pip* 1938, hand blockprinted linen.

distinctly new and vibrant British design vocabulary. The roots of design reform were, of course, firmly embedded in the aims and objectives of the Arts and Crafts Movement of the 1880s. However, the general level of concern had been raised at the International Exhibitions of 1851 and 1862. Both events revealed that, although the quality of British manufacturing was a force to be reckoned with, the continuing lack of a distinctly original 'modern' style to equal the success of Britain's technological advances and business acumen was proving disastrous for the country's image and starting to affect its prosperity.

Throughout the nineteenth century, the quest for artistic and design reform covered all branches of the practical arts, including architecture. The lack of support provided by the Royal Academy, which held sway in matters of taste and fashion, would ultimately prove its downfall as calls for reform became increasingly vocal and indeed volatile. Realistically, an alternative to the exhibition policy of the Royal Academy had to be found, one which would offer artists and designers the opportunity to exhibit their work in sympathetic and, most importantly, accessible surroundings. Textiles played a crucial role in the Arts and Crafts exhibition from the very beginning,

with traditional hand-made crafts appearing alongside commercially woven and printed textiles. The block printing and hand-loom weaving techniques forever associated with William Morris would continue to be popular well into the twentieth century, primarily in small, independent workshops (fig.3). However, this type of hand-produced craft could not be sustained by a textile industry which ultimately relied on mass production for its survival. The vast majority of commercial manufacturers continued to focus their attention on supplying reasonably priced, if somewhat staid, textiles to the growing ranks of affluent middle classes.

The concept of a 'National Exhibition for the Arts' was supported by over four hundred of the country's leading artists and designers, convinced that the project would provide a unique opportunity for the decorative and applied arts to be shown together, in a co-operative movement which would emphasise the equality of the various branches of the arts. In the event, the exhibition fell at the first hurdle; in-fighting and dissent within the exhibition committee fractured the unity of the project. However, momentum had been established and at this point there was no going back. On 11 May 1887 the Arts and Crafts Exhibition Society held its inaugural meeting, and in 1888 the first display of work by the society opened at the Grosvenor Gallery, thus securing the movement's place in history.

Much has been written regarding the progressive teaching style of Alice Gostick, Moore's art teacher at Castleford Secondary School, and her teaching was certainly based on the reforms promoted by the Arts and Crafts Movement. A leading member of the Art Teachers Guild, Gostick engaged both her pupils and their parents in extra-curricular evening classes, which tended to focus on pottery. She also took the unexpected but generous step of inviting pupils into her home, and here Moore would certainly have had access to a number of specialist art and design journals and publications. Roger Berthoud, in his biography of Moore, describes Gostick's home: 'In her sitting room were fascinating art books and such influential art magazines as *Studio*, which had a European circulation and reproduced the work of the continental avant-garde. With the Cubist movement in full swing at this stage, some of these reproductions must have looked baffling, if exciting, to teenagers who had not ventured far from Castleford. Such matters could be freely discussed in the Gostick salon'.[2] Established in 1893 and published until 1920, *Studio* became the most influential decorative and applied arts magazine and was unique in that, unlike other art journals, it gave equal weight to textiles as well as other arts.

Access to such publications would have provided the young Moore with the opportunity to engage in the debate regarding design reform, possibly even regarding the textile industry.

A new century

The legacy of the Arts and Crafts Movement continued to resonate throughout the early decades of the twentieth century, causing *The Times* to note that 'much of the present day style of decorated fabrics is stamped with the personality of William Morris in the design and colouring.'[3] 'Le Style Anglais' proved equally popular in Europe, although by 1905 Arts and Crafts textiles tended to focus much on innovative hand-woven textiles, rather than the popular printed designs forever associated with Morris. Despite the success of the 1900 Paris Universal Exhibition and the emergence of Art Nouveau, many manufacturers turned their backs on major Continental developments. The conscious decision to disengage with developments abroad was in part due to the lingering economic depression of the 1890s but also a result of the implementation of the McKinley Tariff, which imposed duties as high as 60 per cent on textiles imported into the United States. This legislation effectively destroyed the lucrative overseas middle-class market which relied on cheap but well-designed commercially manufactured textiles from Britain and set the tone for the bleak decades leading up to the outbreak of hostilities in 1939. Given the volatile economic situation, manufacturers became increasingly more cautious regarding innovation: the reorganisation of the British Calico Printers' Association (CPA), founded in 1904,

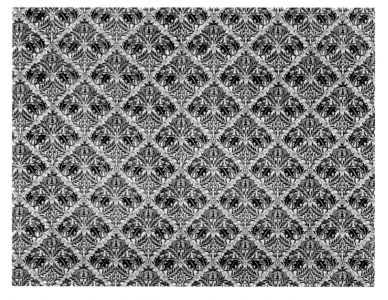

fig.3 William Morris, *Indian Diaper* 1875, blockprinted cotton.

exacerbated the move towards standardisation of pattern design as manufacturers sought to 'batten down the hatches' to ensure survival, relying on archives of unused historic designs, which, although unimaginative, were the bread and butter of the industry. Although British designers and manufacturers continued to participate in the influential international exhibitions, by the end of the decade the standard of commercial design had fallen considerably.

The gravity of the situation was not lost on artists and teachers: in 1909 the students at Macclesfield School of Art were informed that 'the reproduction of period styles provides work for the draughtsman, not the designer, and their frequent use is not so much due to their being preferred as to the scarcity of modern original designs equal in merit and pure in detail of motive and ornament.'[4] C.R. Ashbee, an architect, planner and Master of the Art Workers Guild, well aware of the developments taking place on the Continent, was loud in his demands for educational reform and the training of designers for industry – a demand which would eventually come to fruition in the establishment of the Royal College of Art. Despite the continued efforts of enlightened manufacturers such as G.P. & J. Baker, A.H. Lee, Alexander Morton, Turnbull & Stockton, Warner & Sons and Wardle & Co., the onset of war proved disastrous for an industry desperately in need of radical reform.

'I wish to develop a definitely English style . . .'

In the first decades of the twentieth century perhaps the most important contribution to British textile design was made by the artists employed by the Omega Workshops. The founder of the workshops was Roger Fry, the painter and critic whose writings so profoundly affected Moore as a young man. Fry had the vision (if not the leadership skills) to challenge the prevailing taste for the dark and sombre tones of the Edwardian domestic interior, and endeavoured to create a truly 'modern' style, one which would match his interest in Continental art movements. In 1910 and 1912, Fry had organised the two avant-garde Post-Impressionist exhibitions which were to influence a generation of young artists; his next venture would ensure that home-grown artistic talent would get an opportunity to make its mark in both the decorative and applied arts. The Omega Workshops, in effect a loose co-operative of artists and designers championed by Fry, Duncan Grant and Vanessa Bell, represent a turning point in the alliance of art and design and witness the development of a radically new style in the field of textile design.

Fry was damning in his analysis of the crisis facing British textile production: 'I wish to develop a definitely English tradition. Since the complete decadence of the Morris movement nothing has been done in England but pastiche and more or less unscrupulous imitation of old work.'[5] He looked for inspiration for his venture to the Paris-based workshop Studio Martine, created by the innovative French couturier Paul Poiret. Poiret had initially commissioned designs from the French artist Raoul Dufy for his interior decorating company Maison Martine. Dufy's stylised designs, inspired by primitivism and folk art, combined elements taken from woodcuts and the modern art movements of Fauvism and Cubism – all of which can be identified in the subsequent designs produced by Omega. These blurred the boundaries between art and design; the abstract and geometric textile designs produced by artists such as Edward Wadsworth, David Bomberg and Paul Nash, all of whom had studied at the Slade, together with Henri Gaudier-Brzeska challenged the conservatism of much of contemporary textile production. Although Omega tended to concentrate on furniture and ceramics, textiles played an important part in the overall concept of the complete 'artist-designed' interior. The launch collection included printed and woven furnishing fabrics, carpets and hand-painted silk scarves; the artistic freedom offered to those artists involved in the project effectively meant that they could create a custom-made design service for their clients, who could choose to use the textiles as either dress or furnishing fabric.

There is no doubt that Fry's ideals were laudable, but the chaotic management structure of Omega and somewhat arbitrary approach to commissions and orders ensured that the enterprise was short-lived; the onset of war and the rising cost of materials contributed to its demise in 1919, but Omega had secured itself a place in the history of artist-designed textiles. The abstract designs and bright colours produced by the workshops would continue to influence the more innovative designers and manufacturers for the next thirty years.

A brave new world

The onset of the First World War did nothing to abate concerns regarding the future of the British textile industry; the conviction that Britain continued to lag behind foreign competitors was fuelled by manufacturers' stubborn reliance on the perennially popular, if somewhat obsolete, styles of the last century. The Design and Industries Association was

formed in 1915 with the specific remit to raise the standard of design and 'promote the development of British industry by encouraging good workmanship based on excellence of design and soundness of material and to educate public taste to look for such design in what they buy'.[6] The DIA recruited teachers, artists, craftsmen – indeed anyone with a vested interest in re-energising the industry, including retailers. Emphasis was placed on the need for technological revolution – the ability to mass produce well-designed consumer goods at a price which the vast majority could afford, summed up by the slogan 'Nothing Need Be Ugly'. Despite the DIA's best efforts in terms of innovative textile design, commercial production in the immediate post-war years was, on the whole, unremarkable. Meanwhile, developments on the Continent continued to cause alarm among the most passionate of British design reformers.

The post-war period has been identified as the point at which textile design became more closely aligned with major developments in art and architecture. In 1925 the seminal Paris-based *Internationale des Art Decoratifs et Industriels Modernes* provided the catalyst for the decorative movement which would dominate and influence the textile industry for the next fifteen years. This was effectively a trade fair designed by the French to increase their lucrative export markets; British manufacturers took a back seat at the exhibition, believing that they were unlikely to drum up much trade amongst their French rivals. Although technically superb, the British designs were no match for the luxurious ornamental patterns of the French, and the more angular and abstract designs associated with America were to prove extremely influential for textile designers.[7]

The dark days

Throughout the 1920s and 1930s the British design reform movement gained momentum, driven by the continuing need to rival overseas competition. Several government-sponsored organisations followed the example set by the independent DIA in influencing and developing public taste. The Society of Industrial Artists (1930), established to protect the interests of designers, campaigned vigorously – albeit ultimately unsuccessfully – to legitimise the profession, advocating the establishment of qualifications along the same lines as those held by the Royal Institute of British Architects; it also played an active role in encouraging fine artists to engage in industrial design. In more rural areas, the debate regarding the marriage of craft and design had been taken up by the formation of the Rural Industries Bureau (1921). Driven by the need to address high unemployment in rural areas, the RIB provided opportunities for training, as well as employing professional designers to produce pattern books and drawings, and even securing funding for two design research studentships at the RCA.[8] The recognition that artists could help to regenerate the textile industry was echoed in a pamphlet published in 1929 by the Board of Education: 'As a result of the undoubted rise in the general level of taste in this and other countries, the demand for good design is increasing . . . It is, therefore, vitally important that effective means shall be found to draw into the service of the industry men and women of trained artistic ability.'[9]

Educating and influencing taste was most successfully achieved via exhibitions, and both independent and government-backed agencies developed a series of events to raise public and commercial awareness to the benefits of good design. In 1933 the DIA mounted an exhibition entitled *British Industrial Art in Relation to the Home* at Dorland Hall, London – a year later publications on industrial design and the role of art in relation to the home and industry could be found in any booksellers. The *British Art in Industry* exhibition held at Burlington House in 1935, sponsored by the Royal Society and the Royal Academy, played its part in the propaganda campaign, followed by the *Exhibition of Everyday Things* mounted by the Royal Institute of British Architects (1936). However, not all critics were impressed by the broad range of styles exhibited at Burlington House; Herbert Read, Moore's friend and mentor, was particularly concerned at the lack of a modern aesthetic. This is hardly surprising given that Read had published his influential treatise *Art and Industry* a year earlier and had been instrumental in introducing Continental modernism into the country.[10]

The implementation of tariffs by the British Government bolstered the British textile industry, and the ever-present spectre of aggressive foreign competition was, to a certain extent, laid to rest as the home market once again looked towards British manufacturers. That said, the French lead in dictating fashion continued unabated and French dress fabrics continued to be highly desirable, as evidenced by the number of French designs bought by the British textile industry. This was not, however, a one-way street; some British designers were selling overseas, but such was the reputation of the French that the Board of Education, in its pamphlet *Design and the Cotton Industry* (1929), stated: 'There is evidence that the free-lance artist is more likely to get his designs placed

if he commissions a French agent than if he tries to place them himself.'

The search for new materials and techniques

The trend for simplicity, order and convenience in the home throughout the 1930s provided a welcome opportunity for some manufacturers to look for new ways of producing cheap furnishing fabrics for the home market. This was in part dictated by the continuing rising cost and limited availability of natural fibres, as well as the need to provide fresh new designs for a more demanding consumer. Much of the success of British textile design during this period may be attributed to the introduction of screenprinting,[11] although for the vast majority of commercial manufacturers, roller printing continued to be the most viable method of producing vast yardages at competitive prices.[12] The rigidity of this system, however, worked against any form of spontaneity or freedom of artistic expression; screenprinting, like hand blockprinting in the nineteenth century, offered artists and designers scope for experimentation. Ideally suited to short runs of good quality, albeit of exclusive printed and woven furnishing fabrics, screenprinting provided small manufacturers a relatively cheap means of responding to calls for design reform.

Silk-screen printing originated from a Japanese technique of stencilling and had been developed in both America and Europe in the late nineteenth and early twentieth centuries. Quicker than traditional hand blockprinting, screenprinting could be used on fabrics of varying thickness and also offered benefits in terms of cost; it required less financial investment by manufacturers, as the fine mesh screens were relatively inexpensive and allowed each colour in the pattern to be printed separately. Rollerprinting restricted not only pattern height but also extensive use of dyes and pigments, since individual rollers were required for printing each successive colour.[13] Certainly the greater number of designs created during this period by freelance designers were specifically intended for hand screenprinted fabrics – and they could afford to experiment. Anthony Hunt, a textile designer and commentator, extolled the numerous virtues offered by the medium: 'Brushwork, stipples, dapples and etched effects can be faithfully reproduced by screenprinting and help to convey different surfaces and provide contrast and interest.'[14]

More affordable experimentation during the 1930s was also helped by the technological advances made in the production of fabrics and synthetic dyes, which facilitated the use of strong colour in pattern design. Rayon, also known as 'artificial silk', had initially been manufactured in America in the nineteenth century, but its gleaming appearance was considered by many to be cheap and vulgar. By the late 1920s the process had been perfected and reputable companies such as Courtaulds, Britain's largest rayon producer, embarked on publicity campaigns to help improve its image. By the 1930s, rayon equalled silk in terms of its draping qualities and feel, and its use in textile production became increasingly important as the availability of natural fibres dwindled. The combination of new delustred finishes, brilliant colours and fresh, contemporary designs appealed to both the mass and more select markets. Most importantly rayon, unlike silk, was remarkably inexpensive, an attribute which became increasingly attractive during a period of economic depression.

The name 'rayon' originated in America and entered into the British vocabulary in 1925, a generic term for man-made fabrics made of regenerated cellulose derived from wood pulp. Rayon could be divided into two main types according to the method of manufacture. Rayon acetate was more usually used for fashion fabrics, most suitable for dresses and lingerie, whereas rayon viscose produced a harder-wearing fabric and proved more suited to home furnishings. At approximately half the price of silk, rayon provided an affordable substitute for many women eager to purchase new dress and furnishing fabrics in modern designs and colourways. By 1939, rayon and rayon mix fabrics became the staple of every home; hard wearing and colour fast, they did not fade as a result of washing and exposure to sunlight. This opportunity to bring much-needed colour into the home provided welcome relief as the threat of war loomed once more over Europe.

The rise of the avant garde

Throughout the decades before the onset of the Second World War, many emerging and indeed established British artists joined the crusade and actively engaged in the creation of a distinctly British modern style. In 1933, in the midst of deepening economic depression, Henry Moore and Ben Nicholson were approached by Paul Nash to form a progressive new group called 'Unit One'. Supported by Herbert Read, who edited the *Unit One* publication, Nash chose *The Times* to launch his crusade for a 'truly contemporary spirit, for that thing which is recognised as peculiarly *of today*'.[15] It is important to stress that many artists did not see any contradiction between designing for industry and artistic

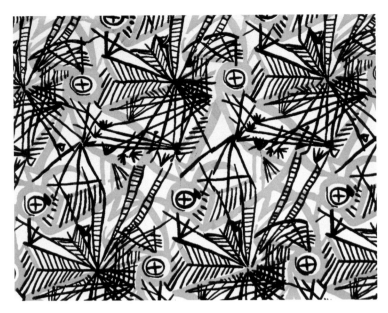

fig.4 Graham Sutherland for Cresta Silks Limited, *Web* 1947, screenprinted rayon crepe.

production; throughout the period key names in the evolution of British modernism, including Nash and Nicholson, also designed textiles, furniture, wallpapers, ceramics, illustrations for books and magazines. Of course, uncertain finances will always be an important factor in anyone's life and career choices, and certainly the economic climate of the late 1920s and 1930s meant that many aspiring artists would take work wherever they could get it. In this respect Moore was more fortunate than many of his contemporaries; financially secure since receiving his scholarship to the RCA,[16] he was able to rely on his teaching post to keep the wolves from the door, and this may account for his lack of engagement with other activities. Alternatively, it may simply reflect Moore's single-mindedness; from the age of seventeen he was determined to succeed as one of the most influential sculptors of his generation. Certainly, the 1930s was a period of great experimentation for Moore and he would have had little time or inclination to dabble in other projects.

Herbert Read described Hampstead in the 1930s as 'a nest of gentle artists', and it is tempting to construct interesting and perhaps volatile discussions between artists, designers and architects regarding work in progress and new developments. The influx of influential and talented émigrés who had fled the Continent as war became a reality included influential artists and designers such as László Moholy-Nagy and Walter Gropius, and in 1939 Zika and Lida Ascher contributed to the exotic and heady mix of modernist ideas and activities. Henry and Irina Moore had been introduced to the area in 1929 by Barbara Hepworth, then married to the

sculptor John Skeaping, who helped the young couple find their first married home. Moore had known Hepworth since they studied together at Leeds School of Art. In the 1930s Hepworth and Ben Nicholson, with whom she was by then living, experimented with blockprinting for textiles for Poulk Prints, a small enterprise set up by Nicholson's sister Nancy, whose technique of combining blockprinting with stencilling produced a small but charming range of textiles, albeit mostly for friends and acquaintances. Ben Nicholson had visited the influential textile designer Enid Marx in her Hampstead studio and both he and Hepworth developed a limited range of naive printed textiles, deliberately aimed at challenging the technical sophistication of mass production. Marx, four years younger than Moore, had also studied at the Royal College of Art and attended drawing classes run by Leon Underwood, described by Moore as 'the only teacher I learned anything from in a useful way'.[17] From her workshop in Hampstead Marx designed and carried out commissions for the London Underground and the Government's wartime Utility Scheme. Her geometric, abstract designs are generally considered crucial in the establishment of the British avant-garde movement of the 1930s. Indeed, in a photograph accompanying his article 'Modern English Textiles' in the *Listener* (1932) Nash juxtaposed a carving by Moore with a textile by Marx.[18]

The 1920s and 1930s are seen as a highpoint in the marriage between industrial art and design, as a number of independent manufacturers commissioned designs from established and aspiring modern artists and sculptors. Crysede is credited with producing some of the most innovative textiles of the period. Alec Walker, its founder, graduated from

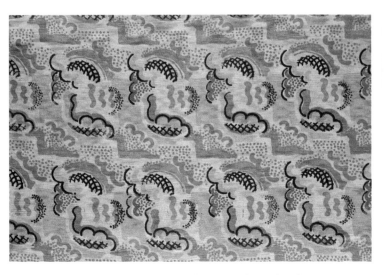

fig.5 Duncan Grant for Allan Walton Textiles, *Clouds* 1932–33, screenprinted cotton

a textile background and had trained as a painter before establishing the company in the artists' colony of Newlyn in Cornwall (1920). Walker travelled to Paris in 1923 to commission designs for Crysede's range of printed silks and dresses, where he was introduced to Raoul Dufy. Dufy, committed to an exclusive contract with Poiret and, unable to commit to a commission with Crysede, encouraged Walker to produce textiles based on his own paintings, and the resulting Fauvist-influenced designs were both an artistic and commercial success. Walker's aim was to produce high-quality blockprinted silk of artistic design for the fashion industry in order to 'revolutionise the art of designing and to introduce some artistic sense without which it [would become] vulgarised and commercialised.'[19] *Studio* described Walker's textiles as having 'a unity and distinction which gave them a unique decorative value in sympathy with Modernist aims.'[20] In 1925 Tom Heron, a friend of Walker's and an advocate of modern art, joined Crysede as manager. Under his leadership, the company rapidly expanded and moved to new premises in St Ives, but the relationship between Walker and Heron soured and in 1929 Heron went on to found his own company, Cresta Silks, in Welwyn Garden City. Heron commissioned a number of modern artists and freelance designers, including Edward McKnight Kauffer, Cedric Morris and Graham Sutherland (fig.4), as well as Paul Nash. Heron's son, the St Ives artist Patrick Heron, worked as chief designer at Cresta Silks, creating painterly abstract designs for a highly successful range of artist-designed silk scarves.

Allan Walton, who with his brother Roger created Allan Walton Textiles (1931), was one of the most successful manufacturers to combine the technique of hand screenprinting with the use of rayon, commissioning designs from artists and sculptors including Frank Dobson, Duncan Grant and Vanessa Bell. Walton, himself a trained artist and textile designer, encouraged artists to work without commercial considerations, exploiting the creative opportunities for experimentation offered by screenprinting. Grant and Bell created a number of designs for linen, cotton and rayon for Walton, which evoked the spirit of Omega in both colour and pattern (fig.5) The development of screenprinting by pioneering manufacturers such as Allan Walton paved the way for Zika Ascher and the artist-designed textiles of the post-war era.

Edinburgh Weavers was set up in 1928 by James Morton as a subsidiary of Morton Sundour, with the specific aim of creating a new range of woven textiles which would complement modern interior design. In 1932 the company

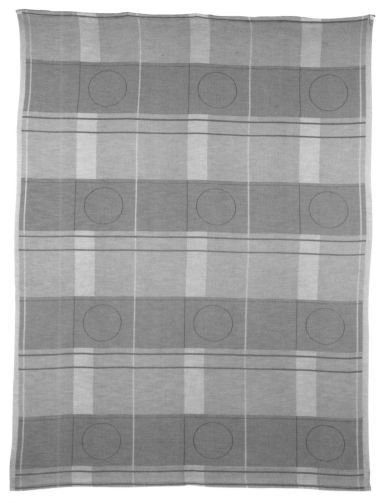

fig.6 Ben Nicholson for Edinburgh Weavers, *Three Circles* 1937, screenprinted linen.

was taken over by Morton's son Alastair, an artist and designer who experimented with hand screenprinting. Morton commissioned a number of ground-breaking artists among the avant garde of British modernism in the 1930s, including Ben Nicholson (fig.6) a close friend of Morton, Barbara Hepworth, Edward McKnight Kauffer, Paul Nash, Edward Bawden, Eric Ravilious and John Piper. The range of 'Constructivist Fabrics' launched in 1937 included three designs by Nicholson, who the same year co-edited *Circle, International Survey of Constructive Art*, a direct attempt to establish a distinctive form of modernism in Britain. The commercial artist Ashley Havinden, a friend of the Moores, who also contributed to Morton's project, wrote that the fabrics 'at their best are a visual equivalent in terms of draped materials of modern paintings and architecture of today.'[21]

The naming of independent artists and designers on textiles gave the fabrics a certain cachet, but it was of equal benefit to the artists themselves, providing a relatively cheap

way of disseminating their designs and artistic 'vocabulary' to a much wider audience. Some regarded this work as a secondary interest. An interview with Ashley Havinden is revealing: 'Ashley does not regard his fabric and rug design as work. They are the result of play rather than work in the sense that he is independent of their earning capacity.'[22] There is no documentary evidence to suggest that Moore considered his textile designs play, and the point about earning capacity is moot – by 1943 Moore was on his way to firmly establishing himself on both the national and international stage.

Make do and mend

Textile production was severely restricted during the Second World War, due to cutbacks in raw materials coupled with the drive to produce luxury goods destined for the lucrative overseas markets. Despite hostilities, the export drive continued apace, generating much-needed revenue to support the war effort and playing an active role in terms of British propaganda. At home, the government-sponsored Utility Scheme was introduced in 1941 in an effort to support production and ensure a continued, although severely limited, supply of consumer goods to the British public. The scheme employed a number of established designers, among them Enid Marx, who accepted the role of consultant–designer on the Design Panel of the Utility Furniture Advisory Committee (1943). Although fabrics did not have to be black to conform to blackout regulations, the use of colour was restricted for both technical and financial reasons. Marx rose to the challenge and produced nearly two dozen abstract and geometric designs which were woven by Morton Sundour. Despite the popularity of fabrics such as 'Spot' and 'Stripe', 'Honeycomb' and 'Chevron', Marx was disappointed with the restricted and sombre palette, later remarking, '[I] would have condemned the "rust" which I think most deplorable and responsible for much of today's low standards of public taste.'[23]

Utility regulations, which enforced rationing from 1943, together with dwindling supplies, resulted in new and ingenious ways of designing and wearing clothes; Marx's concern about the drab colours supplied under the Utility Scheme was subverted by the colourful range of printed 'propaganda' textiles. Produced by a number of enterprising manufacturers including members of the Calico Printers' Association and Jacqmar, the dress fabrics and accessories were almost exclusively printed on rayon, which became the wartime substitute for silk. The patriotic messages included in the designs were extremely popular and went some way to injecting a sense of pride and national unity during the dark days of wartime Britain. The headscarf proved particularly versatile and practical, at home and in the workplace, where women had replaced men in many roles in industry and agriculture. The range of scarves produced by the manufacturer and fashion house Jacqmar proved particularly popular both at home and overseas, and clearly provided the inspiration for Zika Ascher's post-war project.

Despite the euphoria generated by VE day, the post-war years continued to be difficult ones for Britain and the British textile industry. The legacy of the 'make do and mend' climate was difficult to shake off as long as shortage of raw materials and Utility regulations limited the supply of consumer goods. The export markets continued to preoccupy most manufacturers. Zika Ascher, however, with his business acumen and keen eye, was determined to inject a new spirit of creativity into British fashion. The country had endured six years of war and deprivation – women, and the country, needed something to look forward to.

The Ascher project

Zika and Lida Ascher were Czech émigrés who came to London in 1939, setting up a small textile production company. Lida, Ascher's wife, had successfully supplied the London couturier Molyneaux with designs for his export collection in 1942, which helped raise much-needed funds for the British war effort. Ascher's drive and personal involvement in the company enabled him to survive the war years successfully and prepare for the launch of a new collection of dress fabrics and scarves. His discovery and refurbishment of a collection of nineteenth-century woodblocks illustrates his extraordinary ability to convert historic designs; refreshed and revitalised via the strategic use of modern colourways, the patterns recall the heady days when British workmanship was the bedrock of the country's textile industry. Although Ascher's fashion fabrics were initially supplied to couture fashion houses, he was always aware of the potential of the mass market, and the ubiquitous headscarf, so long an essential fashion accessory in the meagre Utility wartime wardrobe, provided the opportunity to disseminate the very best of British art and design, at home and abroad.

Henry and Irina Moore had left Hampstead in 1940; displaced as a result of aerial bombing, they moved to the safety of Perry Green, Hertfordshire, which would remain their home for the rest of their lives. Wartime restrictions meant

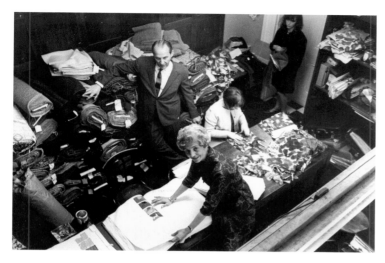

fig.7 Zika and Lida Ascher in their basement stockroom, London, July 1966.

that Moore could no longer travel to his cottage in Kent, and the large open-air carvings begun there lay dormant as the Battle of Britain raged overhead. So he returned to drawing, never fully abandoned but secondary to his love of sculpture. The Shelter Drawings (1940–42), worked up from sketches at the instigation of Kenneth Clark, Director of the National Gallery and Chairman of the War Artists' Advisory Committee, were subsequently displayed in *War Pictures at the National Gallery* in 1944. Effectively a propaganda campaign on behalf of the Ministry of Information, the exhibition was designed to introduce modern art to the 'man in the street'. Moore's drawings, focusing on the courage and fortitude of Londoners during the Blitz, were an immediate success, capturing the imagination of the public – and of Zika Ascher. Contemporary newsreel footage of the period reveals Ascher trawling the corridors of the National Gallery, examining Moore's drawings with a view to creating a new and innovative range of textiles; commentary suggests that this visit provided the inspiration for Ascher to approach the artist. Certainly Moore was interested in experimenting with new materials and techniques, and given his finely tuned ability to engage with current politics and debate, he would have found a fresh project both stimulating and challenging – an opportunity to create a new and vibrant design language which would be accessible to all.

Ascher's aim was clear. Rather than commission commercial designers who understood and worked within the constraints of the printing process, he would engage a range of leading modern British painters, sculptors, graphic artists and theatrical designers who would incorporate all the verve and vitality of the modern art scene in their designs. The brief

was relatively simple: contributors would be asked to produce designs, in any medium, colour or size, for a 36 inch (90 centimetre) silk or rayon square. Artists could choose their own subject matter; it was left to Ascher to select the design which best typified each individual style. Given the proliferation of Moore's wartime drawings, the variety and potential of the sketchbooks may have been the catalyst for Ascher's suggestion for a further commission, one which was also extended to the official war artist Feliks Topolski, who submitted images and motifs from his wartime sketchbooks. Topolski's designs were screenprinted on to surplus parachute nylon launched as a collection of evening dresses; over twenty of Moore's designs were converted into printed rayon lengths in a wide variety of colourways. The large number of patterns selected recalls the confident sense of design he had exhibited both at Alice Gostick's Castleford pottery classes and Leeds School of Art, where Moore had won a prize for dress design.

Moore worked closely with Ascher throughout the project, choosing the best designs, including several recurring themes and subjects which would remain with the artist throughout his career. The family group and mother and child, which had captured Moore's imagination since his early visits to the British Museum, reflect his own personal experience of maternal devotion but also became evocative symbols of the ideal domestic relationship, providing a sense of community, parental unity and stability after the dark days of the war. The innate ability of humanity to survive even the most atrocious of events would continue to influence Moore's work and would find favour with both the popular and specialist press. Moore's desire to think beyond Ascher's original brief and develop designs which would work well in repeat is evident in his arrangement of individual elements and motifs in lines, or contained within borders. The seemingly random and bizarre range of safety pins, clock hands, piano keys, caterpillars and insect wings recall the enormous assembly of found objects in Moore's maquette studio. Although Ascher had not intended the textiles to be used for furnishings, Irina, an enthusiastic seamstress, saw no contradiction in running up curtains for their Perry Green home from the exotic **Horse's Head and Boomerang** (TEX 3). The wide appeal of Moore's designs can be illustrated by the appearance of **Barbed Wire** (TEX 4) to great effect in the 1947 British film noir, *They Made Me a Fugitive* (see p.79).[24] The success of Moore's design, and Ascher's ability to convert it into repeat for fabric length, was acknowledged by the trade journal *Silk and Rayon* (1947): 'Dressing a film is by no means an easy task. The point that has to be kept in mind all the time is the photogenic qualities

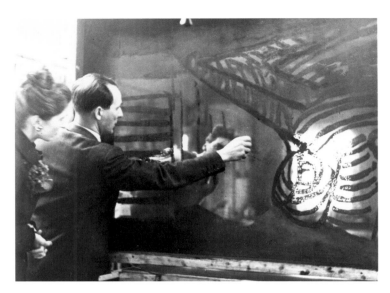

fig.8 The Aschers c.1949, inspecting the printing screen of Moore's wall panel **Reclining Figure** (TEX 21).

of the materials used. Some fabrics photograph well, and so do some colours, whereas others just look drab and uninteresting and spoil the carefully thought out mise-en-scène. Aschers are now concentrating on producing fabrics that will be first class for film purposes, and designs lending themselves to photography are more and more being found in their new range of rayon.'[25] For the public, aspirations of glamour were firmly linked with the stars of cinema; fashions, make-up and hairstyles portrayed on screen were avidly copied. Home dressmaking was an economic way of acquiring fashionable clothing, and the home-spun jacket, also constructed from **Barbed Wire** fabric (TEX 4.14), in the Victoria and Albert Museum's collection illustrates how the maker may have emulated a glamorous screen idol (pp.76–82).

Despite the wide range of motifs in Moore's sketchbooks, fewer than thirty were actually transferred into fabric and only four were used for Ascher scarves – **Three Standing Figures** 1946 (TEX 1) printed on parachute nylon as well as rayon, **Figures on Ladder Background** (TEX 2), **Family Groups** 1946 (TEX 6) and **Bird** (TEX 7). Determined to capture Moore's unique style, Ascher experimented with the same wax-resist technique for the silk-screen negatives Moore had used in his Shelter series; however, the method presented Ascher with serious problems. Working at his printing works in West London, Ascher, ever the perfectionist, ordered and supervised numerous experiments before feeling convinced that the process captured the spontaneity of the original design. Photographs of Moore, who had dabbled with batik using silk, candle grease and brightly coloured dyes at Leeds School of

Art, show the artist paying great attention to the proceedings, although there is no evidence to suggest that he offered any technical advice.

Ascher launched the first collection of scarves together with the revived nineteenth-century block textiles in May 1945, at the Dorchester Hotel, London. James Laver, Keeper of Prints and Drawings at the Victoria and Albert Museum and a leading authority on fashion, and T.A. Fennemore of the Central Institute of Arts and Crafts, both contributed to the event; in speeches reminiscent of the days of the Design and Industries Association, each stressed the vital importance of collaboration between artists and manufacturers. Ascher's success in translating even the most abstract of these designs into fabric quelled any doubts about the viability of artist-designed textiles. Inspired by the result, the *London Illustrated News* commented that women would be 'blossoming out as walking art galleries'.[26] *Art and Design* (April 1946) applauded Ascher's vision in approaching some of Britain's most celebrated artists: 'One future working pattern is hinted at in small crusading firms like Ascher's of Wigmore Street who, using screenprinting as an economic method for short experimental runs, have collaborated with advanced artists such as Sutherland and Moore, not only reaping the benefit of their names and cultural prestige, but translating the sombre poetry of their idiom into charming prints.'[27] Ascher's astuteness in commissioning such international figures as Moore and Sutherland was a direct move to bolster the all-important export market, as evidenced by the fact that the collection was launched in New York a year before London. Graham Sutherland had previously exhibited in the Cotton Board's exhibition *Design for Textiles by Fine Artists* (1941), one of a series of events organised by the Colour, Design and Style Centre (1940) which helped to foster a more progressive approach and give impetus to the export market. Sutherland would go on to produce textile designs for six companies, including John Heathcoat, Horrockses Fashion, and Helios, which purchased a rose design from the *Design for Textiles by Fine Artists* exhibition and which remained successfully in production even after the company was taken over by Warner.

The success of the launch galvanised Ascher into a second phase; in an effort to capitalise on the unique character of each artist-designed scarf, he commissioned a limited-edition series of between two and six hundred squares, printed in only one colourway. In a bold and enterprising move, Ascher publicised the fact that each silk screen would be destroyed after the initial print run, thus emphasising the originality and desirability of the squares. A further collaboration with

prominent European artists, including Picasso,[28] Matisse and Derain, gave the venture an international perspective, and by 1947 Ascher had embarked on an ambitious programme of exhibitions both at home and abroad.

In September 1947 the Lefevre Gallery hosted *The First Exhibition of Artist Designed Squares*; the collection featured thirty-seven scarves including Sutherland's *Black Trellis* (1946), Topolski's *Scottish Officers* (1945) and Moore's **Three Standing Figures** *c.*1944 (TEX 1). Exhibitions of artist-designed textiles were not a novelty; Allan Walton promoted their expensive range of prints at prestigious venues such as the Mayor Galleries in London. Indeed, Ascher had already experimented with such an event in his Paris office, originally an art gallery, where the scarves were displayed in redundant picture frames, a canny move which reinforced the idea that each square was both functional and a work of outstanding artistic merit. The exhibition, opened by Sacheverell Sitwell, included the cream of the British modernist movement,[29] and the critic was quick to point out Ascher's achievement, both technical and artistic: 'Something like a revolution has been accomplished in industrial design, and it must be a subject of congratulation that this has taken place in England.'[30] Sitwell paid special attention to the limited editions, predicting: 'Not a few of these Ascher scarves will be framed upon walls a hundred years from now, for they are among the best and most characteristic products of our day.'[31] Moore's designs, together with those of Matisse, proved the most popular with public and the media alike; Lida Ascher was invited to talk about the exhibition on national television accompanied by one of Moore's designs, a framed **Standing Figures** placed provocatively on an artist's easel (fig.23). Both the mainstream and specialist press ran features on the exhibition, with photographs of stylish young women wearing the scarves in a variety of ingenious ways; *Picture Post* (20 September 1947) illustrated four scarves, including **Standing Figures** worn as a 'pixie hood'. Almost all reviews picked up on Ascher's ability to convert the designs into fabric; Colin MacInnes of the *Observer* (14 September 1947) opined: 'The artists here are mostly abstract painters using a non-realistic idiom, or one that suggests cognate forms without defining them. How successfully this style of painting lends itself to textile design which has always been, after all, a form of abstract art. The painters have adapted themselves to the decorative quality of the material, and only a few have made pictures that look too much like easel paintings when they are reproduced on silk.'[32] *Harper's Bazaar* (September 1947) reported: 'It is a symptom of the real importance of these

textiles that they should hang in a gallery of such high prestige . . . These squares fall into two quite separate classes. Some are pictures; some are pure designs. But in every single case the artist's work has been translated with skill and sympathy in terms of fabric. The original sketches have been so carefully worked on that, through all the technical processes of reproduction, the artist's spirit and quality are retained.'[33] As a fashion magazine, *Harper's Bazaar* was quick to point out that the scarves also had a practical function and were not merely works of art: '[they] meet the two basic requirements of good design: they are beautiful to look at, and they fulfil their practical purpose (which in this case means that they look well and drape well when they are worn).'[34] *Harper's Magazine* (January 1948), however, questioned Ascher's decision to concentrate on artistic creativity rather than providing a textile-focused design brief: 'It's quite obvious that some of the designers of the Ascher squares had this [function] in mind. Matisse did and so did Henry Moore. Their scarves are designed to fold, to throw on a table, to carry crumpled in the hand – to look handsome in use, not

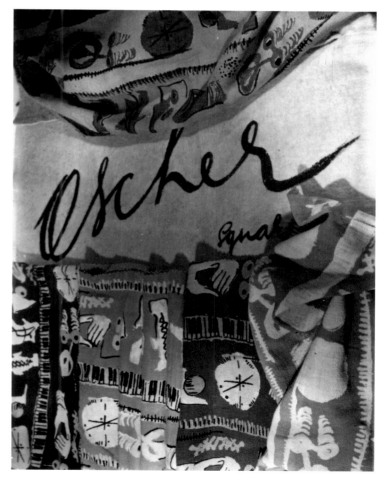

fig.9 Ascher publicity photograph of various colourways of Moore's design **Piano** (TEX 5).

just in a frame. They are real textile designs: clear but subtle colours, lively and surprising patterns, as typical of the artists as any of their paintings or sculptures.'[35] A few reviewers felt that some of the artists had simply reproduced canvas pieces which would only work well 'when stretched and hung the right side up'. *The Ambassador*, edited by Hans Juda, the driving force behind the *Painting into Textiles* exhibition some six years later, was fulsome in its praise for the project: 'Ascher has not only introduced a new element for design he has also introduced an entirely new medium for decoration and costume. They are Accents – casual scarves no longer. They will be the accent of a room as a fine painting should be.'[36] Nikolaus Pevsner was slightly more cautious; although he heaped praise on Moore's technique and **Family Groups** design (TEX 6), he also declared it 'so grave that one may feel it almost as a sacrilege to walk out wearing it'.[37] Despite such reservations, Pevsner was finely attuned to the continuing need for innovation in British textile design, stating, 'For what are the most usual types of designs in printed fabrics? Surely those with realistic or imitation period motifs. But a progressive public, composed of younger people conscious of the changed atmosphere of our century, has grown bored with the hackneyed phraseology of such designs. People want something fresher and more in keeping with their lives; but they don't know what.'[38]

The Lefevre exhibition was followed by both a national and international tour, with venues such as New York, Zurich, Sydney and Cape Town providing ample opportunities to show this unique collaboration between modern artists and textile manufacturers. With his keen eye for business, Ascher reserved some 60 per cent of the scarves, mostly the luxurious silk versions, for the lucrative overseas market. Despite widespread press coverage and on the whole favourable reviews, particularly regarding the level of technical achievement, the scarves were not a commercial success. Ascher did not believe this was down to cost; the limited editions sold for between £4 and £7 each – more expensive than high street scarves – but instead blamed the aesthetically challenged sales staff who 'did not know Moore from Colquhoun'.[39] Undeterred, Ascher continued to commission designs from artists in the 1950s and, as shown by his letter written in 1970, never lost faith in the commercial value of Moore's designs (see p.9).

The squares designed by Moore and the ageing French artist Matisse had proved immensely popular with public and critics alike, who readily identified Moore as both a modern and a visionary, with the capacity to touch the human soul.

This popularity may have galvanised Ascher into approaching both artists with a new venture: to create a series of limited-edition, large wall panels, the modern equivalent of medieval tapestries, for the domestic interior. A year after the success of the exhibition of artist-designed scarves, the Lefevre Gallery again played host to a display of four massive screen-printed panels; two by Matisse, entitled *Océanie – Le Ciel* and *Océanie – La Mar*, were inspired by the artist's experiences at sea in the 1930s. The panels designed by Moore focused once again on the human form: a monumental version of **Two Standing Figures** 1948 (TEX 20) and **Reclining Figure** 1949 (TEX 21). The size of the panels, almost two by three metres, the first examples of screenprinted artwork produced on such a vast scale, once again challenged the ingenuity of both Ascher and his printers, as they struggled to capture the texture and subtle colour variations of Moore's original drawings. The continuing lack of raw materials and shortage of skilled labour presented additional technical difficulties, but Ascher was sufficiently far sighted to employ a young Terence Conran to assist with printing the Matisse panels. It took six months of painstaking experimentation before Ascher, ever the perfectionist, was satisfied with the result; once again he turned towards Moore's favoured drawing technique, using the same wax crayon and watercolour wash method employed on the earlier projects, but this time on massive silk screens. *The Dyer and Textile Printer* (5 November 1948) explained that the sheer scale of the panels created its own problems, due to 'the limited size of available apparatus for steaming and washing'.[40] Moore took a keen interest in the production process, visiting the printing works on more than one occasion before signing each individual panel (only thirty panels of each design were printed). Ascher invited Leigh Ashton, Director of the Victoria and Albert Museum, to write the introduction to the Lefevre catalogue; in it Ashton compares the difference in styles: 'Matisse's designs are purely decorative in the restricted sense of that word. Moore's are pictorial and come, therefore, much closer to tapestry conceptions. But each in his different way has fulfilled his purpose of creating a large panel to be used as a wall hanging and each shows clearly how often it is that a great artist can be a master in other mediums than his chosen one.'[41] Again, Ascher toured the exhibition both nationally and internationally, receiving mixed reviews; some found Moore's subject matter overpowering in a domestic setting. Leigh Ashton believed that 'To eat in a dining-room hung with the Matisse panels would be a delightful experience, while the Henry Moore panels seem to me splendid decoration for any

room.'[42] Erno Goldfinger, a prominent member of the architectural Modern Movement, wrote: 'In the disingenuous atmosphere of the gallery, with a crowd around them, they looked large, obtuse and forbidding. At home on the wall near the fireplace, in the sitting room, next to the African mask and flowers, the big "Reclining Figure" of Henry Moore's became part of its surroundings as if it had been made for the place. Its murky colours and pure whites blended with the surroundings as if it had always been there. In the dining room the "Two Standing Figures" on the wall at the end of the table were part of the proceedings.' (figs 39, 41)[43] Moore's notoriety as an avant-garde artist was played up by the Australian press, who made much of his 'phantasmagorical apparitions', 'weird distortions' and 'panels of disembodied spirits, with an occasional anatomical specimen flung hither and thither, as though abandoned by a careless pathologist'.[44] Although Ascher did not repeat the experience, Moore would go back to designing for large-scale textiles, albeit tapestries, some twenty years later, and his comments regarding his collaboration with the West Dean Tapestry Studio shed light on why he found textiles so appealing: '. . . if it were just going to be a colour reproduction I wouldn't be interested. It is because it is a translation from one medium into another and has to be different that you get a surprise. It is not like a bronze caster who has to produce an absolutely exact copy or it is thrown away; the beauty of tapestry is that it is different, an interpretation, and that to me is the excitement and the pleasure.'[45]

Could Britain make it?

The main thrust for industry throughout the post-war period, as indeed it had been throughout the century, was that Britain should be at the forefront of producing well-designed, affordable goods which would have a market both at home and internationally. On 24 September 1946 the exhibition *Britain Can Make It* was opened by King George VI and Queen Elizabeth at the Victoria and Albert Museum; throughout the war the Museum's collections had been safely stored outside London, secure from the threat of bomb damage, and the still depleted galleries provided ample exhibition space. This, together with the fact that the original purpose of the Museum was to improve the standard of design throughout the country, made it the ideal venue for a propaganda campaign. Sponsored by the Board of Trade and Council of Industrial Design (formed in 1944 with a remit to raise design standards throughout British industry), the exhibition's aim

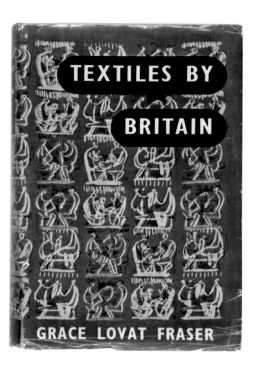

fig.10 Moore's **Family Groups** (TEX 6) on the cover of Grace Lovat Fraser, *Textiles by Britain*, Allen and Unwin, London 1948.

was to show the variety of consumer goods Britain had to offer after the 'make do and mend' austerity of the war years. Moore's commitment towards achieving status and acceptance for industrial design is reflected in his position as a Council Member of the CoID from its inception, along with Paul Nash, and Kenneth Bird, who under the pseudonym 'Fougasse' produced patriotic designs for textiles during the war.[46] Effectively a public relations exercise to show foreign competitors that Britain could compete on the international stage, the exhibition was also a thinly veiled attempt to educate the British public in what constituted good design. The emphasis therefore was on product design for domestic use, reinforcing the idea that the everyday object could make life easier, more comfortable and, above all, more fun. Echoes of the concerns of earlier design reform, most notably in the aims and objectives of the DIA, are reflected in the exhibition's propaganda: 'Let us not allow for the insidious ease of selling in a world starved of goods, to make us aesthetically and – yes – *commercially* soft. British goods have admitted quality and fine workmanship; only their design is in doubt. By recognising and buying good design, in everything, we can help to make them invincible. "Peace hath her victories no less renowned than war" – and this is one which Britain can, and must, win.'[47] However, the effectiveness and decision-making ability of the CoID had been debated since its formation, and accusations of 'aesthetic dictatorship', based on a not altogether unrealistic perception of a London-centred bias in matters of taste, surfaced during the exhibition. Despite being well attended,

some manufacturers felt that 'The Council was out of touch with popular taste and did not realise that the modernistic exhibits of *Britain Can Make It* could not sell.' James Cleveland Bell, Director of the Cotton Board's Manchester-based Colour, Design and Style centre, played a key role in the selection of textiles and fashion for the exhibition. Bell had previously worked on the *Design for Textiles by Fine Artists* exhibition (1941) and was considered extremely influential in matters relating to textile design. Edinburgh Weavers, active once more after wartime closure, contributed designs by Alastair Morton.[48] Zika Ascher was represented by a large collection of textiles and artist-designed scarves, including one each by Sutherland and Moore; both artists were also represented in the Cotton Board's 1946 exhibition held at the Colour, Design and Style Centre in Manchester, exhibited alongside a display of current American textile designs, in an attempt to illustrate what British manufacturers could do once supplies were available. The importance of both the Cotton Board's exhibition and *Britain Can Make It* should not be underestimated, given that in the same year textiles accounted for 20 per cent of British exports.

The Festival of Britain in 1951 heralded a new era for the textile industry and set the tone for a revolution in fabric designs which would reverberate well into the 1960s. Mark Hartland Thomas, Chief Industrial Officer at the Council of Industrial Design, instrumental in setting up both the main event and the Festival Pattern Group (1949), stated: '. . . we are at a stage in the history of industrial design when both public and leading designers have a feeling for richness in style and decoration, but are somewhat at a loss for inspiration'.[49] With the passing of the years, it is sometimes difficult to appreciate the originality and impact of designs which so gallantly challenged the dominance of the tried and tested floral patterns. The 'contemporary' style, however, characterised by an exuberant use of colour, materials and lightness of structure, finally laid to rest the drabness of the war years and set the tone for a new period of creativity and verve. Established designers such as Enid Marx and Marianne Straub rubbed shoulders with a new generation of talented individuals who would all receive critical acclaim for the emerging 'contemporary' style which would define both the Festival and the period. Lucienne Day, an ex-RCA student, Jacqueline Groag and Marianne Mahler are all names synonymous with the distinct new style, influenced by modern artists such as Jean Arp, Paul Klee and Alexander Calder. Both Groag and Mahler were émigrées who had studied at the Kunstgewerbeschule and had had designs

produced by the Weiner Werkstatte. Although manufacturers had been aware of the benefits of identifying artists' names on the selvedge of fabric lengths since the 1930s, the success of the new designs confirmed forever the status of a new breed of textile designer. The Festival highlighted two new design aesthetics. The highly inventive 'scientific' style, inspired by microscopic crystal structure diagrams of atoms in substances such as haemoglobin and insulin, was less successful; it was the abstract forms and organic shapes of the popular 'contemporary' style exhibited in the *Homes and Gardens* pavilion that excited both the popular and specialist press, including *The Ambassador*, and would set the standard of design for industry for the next five years. Post-war Britain, still in the throes of reconstruction after the bombing of its towns and cities, responded with enthusiasm as young couples, determined to stamp their own sense of individuality on their new homes, created contemporary interiors suited to their modern lifestyles. With the advances in textile production such as screenprinting, synthetic materials and dyes, the British consumer was at last presented with a lively variety of materials for both the fashion and furnishing markets.

Painting into Textiles

The Ambassador was a British export magazine which boasted subscribers in ninety countries;[50] the magazine included articles on developments in trade and industry with special features devoted to new materials and techniques. In 1953, the year of the coronation of Queen Elizabeth II and the dawn of what many believed would be an exciting new 'Elizabethan Age', *The Ambassador* sponsored *Painting into Textiles*, an exhibition held at the Institute of Contemporary Arts, then located in Dover Street, London. With the aim of encouraging closer communication between artists and textile converters, Hans and Elspeth Juda commissioned twenty-five modern artists, at a fee of £25 each, to produce work which would reinvigorate the industry and inspire a new generation of design-conscious consumers. Roland Penrose, Chairman of the ICA, wrote to potential participants, who included the cream of the modern British art and design world, laying out the aims of the exhibition as 'to further the promotion of contemporary textile design in Great Britain and to encourage talent among artists and art students'.[51]

By gathering together new sources of inspiration which could be adapted to suit modern production, Juda hoped to push the boundaries of textile design, as his editorial in Issue 11

of *The Ambassador* (1953) made clear: 'Little but good can come from a closer association between the Arts and textiles. The sketches and paintings we commissioned were calculated to stimulate everybody concerned – the designer, the manufacturer, the converter – and provide a *starting point* from which to develop saleable goods.' The Cotton Board's exhibitions of 1941 and 1944 had continued to stimulate interest in the concept of artist-designed textiles, and by 1953 the new ideas and abstract symbols now accepted in modern painting and sculpture were filtering into the consciousness of the general public. Nikolaus Pesvner had set the tone some eight years previously in his article 'Can Painters Design Fabrics?': 'Study [Moore's] fabrics closely and you will be struck by their seriousness, not to say mystery. They have all this great artist's searching intensity. They are like the best modern music, jarring perhaps to the newcomer, but full of hidden meaning and new harmonies. Now all that seems to exclude success in terms of dress yet – here they are, so widely toned down, so skilfully handled that the result is usually a perfectly sound, coherent textile design, acceptable to any discriminating public.'[52] Juda's introduction to the exhibition catalogue echoes the aims and objectives of Ascher's artist-designed scarves project some seven years previously: '. . . the artists were not asked to produce textile designs but paintings which might well be an inspiration and therefore adapted for the purpose. The fact that some of the commissioned artists are not acquainted with the difficulties and techniques of textiles can paradoxically become an asset. This ignorance, almost in the nature of a random element, leads to an adventurous approach which may create difficulties for the convertor [*sic*] but at the same time can be the spark for an unexpected and even startling design.'[53] Most of the designs were taken up by industry, and the exhibition included some already in production, including two by Moore, whose commitment towards industrial design and innate respect for the character of his material enabled him to approach his brief in the same manner as any other commission. His international reputation and the quality of his design made him the natural choice for the front covers of both Issue 11 of *The Ambassador* and the exhibition catalogue. The press were quick to capitalise on Moore's fame, and in some cases notoriety. Writing for the *Yorkshire Post*, A.P. Maguire declared: 'Mr Moore has figures. They are figures from his sculptures rather than from his tube-shelter and coalmine drawings. They are upright figures. Some people say that it would not be a real Henry Moore unless it had a reclining figure. Very well, then, it has a reclining figure too, somewhat

in the background of this three dimensional world of Mr Moore's, where figures have shadows. The sculptor tells me that he did not do this drawing specially for the present exhibition, but he did do it as a textile design.'[54] Not all reviews were complimentary; the *Manchester Guardian* stated: 'Most of the designs are in the abstract manner, strong and forceful, and well away from the current feeling for softly sweeping motifs. For this reason many of them translate into household furnishings rather than into dress fabrics. They are not as feminine as the present feeling in fashion – Moore's set of characteristic figures are for the collector but not for everyone.'[55] Some reviews even harked back to the golden age of British textile designs, believing that textile design had 'improved greatly since the war, but there have been no designs in the grand manner which can compare with the great Georgian floral patterns or the popular regency stripes.'[56] Some found the exhibition a revelation; Winifred Carr writing in the *Daily Telegraph* exclaimed, 'It wasn't until I saw this exhibition that I realised just how pleasurable modern art could be . . . the painting of figures by Henry Moore . . . could very well be the inspiration of an amusingly out of the rut fabric design. Assuming you admire contemporary art, of course!'[57]

Moore had been approached for designs for furnishing fabrics prior to the opening of the *Painting into Textiles* exhibition. Under the leadership of John Murray, appointed as Director of Furnishing Fabric, David Whitehead Limited (formed in 1927) gained a reputation for employing some of the most innovative artists and designers of the 1950s, and would continue to do so into the 1960s. Lucienne Day described the company as one which 'broke with tradition and gave the mass market gay, colourful and imaginative designs . . . Whitehead became synonymous with the contemporary print, banishing forever the era of muddy floral and "folksy" print patterns.'[58]

David Whitehead Limited was one of the first manufacturers fully to utilise mechanised screenprinting and increase its capacity to mass-produce modern furnishing fabrics. Rayon, which had revolutionised textile production in the decades before the Second World War, continued to prove indispensable to manufacturers targeting consumers looking for fresh, colourful textiles to brighten up the home, and Whitehead's became synonymous with a range of vibrant, innovative textiles at affordable prices. Improved production techniques ensured that fears regarding possible shrinkage were banished – as may be seen in contemporary advertisements by the Calico Printers' Association: 'Calpreta

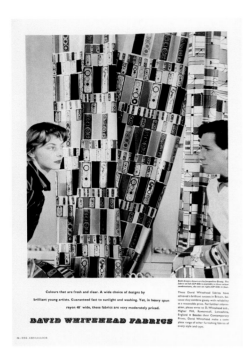

non-shrink finish . . . rayon's most powerful ally . . . Spun rayon curtain materials marked "Calpreta non-shrink" can be made up to exact dimensions. No need to allow for "that extra three inches" and positively _no_ shrinking, stretching or loss of shape – no matter how often the material is washed – and colours remain fresh and clear'.[59] John Murray, who had radically reinvented Whitehead's image, also recognised the importance of advertising, promoting both the benefits of new advances in the production process and tapping into the excitement generated by new young designers. Full-page advertisements were placed celebrating 'Colours that are fresh and clear. A wide choice of designs by brilliant young artists guaranteed fast to sunlight and washing. Yet, in heavy spun rayon 48" wide, these fabrics are very moderately priced'.[60] Murray established good working relationships with established and new artists and designers such as Marian Mahler,[61] Jacqueline Groag, Terence Conran and John Piper. Hans and Elspeth Juda of *The Ambassador* were particularly impressed with Murray's approach, and his determination to produce well-designed, innovative fabrics at relatively low cost. In 1950 Murray outlined his philosophy in an article entitled 'The cheap need not be cheap and nasty' for the journal *Design*: 'It is true that a certain amount of lip service is paid to good design, but the instances in which an ostensible belief is carried into commercial practice are very few, moreover much of the good design which is produced is confined to the higher price ranges, catering for the statistically insignificant wealthy class. My own firm, on the other hand, caters primarily for those vast sections of

humanity in which the emphasis is on cheapness and serviceability . . . the processes of making money and making fine things are not mutually exclusive.'[62] Murray left David Whitehead in 1953, handing over the reins to his friend and fellow architect Tom Mellor, who continued to seek out modern artists who would produce ideas which could be adapted by Whitehead's in-house design studio. Their Managing Director, Fred Peace, described the process: 'Mellor commissioned some designs from Henry Moore and arranged for myself and the head of the Studio to see John Piper in order to find out whether any of his paintings could be translated into textiles . . . A policy of visiting exhibitions of artists' work was followed. In the cases of Henry Moore and John Piper no outright purchase of their work was made. Instead, the right to produce the picture as a textile design was purchased.'[63] Mellor bought work by six artists represented in the *Painting into Textiles* exhibition: William Scott, Paule Vézelay, Cawthra Mulock, J.D.H. Catleugh, and Donald Hamilton Fraser as well as Moore, who had actually been commissioned by Mellor before the exhibition opened.[64] The designs were put into immediate production and were an instant commercial success (artists' names, unlike those of the in-house design team, were always used on the fabric's selvedge), and generated a huge amount of publicity for the company.[65] Once again, Moore's designs proved particularly problematic for Whitehead's design studio; David Peat interviewed a number of Whitehead's internal design team for the exhibition *David Whitehead Ltd: Artist Designed Textiles 1952–1969* held at Oldham Art Gallery in 1993–94. Derek Woodall recalled that Moore's designs '. . . arrived as scraps of cartridge paper – basically wax motifs with a watercolour wash. It wasn't bad with the screenprinting because it was easy to copy, but the woven ones were a problem because it needed to be designed so that the Jacquard cutter could follow the pattern.'[66]

The *Painting into Textiles* exhibition would be Moore's last foray into the world of textile design – enlightened manufacturers such as Edinburgh Weavers, David Whitehead, Heathcoats, Horrockses and Heals would continue to work closely with some of Britain's most innovative modern artists well into the 1960s. The opportunity for the average man – or, more particularly, woman – in the street to acquire the very best of modern British art and design was not lost on contemporary commentators: as Manchester's *Daily Dispatch* proclaimed, 'We can't all afford to hang a Picasso on the wall – but very soon we'll be having Henry Moore curtains at the windows!'[67]

Notes

1 Letter from Zika Ascher to Henry Moore, dated 14 October 1970, The Henry Moore Foundation archive.
2 Roger Berthoud, *The Life of Henry Moore*, Giles de la Mare, London 2003, p.15.
3 Mary Schoeser and Celia Rufey, *English and American Textiles from 1790 to the Present*, Thames & Hudson, London 1989, p.10.
4 Ibid., p.147.
5 R. Fry to G.B. Shaw, 11 December 1912: BL Add. MS. 50534, cited in Francis Spalding, *Roger Fry: Art and Life*, Granada, London 1980, p.176.
6 Lesley Jackson, *Twentieth Century Pattern Design*, Mitchell Beazley, London 2002, p.76. The DIA is still active, organising visits, events, competitions and bursaries 'For the advancement of knowledge to promote, organise and encourage education of the public in the appreciation of good design, more particularly in connection with things in everyday use, and for the purpose to hold lectures, exhibitions and to award bursaries and scholarships to students.'
7 America did not actually participate in the exhibition, which left the way open for the French to position themselves as pre-eminent, not only in the field of modern art but also as leaders in dictating taste and fashion.
8 The role of the RIB is discussed in Christopher Bailey, 'Progress and Preservation: The Role of Rural Industries in the Making of the Modern Image of the Countryside', *Journal of Design History*, Vol.9, No.1 (1996), pp.35–53. In the article Bailey quotes Marianne Straub's definition of the role of the RIB in regenerating rural craft: 'I must stress that what the Bureau was helping here was *industry* not craft . . . It was not interested in people like Ethel Mairet and Bernard Leach, it was interested in *rural industry*', p.38.
9 Christine Boydell, 'Free-lance Textile Design in the 1930s: An Improving Prospect?', *Journal of Design History*, Vol.8, No.1 (1995), p.32.
10 For an analysis of Read's publication see R. Kinross, 'Herbert Read's "Art and Industry": A History', *Journal of Design History*, Vol.1, No.1 (1988), pp.35–50.
11 H.G. Hayes Marshall, *British Textile Designers Today*, F. Lewis, Leigh-on-Sea 1939, p.9.
12 Pevsner estimated that something in the region of 20,000 yards of fabric could be printed in one day of production. Boydell, op. cit., p.27.
13 The cost of engraving rollers could range from £50 to £300 each, making anything over four or five colours for each fabric length financially prohibitive.
14 Jackson, op. cit., p. 75.
15 Paul Nash, letter to the Editor, *The Times*, 12 June 1933.
16 Berthoud, op. cit., p.46.
17 Ibid., p.57.
18 Paul Nash, 'Weekly Notes on Art: Modern English Textiles', *Listener*, 27 April 1932, p.607.
19 Jackson, op. cit., p.73.
20 G. Rayner, R. Chamberlain and A. Stapleton, 'Artists' Textiles in Britain 1945–1970', *Antique Collectors' Club*, 2003, p.13.
21 Ibid., p.19.
22 Boydell, op. cit., p.39.
23 Ngozi Ikoku, *British Textile Design from 1940 to the Present*, V&A Publications, London 1999, p.9.
24 In a letter to Alice Gostick written from the trenches in 1917, Moore wrote: 'If one likes to let one's imagination run ahead one can be quite convinced that the barbed wire posts are forming fours, or advancing in line towards your trench.' Berthoud, op. cit., p.27.
25 Valerie D. Mendes and Frances M. Hinchcliffe, *Ascher: Fabric, Art, Fashion*, Victoria and Albert Museum 1987, p.146.
26 Ibid., p.24.
27 Ibid., p.98.
28 The Picasso scarf never made it to production; Ascher recalled the artist taking 'a shine' to Lida and decided to put his marriage before his business concerns. Picasso would later design a scarf for Roland Penrose as part of a fundraising campaign for the Institute of Contemporary Arts in London; the 'Bull and Sunflowers' design was also used for a limited edition of prints.
29 Participating artists included Barbara Hepworth, Ivon Hitchens, Ben Nicholson, John Piper, Graham Sutherland, Julian Trevelyan, John Tunnard, Keith Vaughan and Gerald Wilde.
30 Mendes and Hinchcliffe, op. cit., p.23.
31 Ibid., p.28.
32 Ibid., p.32.
33 Ibid., p.54.
34 Ibid., p.29.
35 Ibid., p.30.
36 Ibid., p.29.
37 Nikolaus Pevsner, 'Can Painters Design Fabrics?', *Harper's Bazaar*, November 1945, p.80.
38 Ibid.
39 Mendes and Hinchcliffe, op. cit., p.34.
40 Ibid., p.40.
41 Ibid., p.36.
42 Ibid., p.40.
43 Ibid.
44 Ibid., pp.40–1.
45 Ann Garrould and Valerie Power, *Henry Moore Tapestries*, The Henry Moore Foundation in association with Lund Humphries, London 1998, p.8.
46 Members of the Council of Industrial Design included its Chairman, Sir Thomas Barlow, of the textile company Barlow & Jones, who established the independent subsidiary Helios in 1936; Ernest Goodale, Managing Director of Warners & Sons; and Ethel Mairet, Head of Ditchling Weaver School who, at the age of 72, was still recognised as 'a top-rank designer'.
47 Archive of Art and Design, AAD 4/17-1977.
48 Morton had spent part of the war studying with Ethel Mairet in her Ditchling studio and went on to design for Horrockses Fashion, the newly formed subsidiary of Horrockses, Crewdson & Company Limited. The company would achieve outstanding success in the 1940s and 1950s due in part to the contribution of artists such as Graham Sutherland, who replaced Morton in 1954. The company produced several designs by artists including William Gear and Eduardo Paolozzi.
49 Ikoku, op. cit., p.10.
50 Hans Juda opened the London office of *International Textiles* in 1933, a companion to the original Dutch publication. The outbreak of the Second World War severed connections between the two offices, which continued to publish independently. With the return to peace, the situation was formalised and from March 1946 the British version changed its title to *The Ambassador*. Laszlo Moholy-Nagy worked as the magazine's art director.
51 Letter dated 8 May 1953, Tate Gallery Archives TGA.955 1.20.50 2/12.
52 Pevsner, op. cit., p.80.
53 *Painting into Textiles* exhibition catalogue, Institute of Contemporary Art, 21 October–14 November 1953.
54 *Yorkshire Post*, 22 October 1953.
55 *Manchester Guardian*, 22 October 1953.
56 Ibid., 19 October 1953.
57 *Daily Telegraph*, 3 November 1953.
58 Alan Peat, *David Whitehead Limited: Artist Designed Textiles 1952–1969*, exhibition catalogue, Oldham Museum and Art Gallery, 11 December 1993–6 February 1994, p.8.
59 *The Ambassador*, Issue 11, 1953, p.25.
60 Ibid., p.30.
61 After moving to Britain Mahler had worked with progressive textile companies such as Donald Brothers, Edinburgh Weavers, Helios and Allan Walton Textiles, and she would go on to collaborate with David Whitehead Limited, changing her name to Marian.
62 *The Ambassador*, op. cit., p.13.
63 Ibid., p.14.
64 Participating artists besides Henry Moore included Robert Adams, Eileen Agar, Sandra Blow, J.D.H. Catleugh, Geoffrey Clarke, Prunella Clough, Merlyn Evans, Terry Frost, William Gear, Donald Hamilton Fraser, Ivon Hitchens, Charles Howard, James Hull, Peter Lanyon, George Melhursh, Eduardo Paolozzi, Victor Passmore, John Piper, Ceri Richards, William Scott, Graham Sutherland, James Tower, William Turnbull, Keith Vaughan and Edward Wright. Textile designers included Lucienne Day, Jacqueline Groag (used by Whitehead to advertise the benefits of rayon), Marian Mahler and Humphrey Spender.
65 David Whitehead Ltd did not entirely reject Britain's textile heritage. Both Mellor and Terence Conran developed a range of fabrics which gave a new slant on the traditional floral patterns of the pre-war years; the 'modernised florals' juxtaposed flora and fauna with more contemporary objects or settings and were commercially extremely successful.
66 Peat, op. cit., p.16.
67 *Manchester Daily Dispatch*, 22 October 1953.

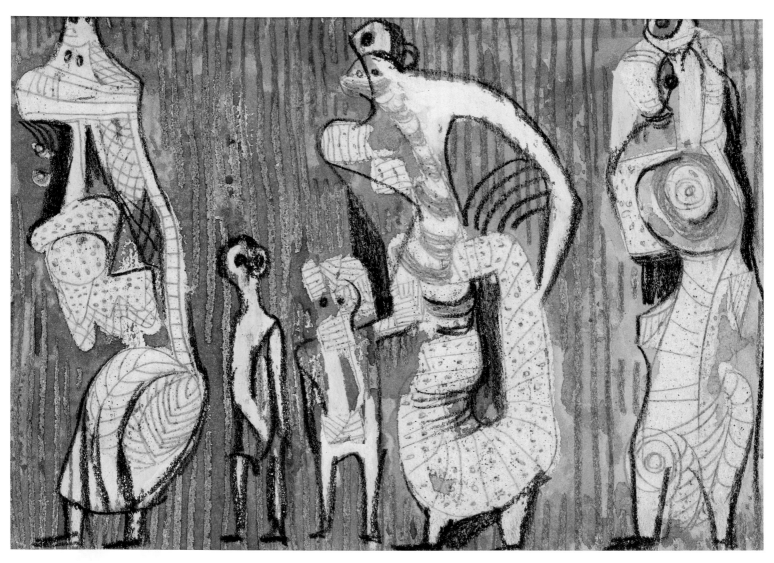

fig.12 **Textile Design: Figure Studies** 1943; page from *Textile Design Sketchbook 2* (HMF 2126a) pencil, wax crayon, coloured crayon, watercolour and poster paint, 178 × 254mm.

Henry Moore Textiles

Anita Feldman Curator

The Henry Moore Foundation, Perry Green

Henry Moore is best known for his monumental sculpture, evocative war drawings and for his inspirational use of natural forms – from bones and stones to gnarled roots and the internal coils of a sea shell. Visitors to his maquette studio at Perry Green are often astonished to discover that the artist worked on an intimate scale with objects he could hold in the palm of his hand, and that fewer than 10 per cent of his ideas were enlarged. His textile designs fall into this category as well: they remain virtually unknown, the majority are drawn on paper measuring a mere 204 × 165mm, and relatively few were put into production. Yet these compositions reveal many illuminating aspects of his work, with links to his interests in non-Western art, organic form and, perhaps surprisingly, industrial materials and vivid colour.

The textiles are intricately connected to Moore's aims as a post-war artist, particularly as a Socialist who believed that modern art should be a part of daily life and that art could act as a cohesive force in society – bringing together communities through public projects, as well as inspiring a new approach to family living in the use of modern designs and materials for dress and upholstery fabrics. Incorporating industrial motifs such as barbed wire (TEX 4) and twisted safety pins (TEX 12) gave the designs a distinctive hard edge, while enigmatic surrealist motifs such as clock hands (TEX 14 and 19) harken back to Moore's pre-war experiments mediating between the camps of the Surrealists and the Abstractionists (fig.13). Vibrant and sometimes dizzying intertwining streaks of colour such as appear in **Fern Leaves and Palm Branches** (TEX 18) anticipate the gestural freedom of the Abstract Expressionists, and question the preconceived notion that Moore was somehow divorced in his aesthetic pursuits from his contemporaries in the post-war avant garde.

Many of the subjects depicted in Moore's textile designs are unusually whimsical, from imaginative sea creatures to twisting caterpillars, insect wings, piano keys and even rows of teepees (TEX 5, 10, 11, 25; HMF 2124d). Although free from direct ties to sculpture, in some instances patterns are carried forward from one medium to another, such as in **Textile Design: Figure Studies** 1943 (HMF 2126a) which clearly relates to Moore's leaf figures in bronze a decade later (figs 12, 14). In

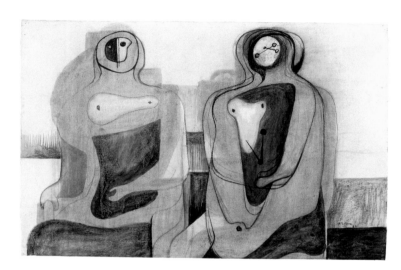

fig.13 **Two Seated Women** 1934 (HMF 1077) charcoal, watercolour, pen and ink and crayon, 370 × 553mm. The Henry Moore Foundation: acquired 1983.

other drawings Moore revisits his compositions from the 1930s (HMF 1171, 1172), reviving the free line and interplay of geometric shapes in **Textile Design** 1943 (fig.15). One expects to find reclining figures, Moore's preferred template for exploring form. Yet out of twenty-eight textile patterns only

fig.14 **Leaf Figure No.3** 1952 (LH 325) and **Leaf Figure No.4** 1952 (LH 326) bronze, height 49.5cm. Museo Nacional Centro de Arte Reina Sofía, Madrid.

three employ this theme, and in one in particular (TEX 8), the lines of brilliantly coloured drapery flow on through the repeat until the figures virtually dissolve within them.

Moore once said that colour for him was 'a bit of a holiday',[1] and his work in textiles, as in his drawings and graphics, gave him unrestrained freedom within which to experiment. For an artist who believed that colour was a distraction from appreciation of form and hence did not paint his sculptures (as did Hepworth), Moore's dynamic manipulation of colour in his textiles, such as shocking pink and acid green, may seem wildly out of character. Yet they do find precedent in many of his war drawings, in which sharp contrasts of colours are used to express the psychological effects of alienation and devastation, and in his compositions from the late 1930s and early 1940s with solitary figures seen against imagined red or pink rock formations. But unlike the atmosphere of foreboding in those compositions, the use of colour in Moore's textiles is essentially optimistic – a looking forward to a new era. Although most of his textiles were printed after the war, many designs date from 1943, before the outcome of the conflict was a certainty.

Moore was first approached by the textile guru Zika Ascher in late 1942 or early 1943. On honeymoon in Norway with his wife, Lida, Ascher managed to escape the Nazi invasion of Czechoslovakia.[2] Arriving in England, he soon commissioned leading British artists to create designs for silk 'squares' (scarves).[3] From 1943 Moore filled four notebooks with compositions for textile designs. These were annotated by the artist to indicate which ideas were intended for squares, furnishing fabrics or dress designs. By the late 1940s Moore was experimenting with signed limited editions of hand-printed textile panels which employed fabrics in a similar way to his graphics; they could be hung as objects of art in themselves. The designs for these were not done in a repeat but as a bold single motif, and were more figurative (TEX 20, 21, 27, 28). The printing of each colour on a separate screen was painstakingly attended to by Ascher along with his team (figs 16–18).

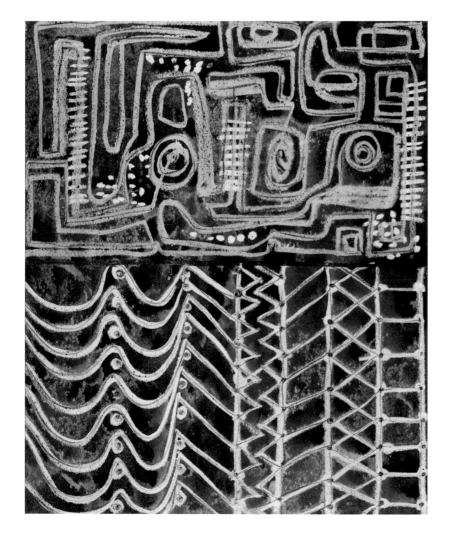

fig.15 **Textile Design** 1943; page from *Textile Design Sketchbook 3* (HMF 2153) pencil, wax crayon, coloured crayon, watercolour. John Robert Wiltgen, IIDA.

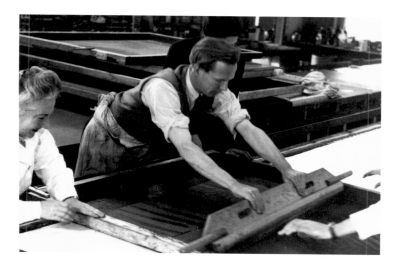

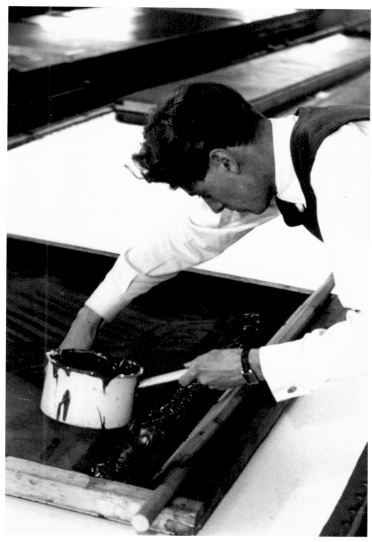

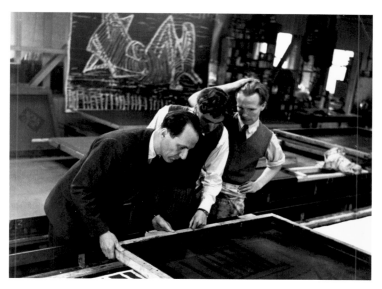

figs 16–18 Printing of **Reclining Figure** (TEX 21) in the Ascher studio, c.1948.

Moore soon afterwards came to the attention of the firm of David Whitehead Fabrics, which, under the directorship of the architect John T. Murray, launched a range of bold, low-cost, rollerprinted fabrics designed by leading artists for the 1951 Festival of Britain. Whitehead subsequently developed a more exclusive range of hand screenprinted textiles with more painterly designs, largely inspired by the 1953 exhibition *Painting into Textiles* held at the Institute of Contemporary Arts in London. Moore's design for **Zigzag** 1954 (TEX 23) was reproduced on the cover of the catalogue (p.143) and went into production the following year along with **Triangles and Lines** 1954 (TEX 22). Moore's home, Hoglands, featured the **Zigzag** fabric made up as bedspreads, as well as Ascher curtains made from **Heads** 1945–46 (TEX 9, p.91) and from **Treble Clef, Zigzag and Oval Safety Pins** 1946–47 (TEX 12, p.103). Moore's vision of artist-designed textiles being a part of daily life had become a reality at least in his own domain.

Until as recently as 2006, only three of Moore's textile notebooks were known and published.[4] A completely unrecorded notebook was then found during the cataloguing of the collection belonging to the Ascher family. This sketchbook, inscribed in pencil 'Number 2 Design Notebook' still contains six pages; another eleven have now been ascribed to it, and of these eleven, seven were hitherto completely unknown. Further research has led to the identification of one of the volumes in Moore's library as the source of many of the Native American motifs which appear in the textile designs, particularly those from *Textile Design Sketchbook 2* (not to be confused with *Number 2 Design Notebook*). This book, *Indian Art of the United States*, by Frederic H. Douglas and René d'Harnoncourt, was published in 1941 by the Museum of Modern Art in New York.[5] In one sketch we find an Inuit mask and a marine ivory drum handle (figs 20, 21), and in another (HMF 2135c, see p.45), a second

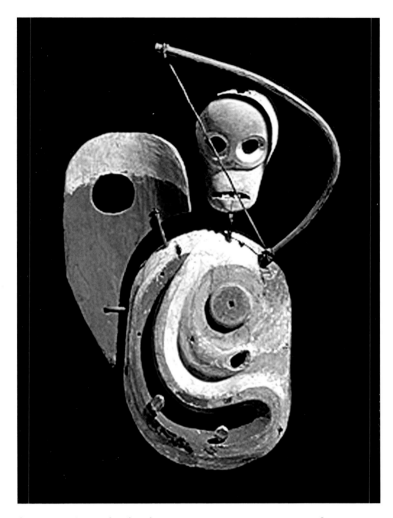

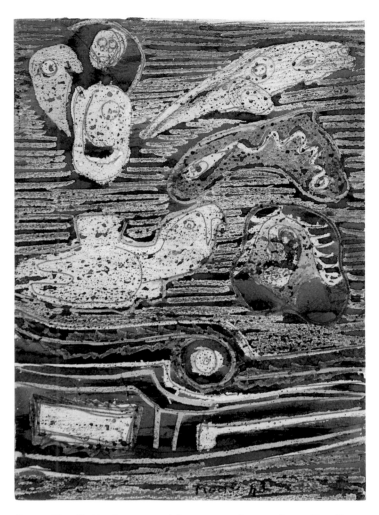

fig.20 Inuit mask. Phoebe Apperson Hearst Museum of Anthropology, University of California at Berkeley.

fig.21 **Textile Design** c.1946 (HMF 2129a); page from *Textile Design Sketchbook 2* pencil, wax crayon, watercolour wash. The Ascher Collection.

Inuit mask, a prehistoric stone pipe from Tennessee, and a Tlingit horn ladle.

Although a small number of Moore's textiles have appeared in exhibition catalogues such as *Henry Moore: War and Utility*,[6] this is the first publication devoted to the subject. All previously unrecorded drawings from the *Number 2 Design Notebook* as well as an additional three recently discovered compositions for textiles (HMF 2135a–c; see TEX 3) are published in the following pages for the first time. Many other drawings are reproduced in colour when they have only been known in black and white. In the final section, each of the twenty-eight Moore textiles is fully illustrated with the majority of their known colourways and fabrics alongside the sketches that led to their creation.

(opposite)
fig.19 Moore in his home, Hoglands c.1948, with a group of his own maquettes, a medieval Madonna and Child and curtains made from his design **Heads** (TEX 9).

Notes
1 Pat Gilmour, unpublished interview with Moore 1975, The Henry Moore Foundation archive.
2 Zika Ascher served in the RAF for a few months of the war but quickly contracted hepatitis. In the meantime Lida, with Zika's sister Jirina (who arrived via the kinder transport), began selling fabrics in Britain. Jirina's husband, Ivo Tonder, served in the RAF and was famously part of the Great Escape. Zika's brother Enda, a painter in Paris, was able to introduce Zika to many artists including André Derain and Henri Matisse. Zika's shop in Prague, which he had run with his brother Pepik since 1929, still remains standing with the original 'ZA' sign.
3 In one revealing letter from the Ascher archive, Ben Nicholson replies to Ascher that he would only consider his offer if he were paid more for his design than his wife Barbara (Hepworth) was for hers.
4 See *Henry Moore: Complete Drawings*, vol.3, Lund Humphries, London 2001, pp.174–89.
5 Moore visited New York five years later on the occasion of his 1946 solo exhibition at MOMA, at which time d'Harnoncourt presented the artist with an inscribed copy of his book. Although the sketchbook from which these drawings derive was begun by Moore in 1943, many pages were drawn in subsequent years. See *Henry Moore: Complete Drawings*, op.cit., vol. 3, p.178.
6 *Henry Moore: War and Utility* originated at Perry Green in 2001 and was accompanied by a small display in the Foundation's Aisled Barn which included six Moore textiles. The exhibition was re-created in 2006 for the Imperial War Museum, London. Two Moore fabrics were previously exhibited at the Baukunst-Galerie, Cologne, in 1970–71, and a number of Moore textiles were shown at the Redfern Gallery, London, 1983.

Designs

All previously unrecorded textile designs are illustrated here along with other textile designs in colour for the first time. These appear in the sequence of the four known sketchbooks. *Textile Design Sketchbook 1* (also known as *No. 1 Design Notebook*) remains intact with twenty-four pages. *No. 2 Design Notebook* was discovered in 2006 with six pages intact; other drawings have since been ascribed to it. *Textile Design Sketchbook 2* was disbanded at an early date and appears to have been drawn from 1943 to 1946. *Textile Design Sketchbook 3* was also disbanded and as yet only nine pages have been identified.[1] Drawings that closely relate to Moore's textiles have been illustrated with those textiles.

1 All known textile drawings not illustrated here can be found in *Henry Moore: Complete Drawings*, vol.3, Lund Humphries, London 2001, pp.174–189.

Textile Design Sketchbook 1 (also known
as **No.1 Design Notebook**) 1943
Sketchbook of cream medium-weight laid
paper 204 × 165mm containing 24 pages
numbered upper right on the recto; they are
unsigned and undated.
The Ascher Collection
(other pages illustrated with TEX 9, 10, 11, 12,
13, 17)

Textile Design 1943
HMF 2102
pencil, wax crayon, watercolour, pen and ink
inscription: pencil u.l. *Square*

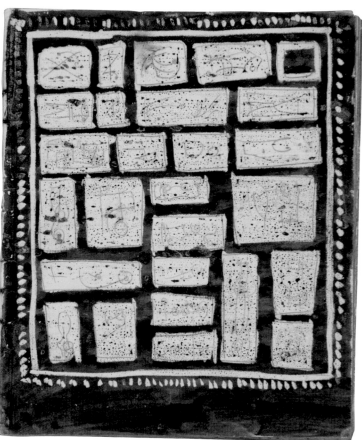

(above left)
Textile Design 1943
HMF 2103
pencil, wax crayon, watercolour
inscription: pencil u.c. *Find motives*

(left)
Textile Design 1943
HMF 2104
pencil, wax crayon, watercolour

(above right)
Textile Design 1943
HMF 2105
pencil, wax crayon, watercolour

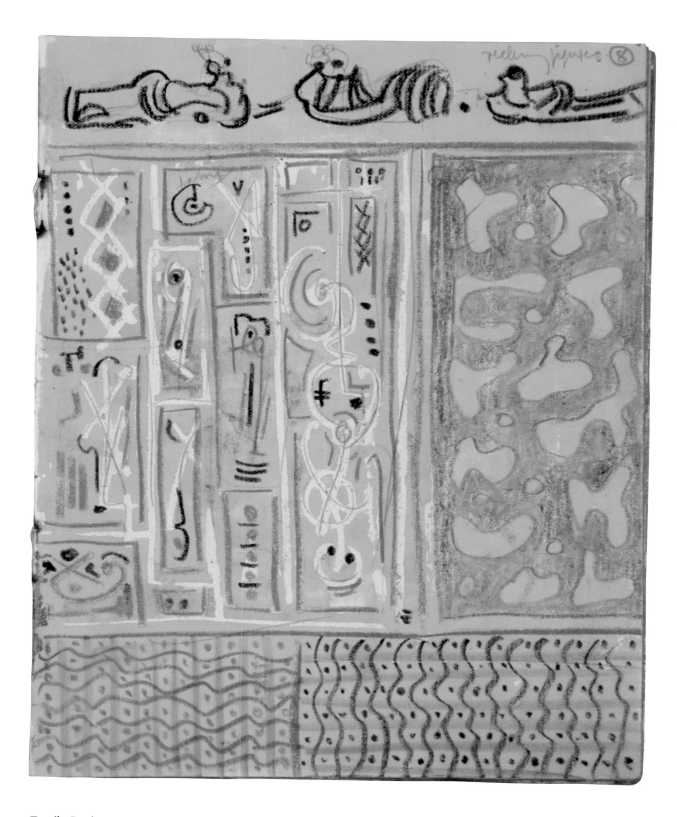

Textile Design 1943
HMF 2108
pencil, wax crayon, watercolour
inscription: pencil u.r. *reclining figures*

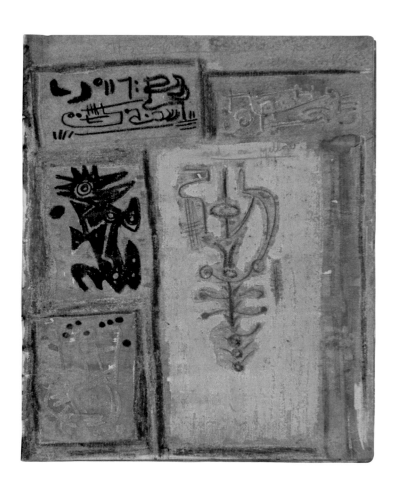

Textile Design 1943

HMF 2109

pencil, wax crayon, watercolour

inscription: pencil u.c.r. *red on yellow*

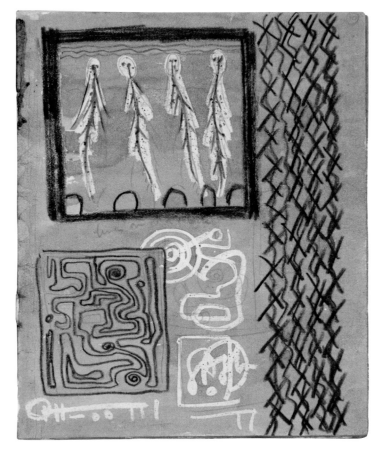

Textile Design 1943

HMF 2110

pencil, wax crayon, watercolour

inscription: pencil c.l. *lines on* (. . .)

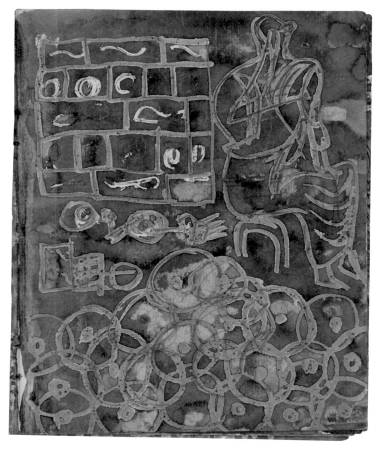

No.2 Design Notebook 1943
Sketchbook of cream medium-weight laid
paper with grey covers; six pages extant
(HMF 2124a–f); pages are unsigned and
undated.
203 × 165mm
inscription: pencil u.r. *No.2 Design/Notebook*
The Ascher Collection
(other pages illustrated with TEX 14, 15, 25)

Textile Design: Seated Figure 1943
HMF 2124a
pencil, wax crayon, watercolour wash,
gouache
inscription: pencil u.l. *Seated Figures*

fig.22 Anita Feldman and Peter Ascher in
New York, March 2007, cataloguing
Moore's textile drawings, including pages
of the *No 2. Design Notebook*.

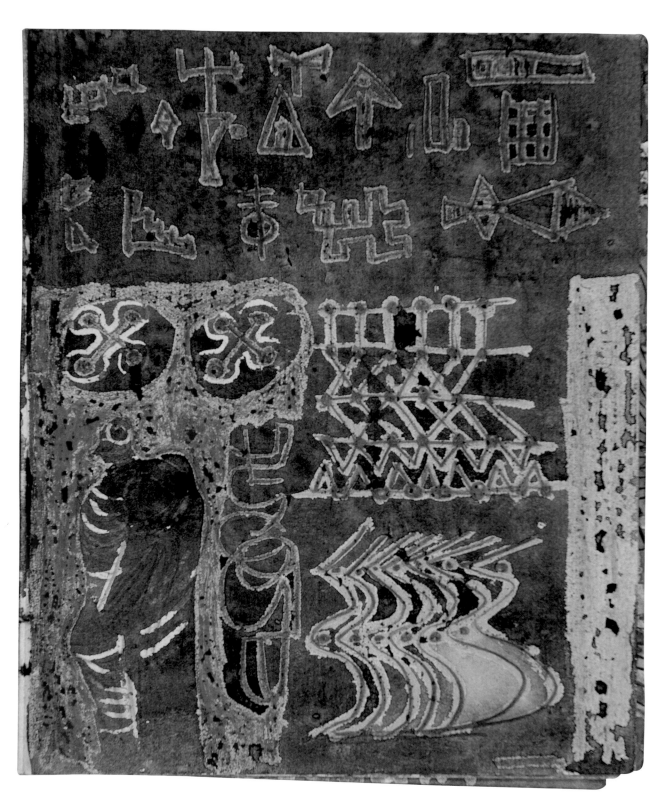

**Textile Design: Standing Figure and
Abstract Motifs** 1943
HMF 2124b
pencil, wax crayon, watercolour wash,
watercolour, gouache

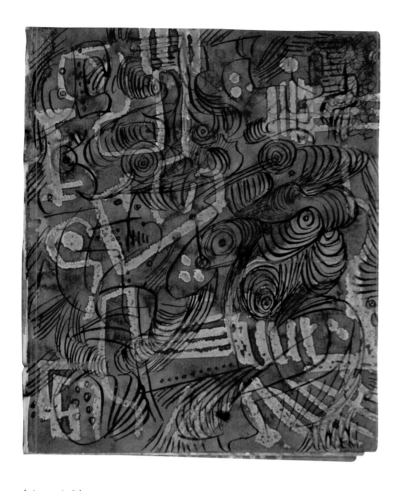

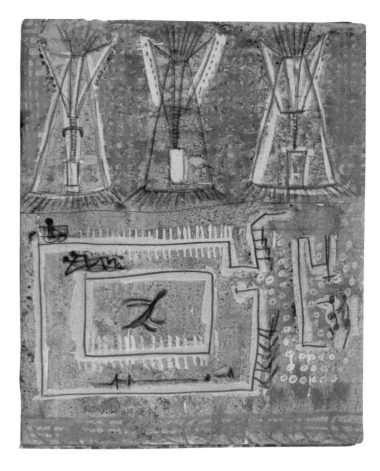

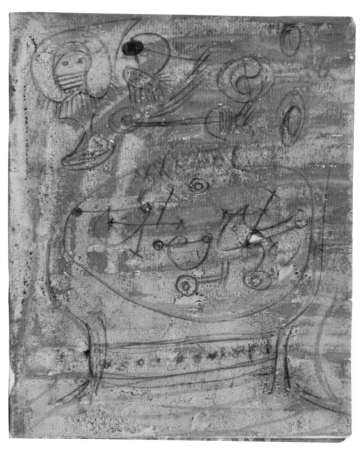

(above left)

Textile Design in Reds 1943

HMF 2124C

pencil, crayon, watercolour wash, pen and ink

verso

inscription: pencil left *No 1* (circled)

Notebook/Squares – 2.3.4.10.15./ 18

Curtains (underlined) *& furnishing fabrics*

5.6.8.10.11/ 13. 14. 17. 18. / 21. 22. 24. /

Dress designs (underlined) *9. 11. 12.16.18.*

right *No 2* (underlined) *Notebook*

(above right)

Textile Design: Teepees 1943

HMF 2124d

pencil, wax crayon, watercolour wash,

gouache

inscription: pencil u.r.c. *1* (circled)

(right)

Textile Design: Head and Necklace 1943

HMF 2124e

pencil, wax crayon, watercolour wash,

gouache

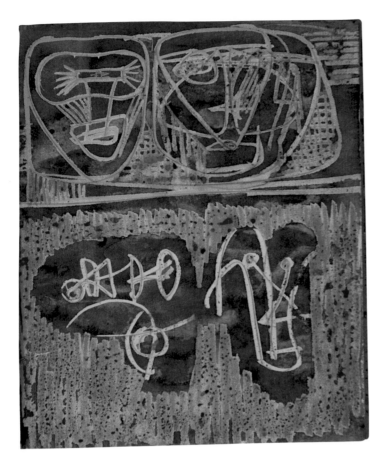

(above left)
Textile Design: Four Heads 1943
HMF 2124f
pencil, wax crayon, watercolour wash,
gouache

(left)
**Textile Design: Figures and Abstract
Motifs** 1943
HMF 2124g
pencil, wax crayon, watercolour wash, pen
and ink, brush and ink
inscription: pencil l.l. *page 16* (crossed out)
'Rescue'

(above right)
Textile Design: Strands of Colour 1943
HMF 2124h
pencil, wax crayon, watercolour wash

(left)
Textile Design: Family Group 1943
HMF 2124i
pencil, wax crayon, watercolour wash, pen
and ink

(below left)
**Textile Design: Reclining Figures in
Landscape** 1943
HMF 2124l
pencil, wax crayon, watercolour wash, pen
and ink

(below right)
Textile Design: Reclining Figure in Void
1943
HMF 2124m
pencil, wax crayon, watercolour wash

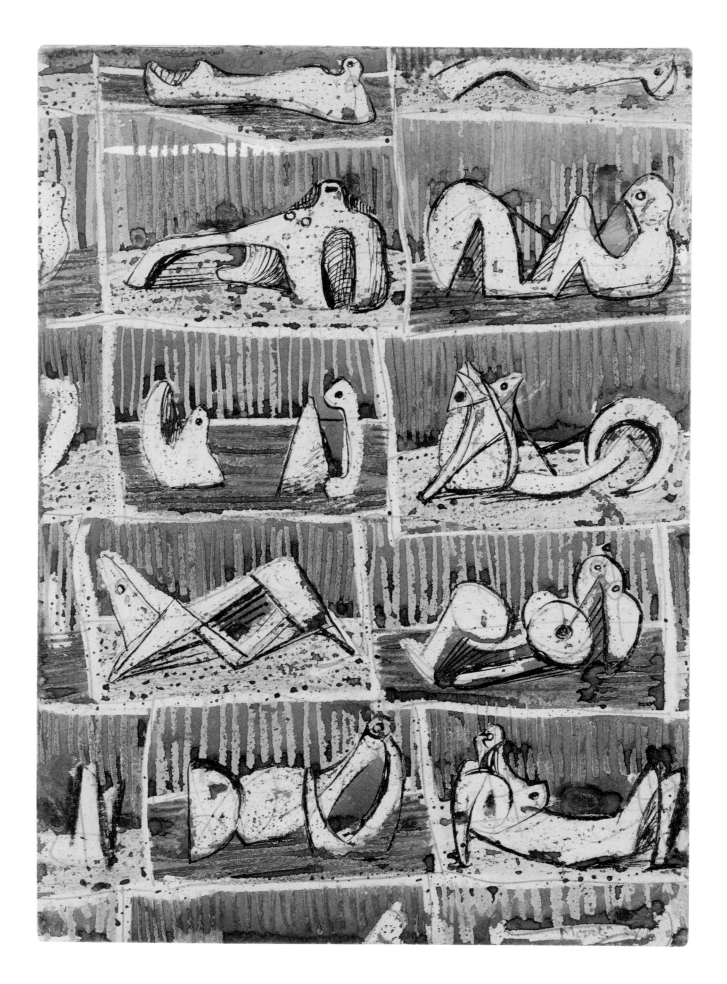

Textile Design: Framed Heads 1943
Page from *Textile Design Sketchbook 2*
HMF 2127
pencil, wax crayon, coloured crayon,
watercolour on cream medium-weight
wove
178 × 254mm
signature: wax crayon l.r. *Moore/43*
The Henry Moore Foundation: gift of the
artist 1977

Textile Design 1943
Page from *Textile Design Sketchbook 2*
HMF 2132
pencil, wax crayon, watercolour wash,
poster paint on cream medium-weight
wove
254 × 178mm
signature (added later): wax crayon l.r.
Moore/43

(opposite)
Textile Design: Reclining Figures 1943
Page from *Textile Design Sketchbook 2*
HMF 1310
pencil, wax crayon, watercolour, pen and ink
on cream medium-weight wove
254 × 178mm
signature (added later, misdated): pencil l.r.
Moore/37
Private collection, US

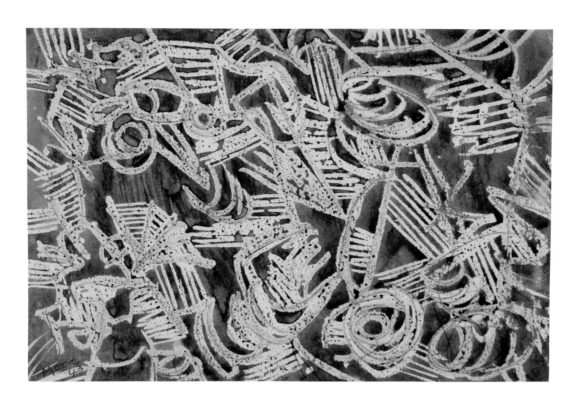

Textile Design 1943
Page from *Textile Design Sketchbook 2*
HMF 2135
pencil, wax crayon, watercolour
wash, gouache on cream medium-
weight wove
178 × 254mm
signature: wax crayon l.l. *Moore/43*
The Ascher Collection

**Textile Design: Red and Yellow
Lines** 1943
Page from *Textile Design Sketchbook 2*
HMF 2135b
pencil, wax crayon, watercolour
wash, gouache on cream medium-
weight wove
178 × 254mm
The Ascher Collection

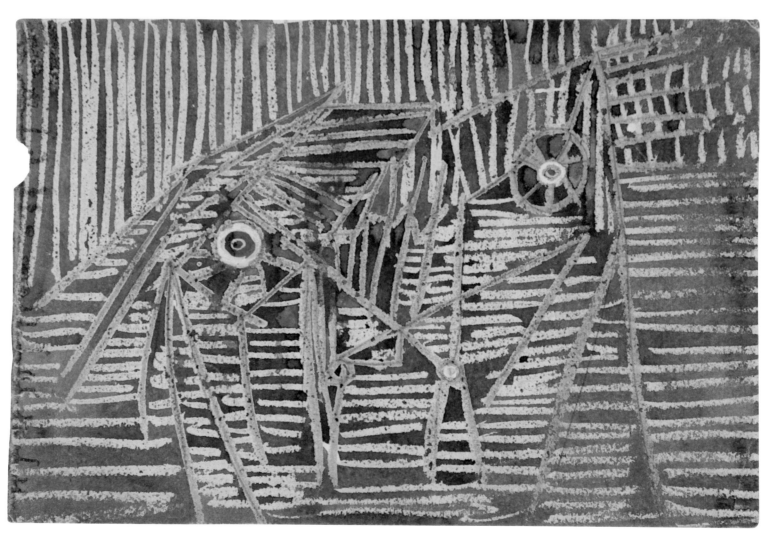

Textile Design: Motifs and Boomerang

1943

Page from *Textile Design Sketchbook 2*

HMF 2135C

pencil, wax crayon, watercolour wash on
cream medium-weight wove

254 × 178mm

The Ascher Collection

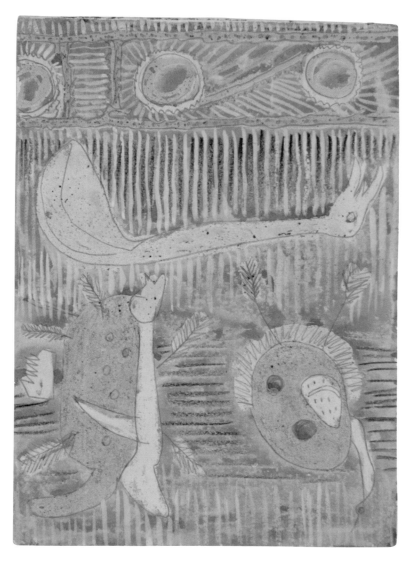

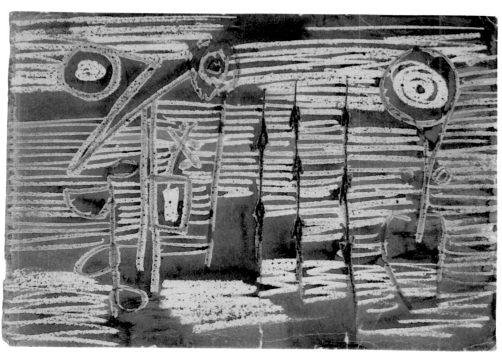

Textile Design: Flowers in Landscape

1943

Page from *Textile Design Sketchbook 2*

HMF 2140b

pencil, wax crayon, coloured crayon,
watercolour wash on cream medium-
weight wove

178 × 254mm

The Ascher Collection

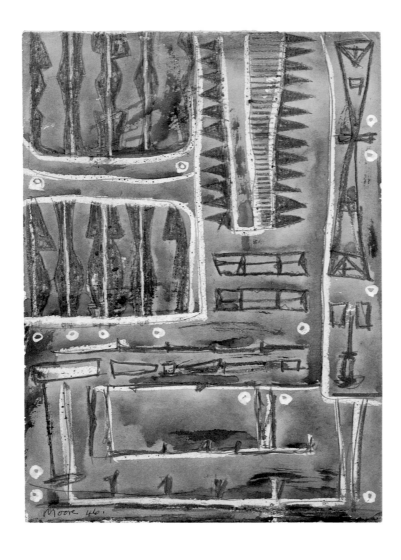

Textile Design: Blue Scrollwork 1943
Page from *Textile Design Sketchbook 3*
HMF 2148
pencil, wax crayon, coloured crayon, wash
on cream medium-weight wove
305 × 229mm
signature (added later): pen and ink l.r.
Moore

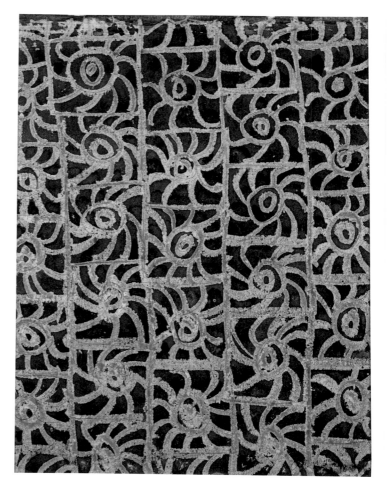

Textile Design 1943
Page from *Textile Design Sketchbook 2*
HMF 2141
pencil, wax crayon, coloured crayon,
watercolour, gouache on cream medium-
weight wove
254 × 178mm
signature (possibly added later and
misdated): ballpoint pen l.l. *Moore/46*
The Henry Moore Foundation: gift of the
artist 1977

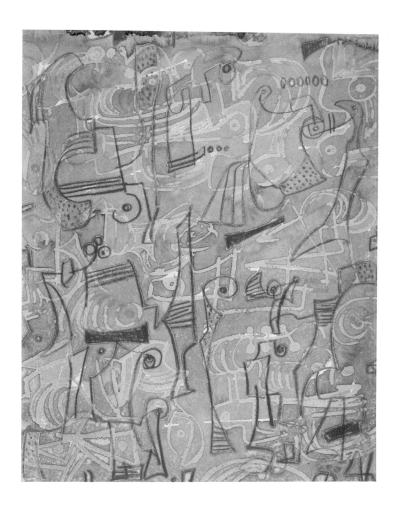

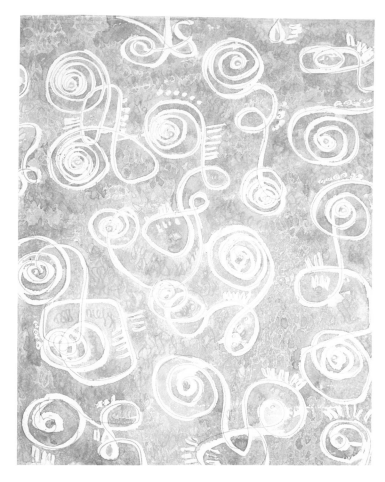

(above left)
Textile Design 1943
Page from *Textile Design Sketchbook 3*
HMF 2150
pencil, wax crayon, coloured crayon,
watercolour on cream medium-weight
wove
305 × 229mm

(above right)
Textile Design 1943
Page from *Textile Design Sketchbook 3*
HMF 2154
pencil, wax crayon, coloured crayon,
watercolour on cream medium-weight
wove
305 × 229mm

Textile Design 1943
HMF 2137
crayon on cream medium-weight wove
191 × 280mm
The Henry Moore Foundation: gift of the
artist 1977

Textile Design 1943
HMF 2138
coloured crayon, crayon on cream medium-
weight wove
279 × 191mm
signature (added later): pen and ink
l.l. *Moore*, undated
The Henry Moore Foundation: gift of the
artist 1977

Textile Design: Reclining Figures c.1943
HMF 2138a
pencil, wax crayon, coloured crayon, pen
and ink
93 × 185mm
signature (added later, misdated): pen
and ink l.r. *Moore/46*
Private collection, Belgium

Textile Design 1943
HMF 2139
pencil, wax crayon, coloured crayon, crayon,
watercolour on cream medium-weight
wove
278 × 192mm
The Henry Moore Foundation: gift of the
artist 1977

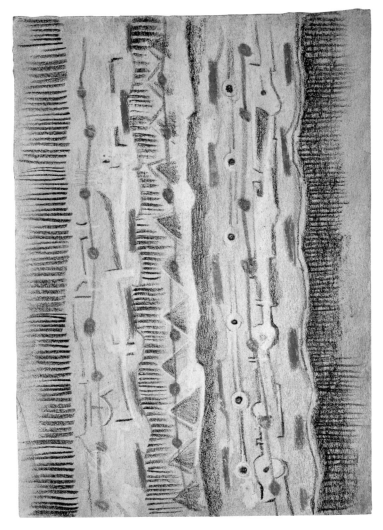

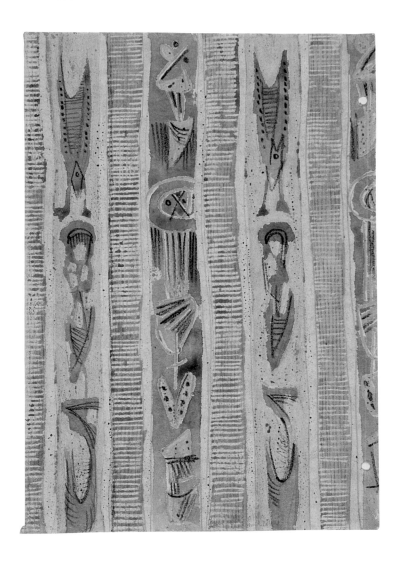

Textile Design 1943
HMF 2140
wax crayon, watercolour wash
279 × 190mm
Museo del Tessuto, Prato

Textile Design: Pink and Green Motifs

1943

HMF 2140C

coloured crayon, wax crayon, watercolour wash

170 × 265mm

The Ascher Collection

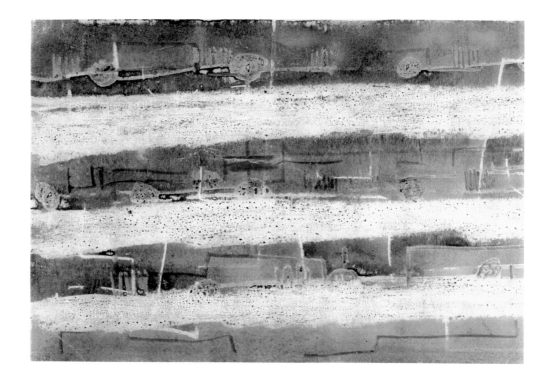

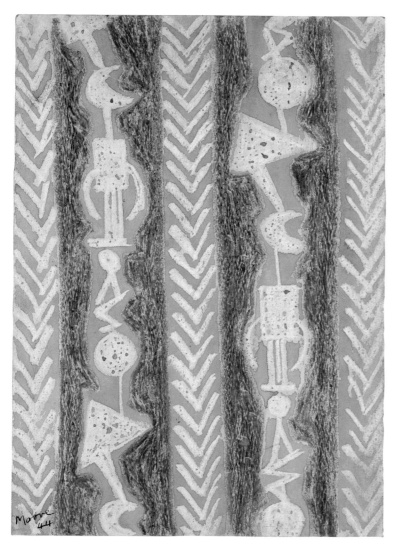

Textile Design c.1943

HMF 2142

pencil, wax crayon, coloured crayon, watercolour wash

276 × 190mm

signature (probably added later and misdated): pen and ink l.l. *Moore/44*

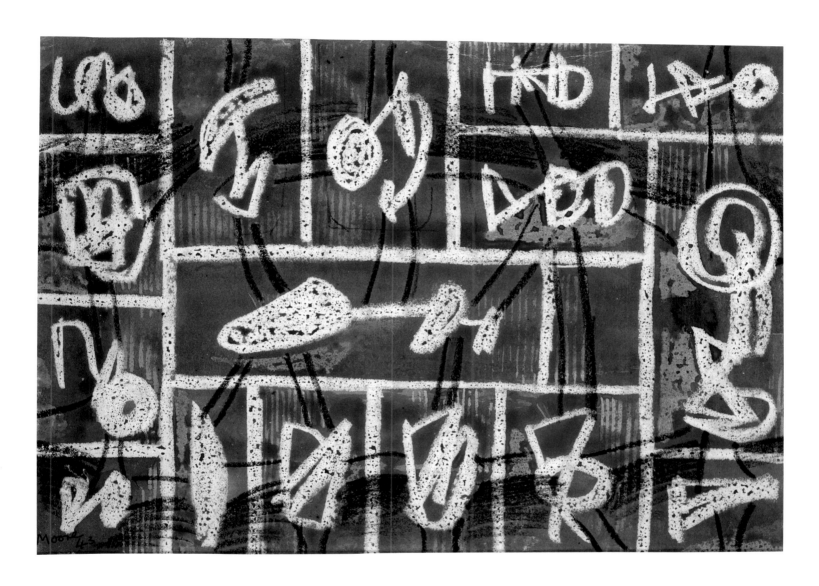

Textile Design: Abstract Ideas 1943

HMF 2143

wax crayon, coloured crayon, watercolour
wash on cream medium-weight wove

190 × 273mm

signature: pen and ink l.l. *Moore/43*

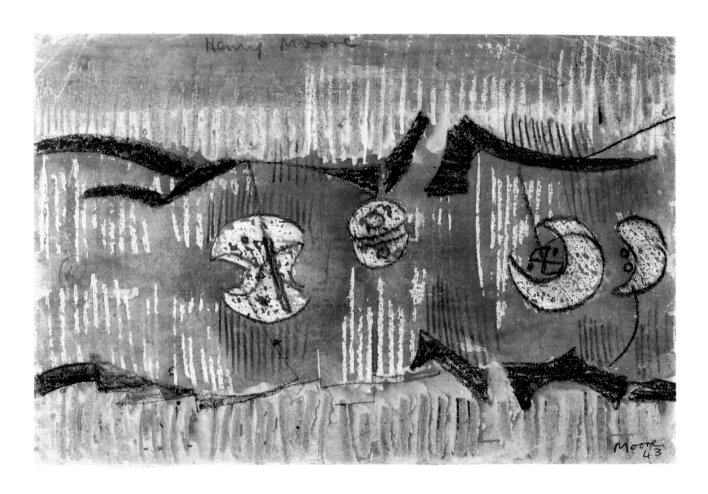

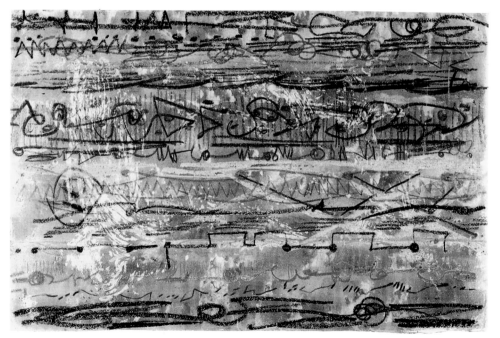

Textile Design: Four Motives 1943
HMF 2143a
pencil, wax crayon, coloured crayon,
watercolour wash, chinagraph on cream
lightweight wove
190 × 275mm
signature: pencil u.c. *Henry Moore;*
l.r. ballpoint pen *Moore/43*

(left)
verso
Lines of Colour
pencil, wax crayon, watercolour wash,
chinagraph
The Ascher Collection

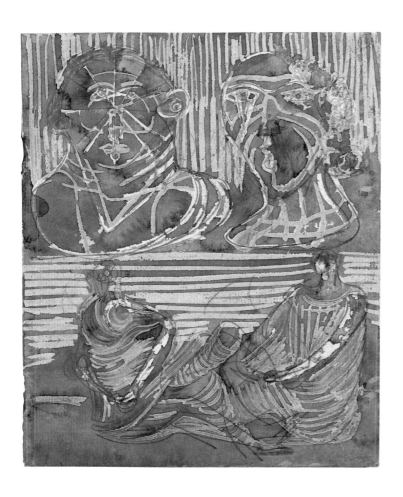

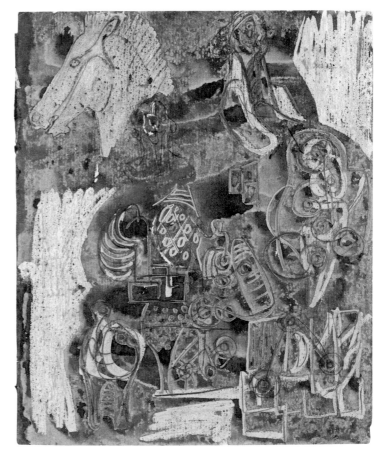

**Textile Design: Two Heads and Two Seated
Figures** c.1944
HMF 2151a
pencil, wax crayon, coloured crayon,
watercolour on cream lightweight wove
203 × 165mm
Edmund Peel & Asociados, Madrid

Textile Design: Horse's Head in Profile 1943
HMF 2151C
pencil, wax crayon, coloured crayon,
watercolour on cream lightweight laid
203 × 165mm
John Cleater Fine Arts, Key Biscayne, Florida

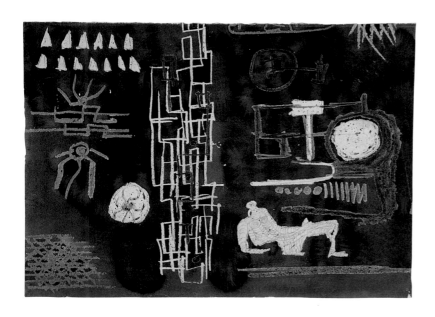

Textile Design 1943
HMF 2155
pencil, wax crayon, coloured crayon,
watercolour wash on cream medium-
weight wove
279 × 381mm
The Henry Moore Foundation: gift of the
artist 1977

Textile Design: Square Forms c.1943
HMF 2155b
wax crayon, coloured crayon, watercolour wash
403 × 505mm
signature: pencil l.r. *Moore/42*

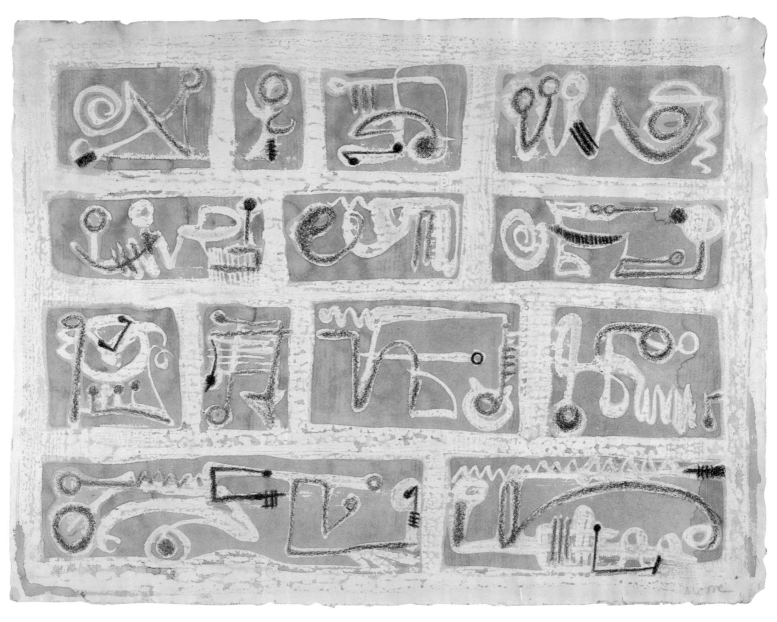

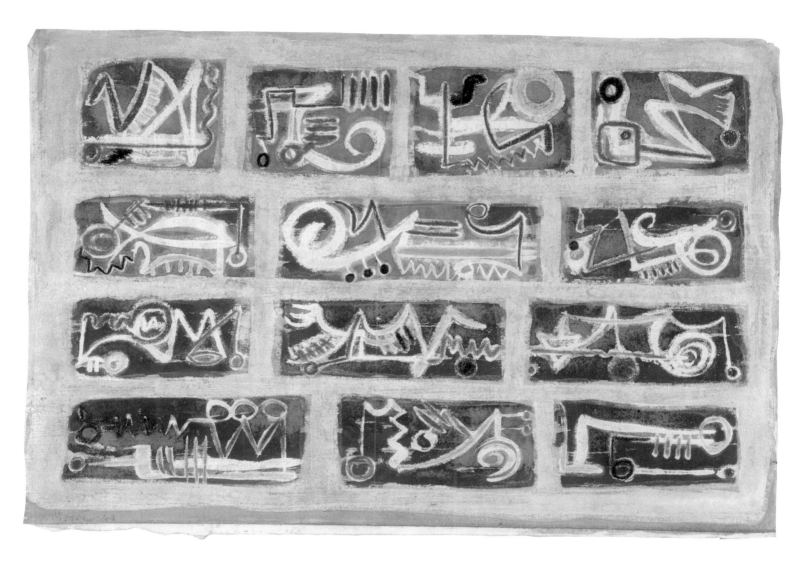

Textile Design: Square Forms *c.*1943
HMF 2155C
wax crayon, coloured crayon, watercolour wash
343 × 485mm
signature: pencil l.l. *Moore/42*

Squares

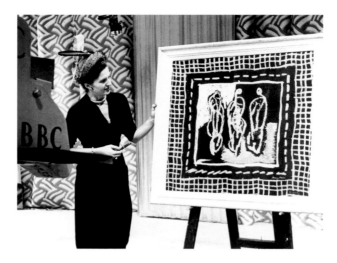

fig.23 Lida Ascher presenting Moore's **Three Standing Figures** on BBC television, 1947.

Between 1944 and 1947 Ascher invited several leading artists to design silk 'squares', or scarves; the only limitation was to keep to a maximum size of 36 × 36 inches (90 centimetres square). As well as Moore, Henri Matisse, André Derain, Graham Sutherland, Ivon Hitchens, Frances Hodgkins, Marie Laurencin and Jean Cocteau participated in the scheme. The initial results were launched in *Britain Can Make It*, the first post-war design exhibition held at the Victoria and Albert Museum in 1946.

The scarves were made using serigraphy, a form of screenprinting. During the 1930s the term 'serigraph' was coined to distinguish artists' screenprints from those used in commercial reproduction and sign-making. The fabrics were hand printed using stencils fixed to a fine silk screen. Dyes were then forced through the exposed areas of the screen on to the fabric.

Produced not only in silk but also in parachute nylon, cotton and rayon, the scarves were intended to liven up the post-war wardrobe with bold colours and designs. They proved extremely popular, with Lida Ascher presenting Moore's **Three Standing Figures** on BBC television in 1947. Yet the reality was that when the squares were purchased, there was a tendency to frame them up as works of art in their own right.[1] This idea was further reinforced when the Lefevre Gallery held an exhibition of the squares the same year. Following the success of the Lefevre exhibition, Ascher scarves toured the world to venues as far afield as Zurich, Montevideo, Philadelphia, San Francisco and Sydney. Roughly 60 per cent of the scarves were reserved for the foreign market. Due to post-war restrictions in Britain, those available at home were usually made in rayon.

Moore's subjects **Three Standing Figures, Figures on Ladder Background** and **Family Groups** relate closely to his drawings and sculpture. More surprising is **Bird**, for which there are no known related studies. Inspiration for this motif may have come from *Indian Art of the United States*, by Frederic H. Douglas and René d'Harnoncourt, in which three variations of a bird with outspread wings appear.[2] This book was in Moore's library from 1946.

1 See Geoffrey Rayner, *Artists' Textiles in Britain 1945–70: A Democratic Art*, Antique Collector's Club in Association with Target Gallery and The Fine Arts Society, London 2003, p.22.
2 Published by the Museum of Modern Art, New York 1941; see Delaware porcupine quill embroidery p.39; Nootka mural painting, p.175; and Kiowa gouache p.210.

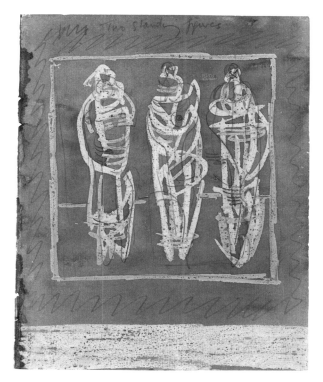

Textile Design for Three Standing Figures 1943
Page from *No.2 Design Notebook*
HMF 2151d
pencil, wax crayon, watercolour on cream medium-weight laid
203 × 165mm
inscription: pencil u.c. *Two* (sic) *Standing Figures*
The Ascher Collection

fig.24 Model wearing Moore's **Three Standing Figures** for the April 1947 issue of *Vogue*. The article suggests wearing the scarf fastened at one corner to one side with 'an important clip or ornament' allowing the scarf to 'fall softly in natural folds . .'

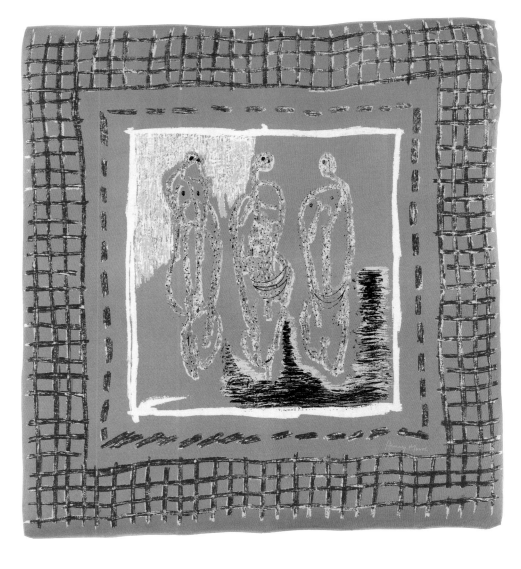

Three Standing Figures c.1944
TEX 1.1
serigraphy in nine colours
rayon (other samples exist in parachute nylon)
889 × 826mm
printed by ASCHER
The Henry Moore Foundation: anonymous gift

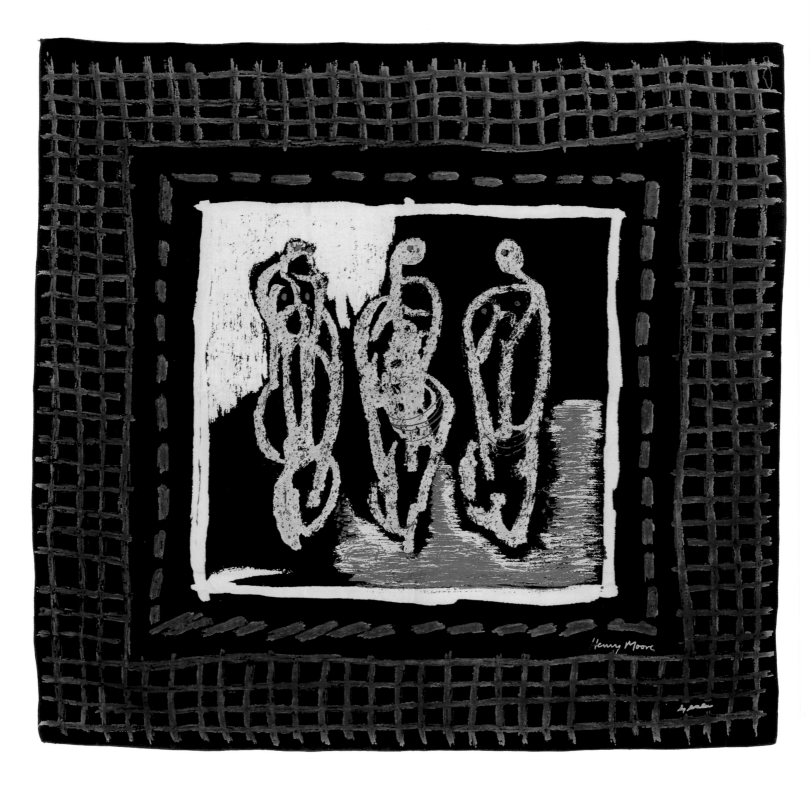

Three Standing Figures c.1944
TEX 1.6
serigraphy in seven colours
silk twill
890 × 920mm
printed by ASCHER
The Ascher Collection

(opposite)
Group of Ascher Squares printed from
Moore's designs.

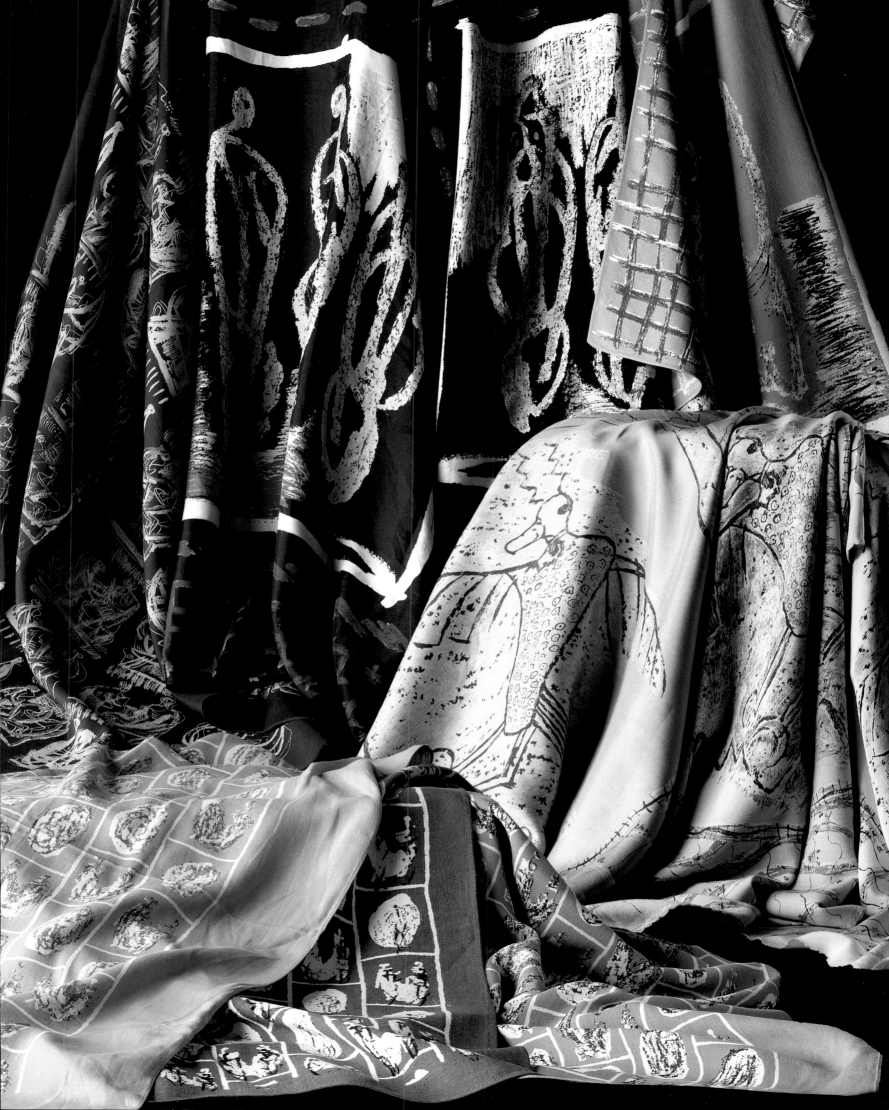

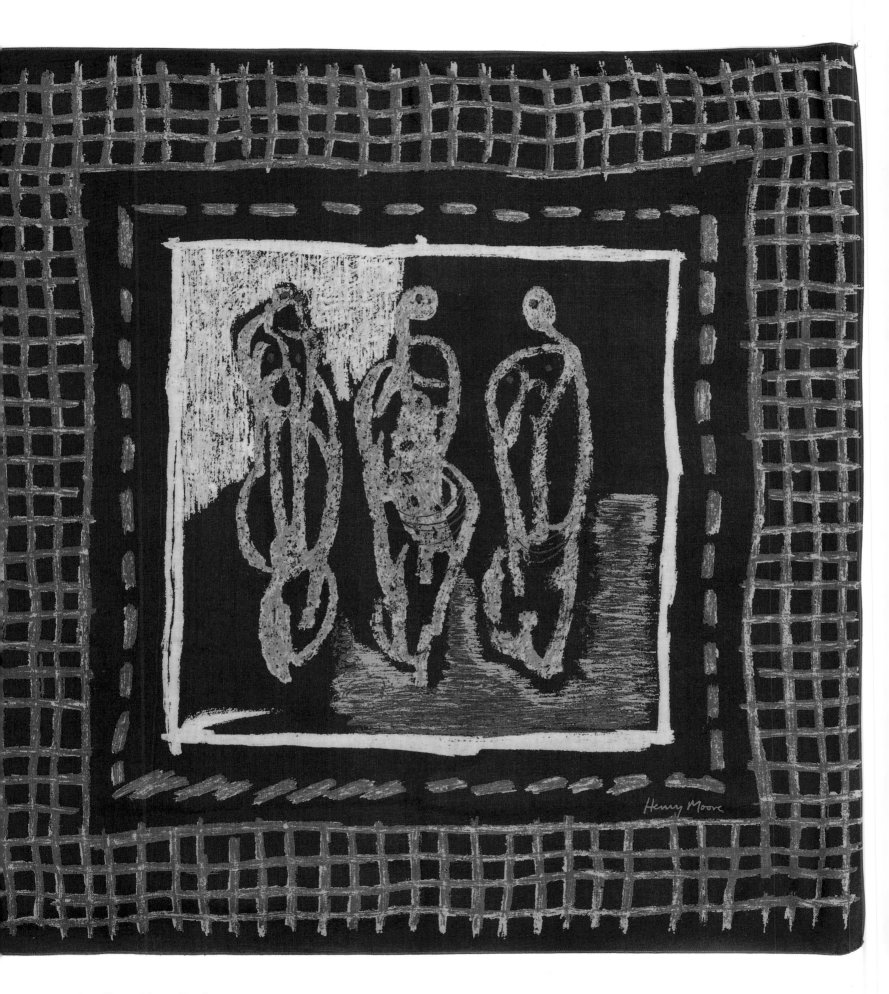

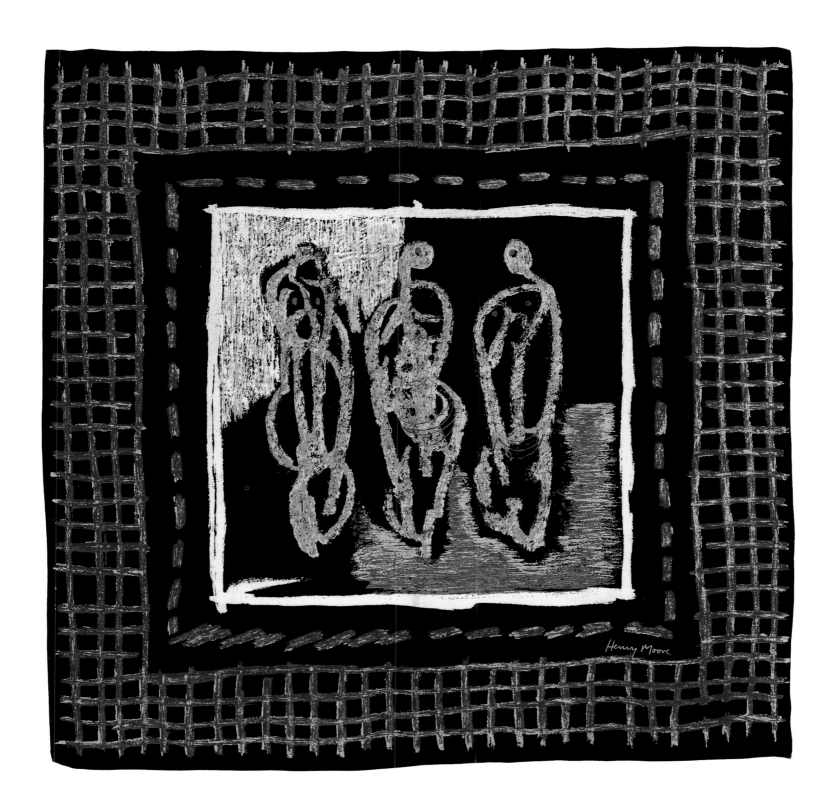

(opposite)
Three Standing Figures c.1944
TEX 1.2
serigraphy in nine colours
cotton
920 × 860mm
printed by ASCHER
Private collection, UK

(above)
Three Standing Figures c.1944
TEX 1.5
serigraphy in nine colours
rayon
890 × 890mm
printed by ASCHER
The Ascher Collection

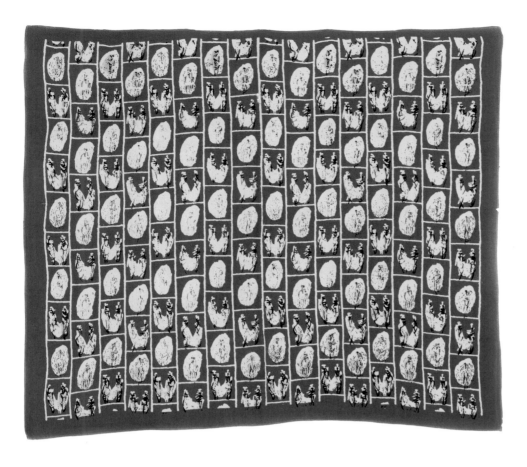

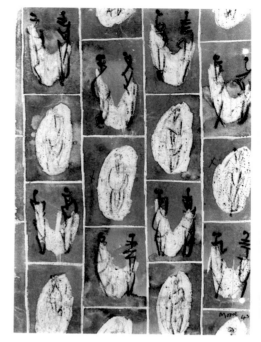

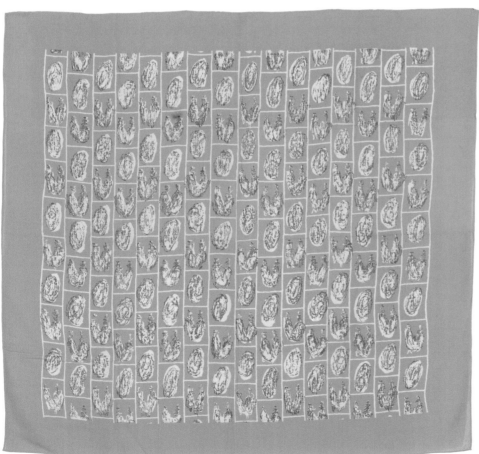

(above)

Textile Design for 'Figures on Ladder Background' 1943
HMF 2131
pencil, wax crayon, coloured crayon, watercolour, poster paint
on cream medium-weight wove
276 × 195mm
signature: pen and ink l.r. *Moore/43*
Private collection, France

(above left)

Figures on Ladder Background *c.*1944
TEX 2.1
serigraphy in three colours
cotton
770 × 820mm
printed by ASCHER
The Ascher Collection

(left)

Figures on Ladder Background *c.*1944
TEX 2.3
serigraphy in four colours
cotton
870 × 850mm
printed by ASCHER
The Ascher Collection

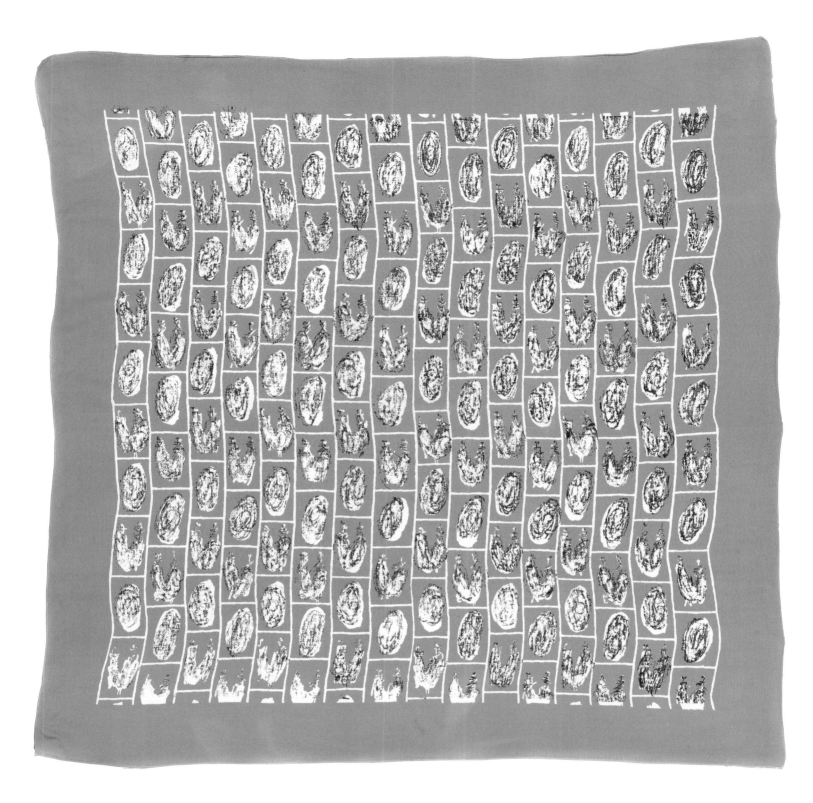

Figures on Ladder Background c.1944
TEX 2.2
serigraphy in three colours
spun rayon (other samples exist in spun linen and cotton)
870 × 880mm
printed by ASCHER
The Henry Moore Foundation: anonymous gift

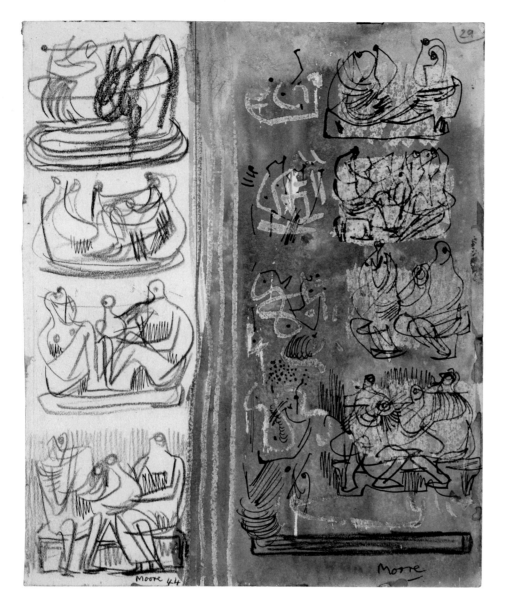

Studies for Family Groups *c.*1944
Page from *The Rescue Sketchbook*
HMF 2288 (verso)
pencil, wax crayon, coloured crayon, wash,
pen and ink on cream medium-weight wove
210 × 165mm
signature (added later): ballpoint pen l.l.
Moore/44; felt-tipped pen l.r. *Moore*
The Henry Moore Foundation: gift of the
artist 1977

The drawing was cut vertically and both
parts signed. The verso lists ideas for
subjects for *The Rescue*, a melodrama by
Edward Sackville-West first broadcast in
November 1943 and published, with
illustrations by Moore, by Secker and
Warburg in 1945.

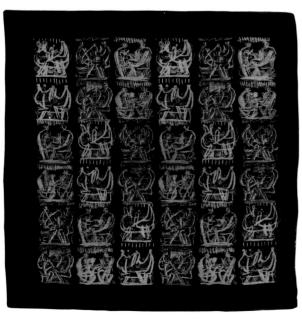

Family Groups *c.*1946
TEX 6.1
serigraphy in five colours
silk
910 × 860mm
printed by ASCHER
The Sherwin Collection

(opposite)
TEX 6.1 with Moore's **Family Group**
1945 (LH 259, see also p.75), 24cm
The Henry Moore Foundation:
acquired by exchange with the
British Council 1991

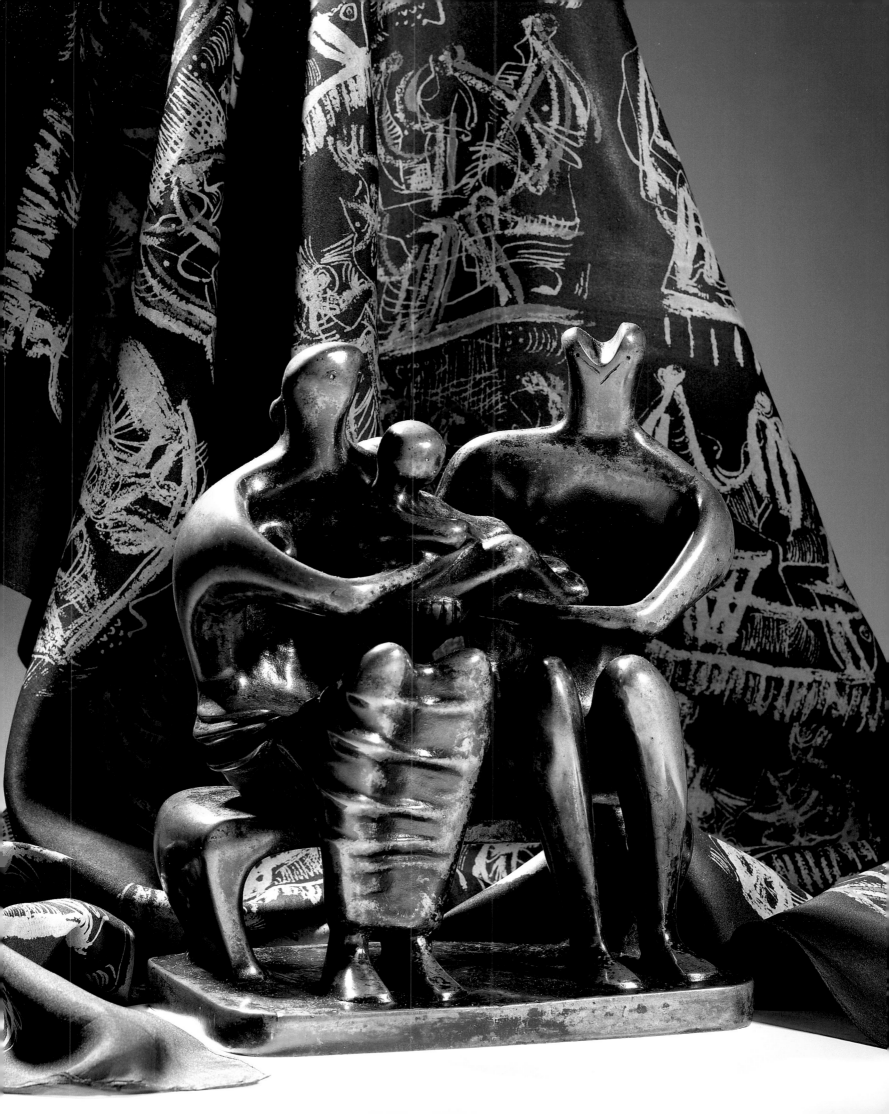

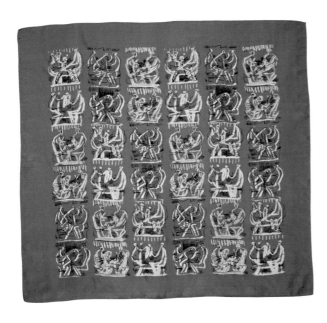

Family Groups *c.*1946
TEX 6.5
serigraphy in four colours
silk
910 × 925mm
printed by ASCHER
Victoria and Albert Museum, London

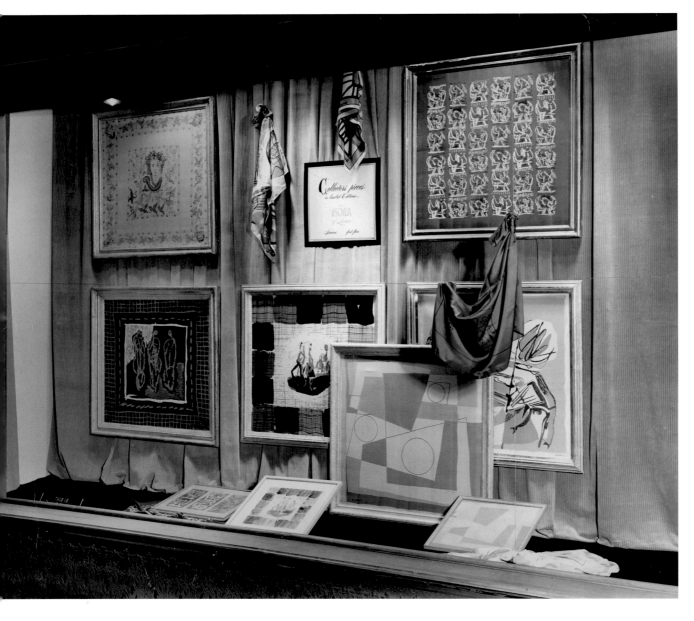

fig.25 *Ascher Squares* at Carson, Pirie, Scott & Co., Chicago 1947 including two Moore designs, **Family Groups** (TEX 6) and **Three Standing Figures** (TEX 1), hanging with others by Christian Bérard (upper left); Feliks Topolski (lower centre); Robert Colquhoun (lower right) and Ben Nicholson (front).

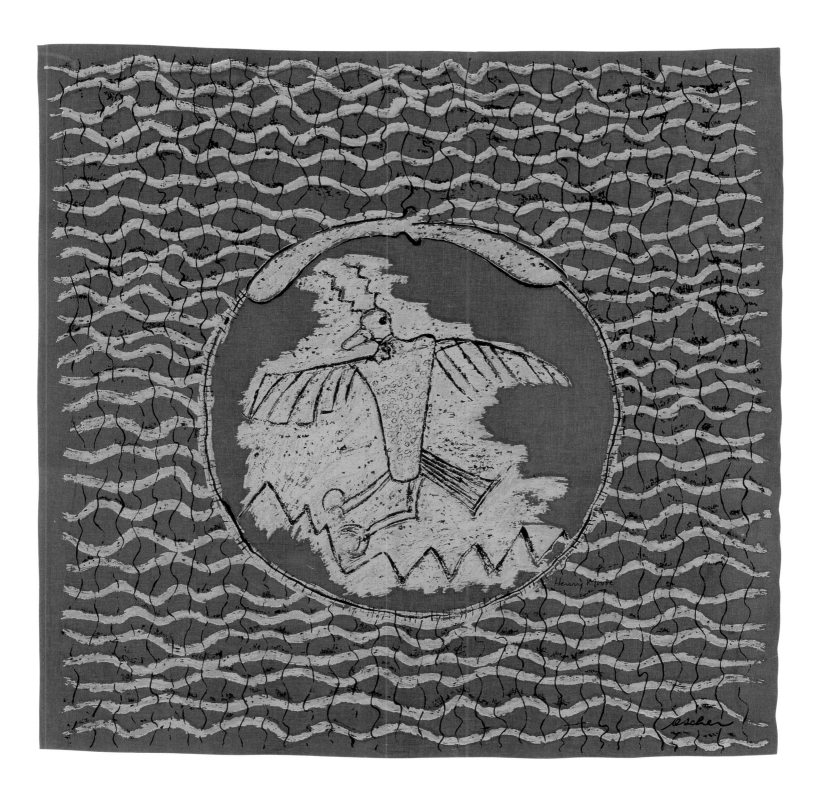

Bird 1945
TEX 7.6
serigraphy in five colours
cotton proof
1195 × 1025mm
printed by ASCHER
The Ascher Collection

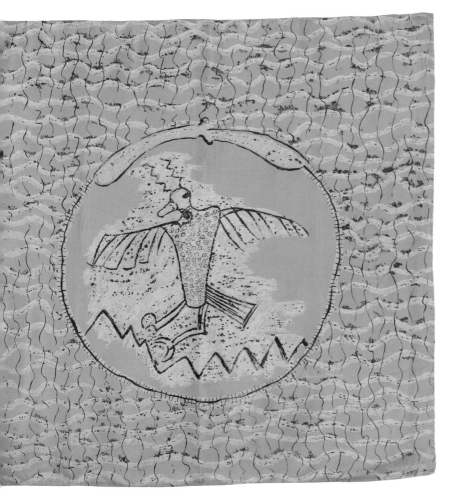

(above left)
Bird 1945
TEX 7.1
serigraphy in five colours
rayon
890 × 860mm
printed by ASCHER
The Henry Moore Foundation: anonymous gift

(left)
Bird 1945
TEX 7.2
serigraphy in six colours
silk twill
900 × 860mm
printed by ASCHER
The Ascher Collection

(above right)
Bird 1945
TEX 7.7
serigraphy in six colours
crepe silk
960 × 930mm
printed by ASCHER
The Ascher Collection

(opposite)
fig.26 Exhibition poster
Ascher Squares, Mánes, 17–31
December 1947. The
exhibition was held briefly in
Czechoslovakia immediately
prior to the country falling
under Soviet control.
The Ascher Collection

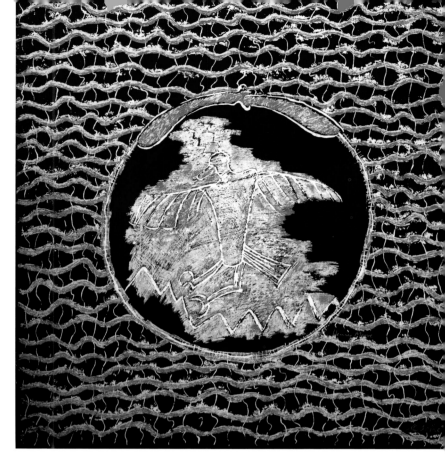

Bird 1945
TEX 7.7 (detail)

Bird 1945
TEX 7.8
serigraphy in three colours
silk
908 × 927mm
printed by ASCHER
Private collection, US

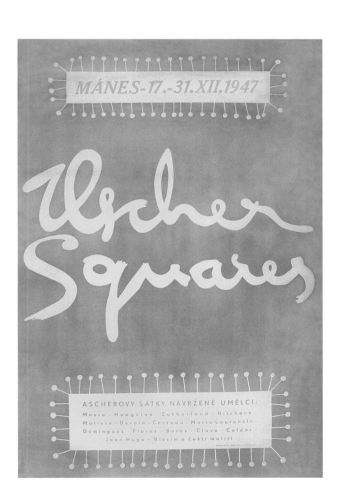

fig.27 Zika's son, Peter Ascher, at the exhibition *Ascher Squares/
Art in the Medium of Textiles*, Nieman Marcus, Dallas 1975.

This scarf was made to celebrate the 1983 Moore exhibition at the Palais Auersperg in Vienna.[3] It is forty years later than the series printed by Ascher at the end of the war and is fundamentally different, most obviously in the monochromatic colour scheme as opposed to the vivid colours of the earlier squares. Rather than Moore's previous use of drawing to work out textile ideas, here we find a more direct translation from one medium to another – the chalk, charcoal, wash and gouache from a drawing (that was not created as a textile idea) into the flowing silk. The concept of the fabric square as a work of art is further reinforced by the printing of the scarves in a limited edition. The pattern is a single image, not in repeat, and when worn transforms from a representational mother and child to an abstraction with dark sectional lines and mysterious shadows.

3 The exhibition toured to the Galerie Ruf, Munich.

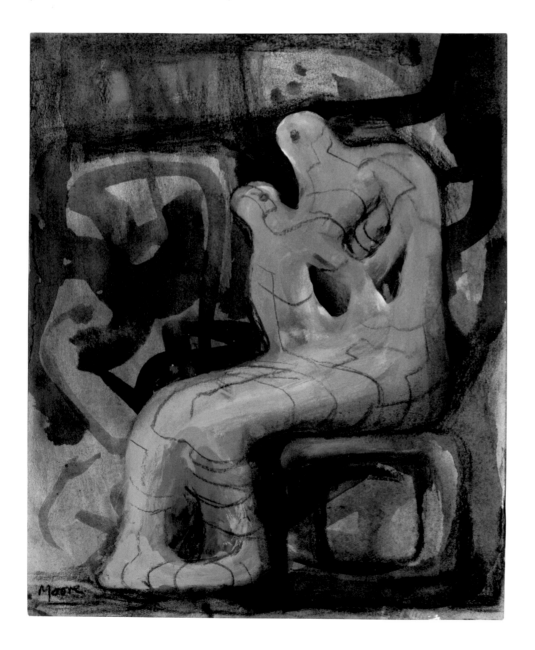

Seated Mother and Child: Idea for Sculpture 1981
HMF 81(42)
charcoal, chalk, watercolour wash, gouache on T.H. Saunders
347 × 274mm
signature: chalk l.l. *Moore*
The Henry Moore Foundation: acquired 1987

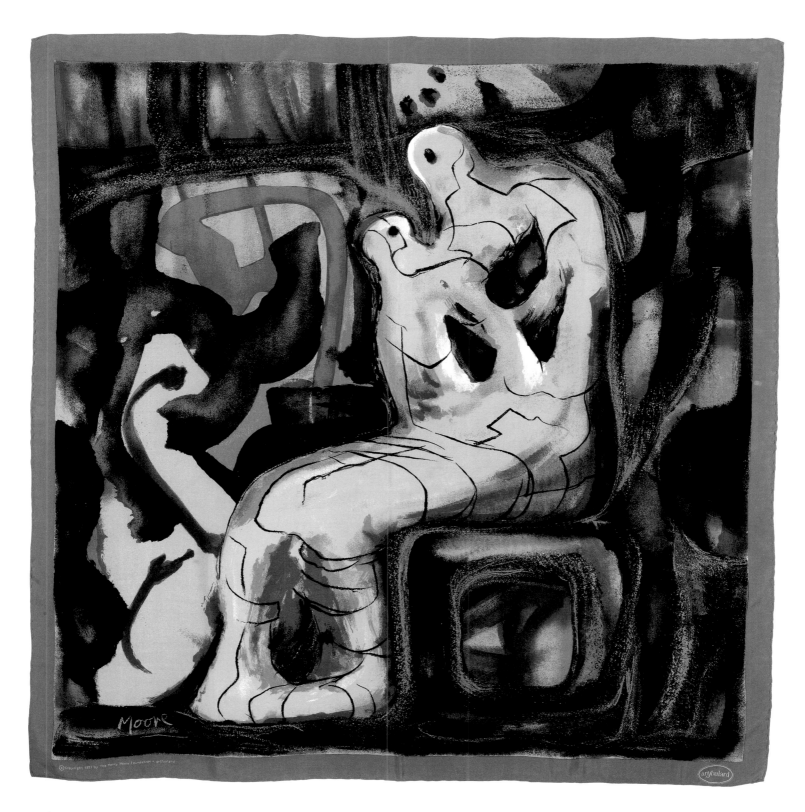

Mother and Child 1983

TEX 24

serigraphy in eight colours

silk

850 × 840mm

printed by Ditta Bianchi Giovanni for art*f*oulard in an edition of 250

The Henry Moore Foundation: gift of Steven Gabriel

Dress and upholstery fabrics

That Moore was producing colourful and imaginative fabric designs as early as 1943 – just two years after creating his evocative Shelter drawings – is extraordinary. Long before the 1951 Festival of Britain, Moore's fabric designs anticipated the end of an era of rationing and the strictly controlled dour Utility fabrics that pervaded post-war Britain. As the war eventually drew to a close, Moore's designs began to be hand screenprinted in numerous colourways by Ascher for dress and upholstery fabrics for the domestic and export market. The notion that leading artists could collaborate with modern industry to produce fabrics that were contemporary in both design and material led the *Illustrated London News* to predict that women would soon be 'blossoming out as walking art galleries'.[1]

1 'Modern Art for Daily Wear', *Illustrated London News*, 28 July 1945, p.22.

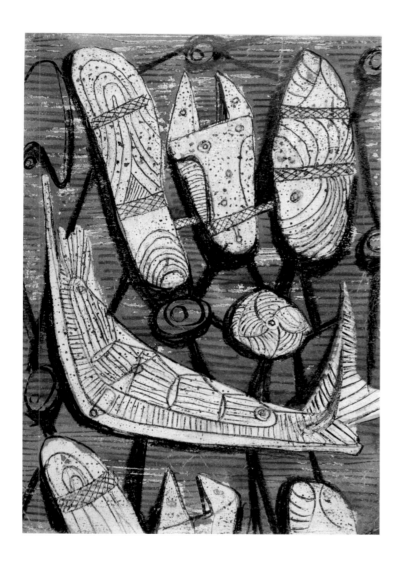

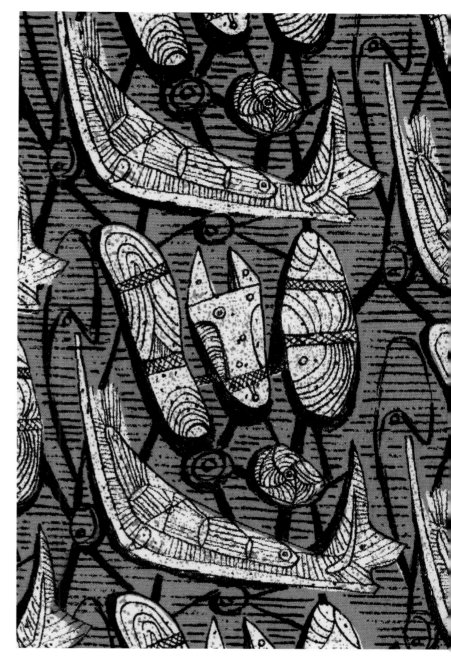

TEX 3
Horse's Head and Boomerang

In his textile designs Moore used media in a very sculptural way, building up the composition first by outlining the forms with pencil or a white crayon, then adding a watercolour wash to reveal the design, and highlighting the forms with pen and ink and gouache. He developed this drawing technique during the war to depict figures emerging from the darkness of the London Underground. This method gives a weight and substance to his designs for textiles – here with animal heads and enigmatic shapes and patterns appearing from a background of rich blue-grey.

Textile Design: Boomerang 1943
Page from *Textile Design Sketchbook 2*
HMF 2135a
wax crayon, coloured crayon, watercolour wash, pen and ink, gouache on cream medium-weight wove
254 × 1780mm
The Ascher Collection

Horse's Head and Boomerang 1944–45
TEX 3.1
serigraphy in three colours
spun rayon
2450 × 1800mm
printed by ASCHER
The Henry Moore Foundation:
acquired 1990

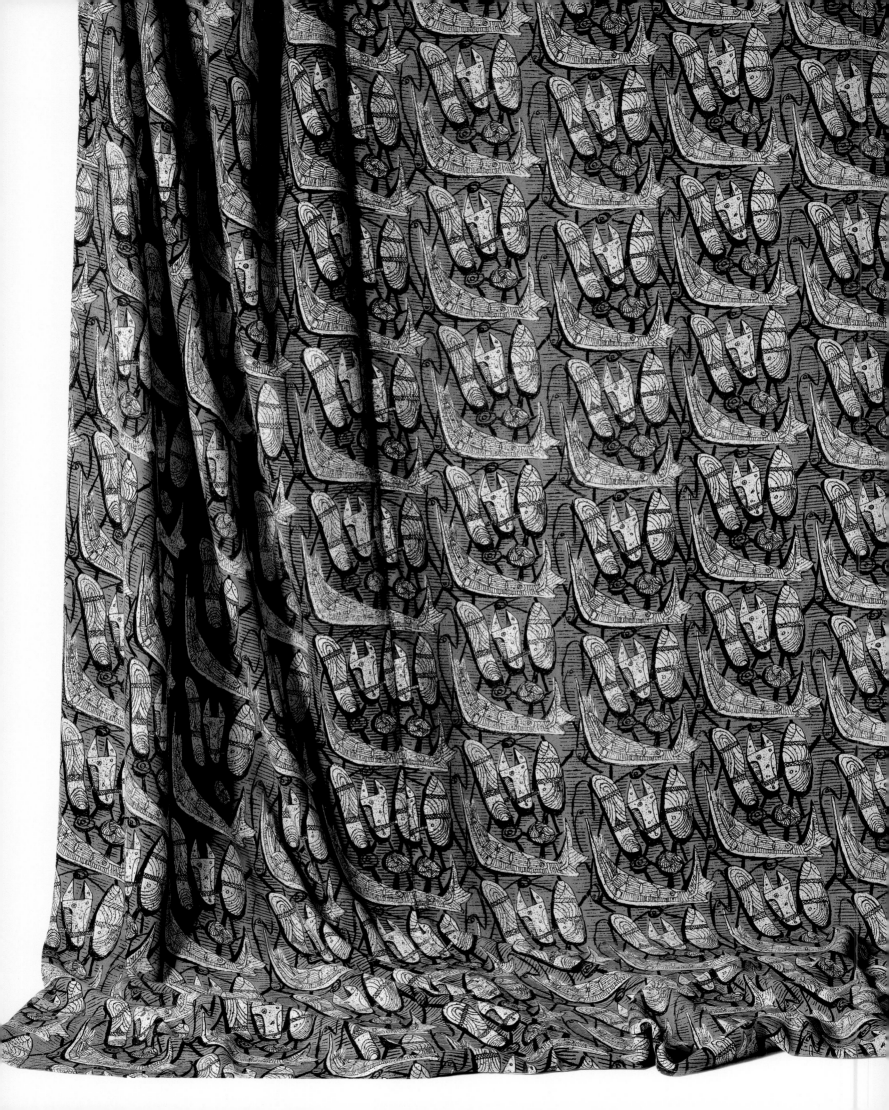

(opposite)
Horse's Head and Boomerang 1944–45
(TEX 3.1)

fig.28 Irina Moore in Hoglands making a curtain from **Horse's Head and Boomerang**
1944–45. Curtains from **Heads** (TEX 9) hang in the window behind, with a family group
maquette (LH 259).

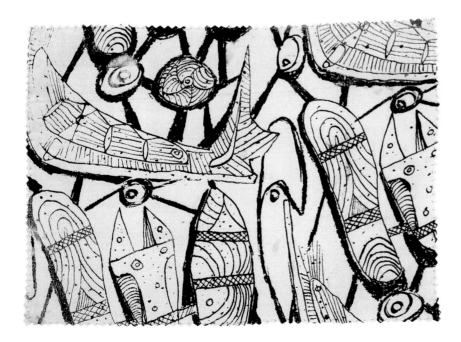

Horse's Head and Boomerang 1944–45
TEX 3.2
serigraphy in two colours
rayon
190 × 250mm
printed by ASCHER
Museum of Domestic Design & Architecture,
Middlesex University

Although the depiction of barbed wire in a dress fabric may seem surprising, the motif appears in Moore's work as early as 1939 in his drawings and graphic work on the theme of the Spanish Prisoner. These were made in aid of the plight of Republican refugees

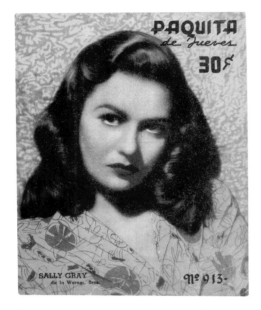

fig.29 *Paquita de Jueves* No.913, Mexico City, 27 May 1948, with cover illustration of actress Sally Gray wearing **Barbed Wire** fabric. Private collection, UK.

fleeing Franco's Spain who were being held in French detention camps. Since Moore was at the forefront of the British Surrealist movement in the 1930s, the irony of using a barbed wire design for a silk dress would not have been lost on him. In these textiles, Moore uses the barbed wire as a compositional device to visually thread through the fabric. Another Moore fabric design, HMF 2138a (see p.48), alternates barbed wire with reclining figures, but this was not put into production. Here, the industrial post-war imagery of barbed wire is broken by wildflowers in various colourways, perhaps an affirmation of life after devastation. Moore later served as Chairman of the Auschwitz Memorial Committee in 1958.

There are no known sketches directly related to the barbed-wire fabric, although HMF 2136 (reproduced vertically in the catalogue raisonné)[2] may be an initial study, with the barbed wire clearly visible and circular apertures for the flowers left incomplete.

2 Ann Garrould (ed.), *Henry Moore: Complete Drawings*, vol.3, Lund Humphries, London 2001, p.185.

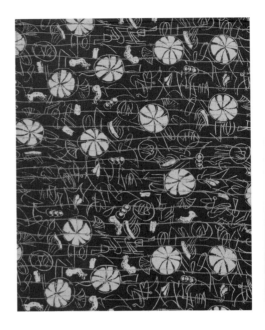

Barbed Wire C.1946
TEX 4.1
serigraphy in five colours
rayon
635 × 460mm
printed by ASCHER
Victoria and Albert Museum, London

Textile Design 1943
HMF 2136
pencil, wax crayon, coloured crayon,
watercolour on cream medium-weight
wove
192 × 278mm
The Henry Moore Foundation: gift of the
artist 1977

(opposite)
Barbed Wire C.1946
TEX 4.2
serigraphy in five colours
rayon
1430 × 890mm
printed by ASCHER
The Henry Moore Foundation:
acquired 1990

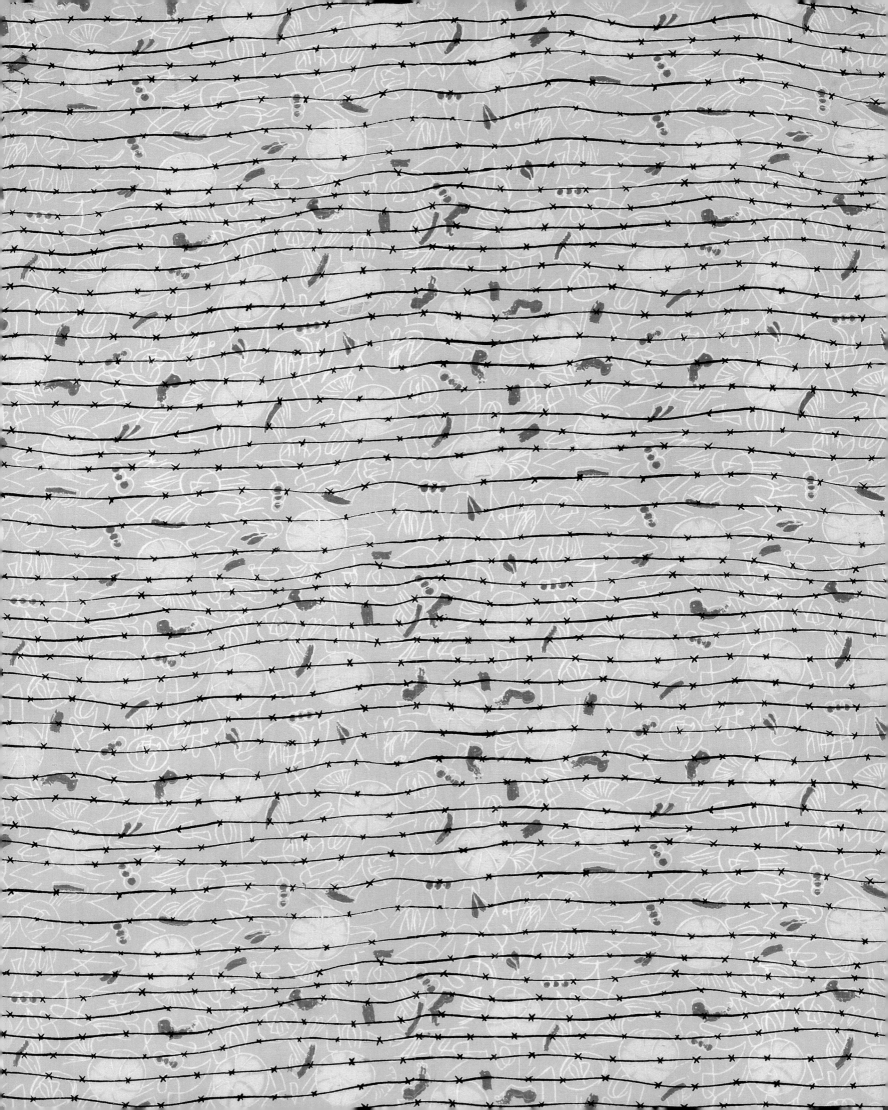

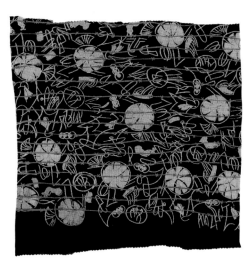

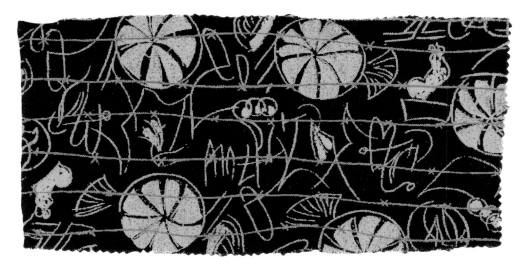

Barbed Wire c.1946
TEX 4.3
serigraphy in four colours
rayon
440 × 410mm
printed by ASCHER
The Henry Moore Foundation:
acquired 1990

Barbed Wire c.1946
TEX 4.12
serigraphy in five colours
rayon
150 × 290mm
printed by ASCHER
The Henry Moore Foundation:
acquired 1990

(below)
Barbed Wire c.1946
TEX 4.13
serigraphy in five colours
spun rayon
430 × 840mm
printed by ASCHER
The Ascher Collection

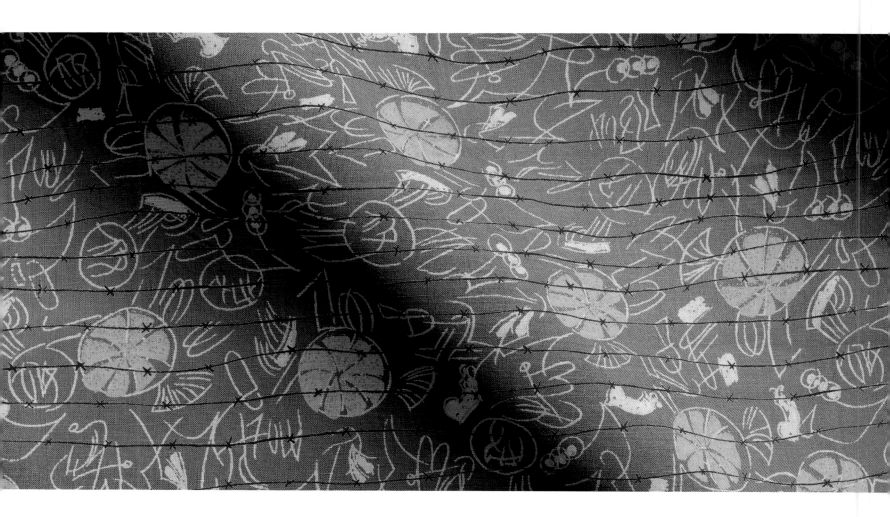

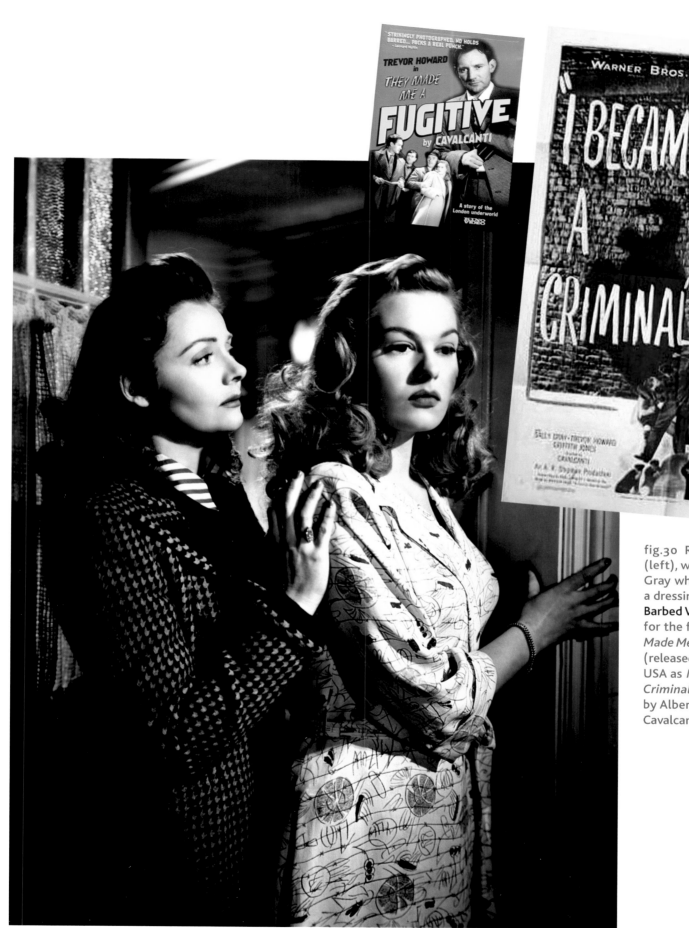

fig.30 René Ray (left), with Sally Gray who is wearing a dressing gown in **Barbed Wire** fabric for the film *They Made Me a Fugitive* (released in the USA as *I Became a Criminal*), directed by Alberto Cavalcanti, 1947.

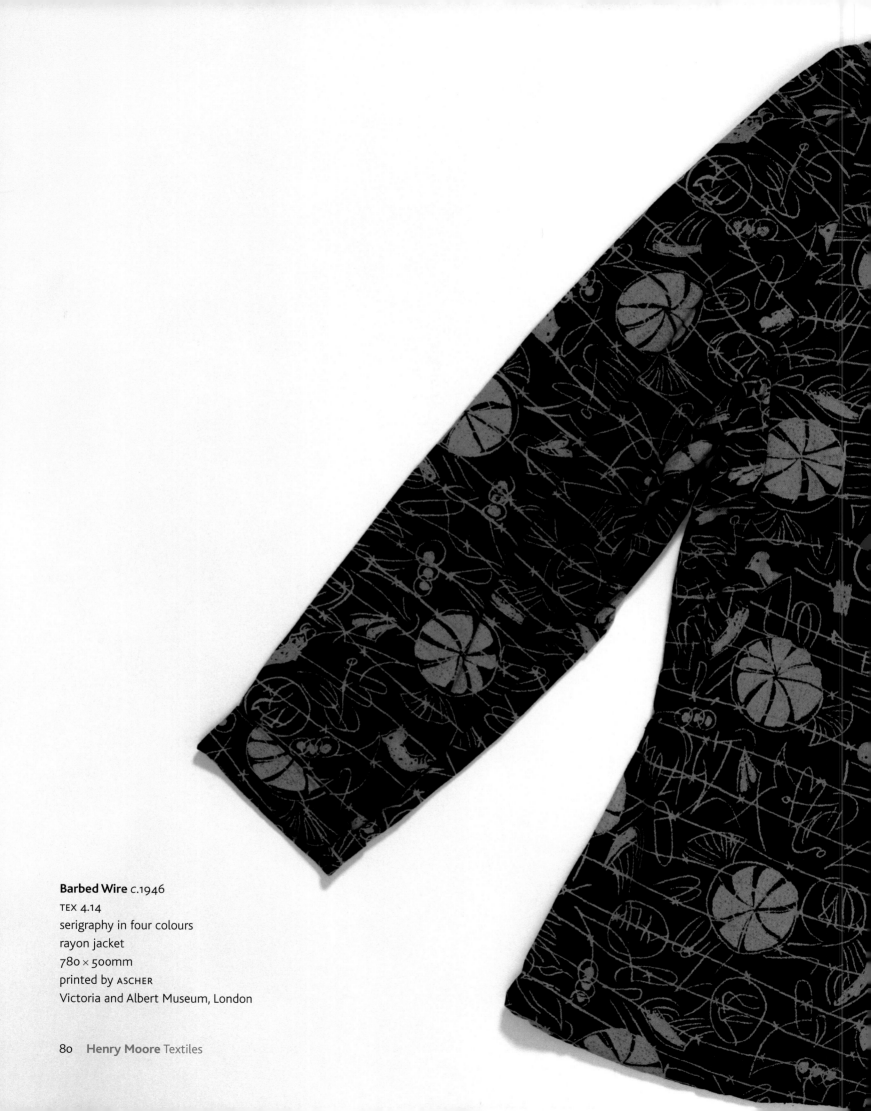

Barbed Wire c.1946
TEX 4.14
serigraphy in four colours
rayon jacket
780 × 500mm
printed by ASCHER
Victoria and Albert Museum, London

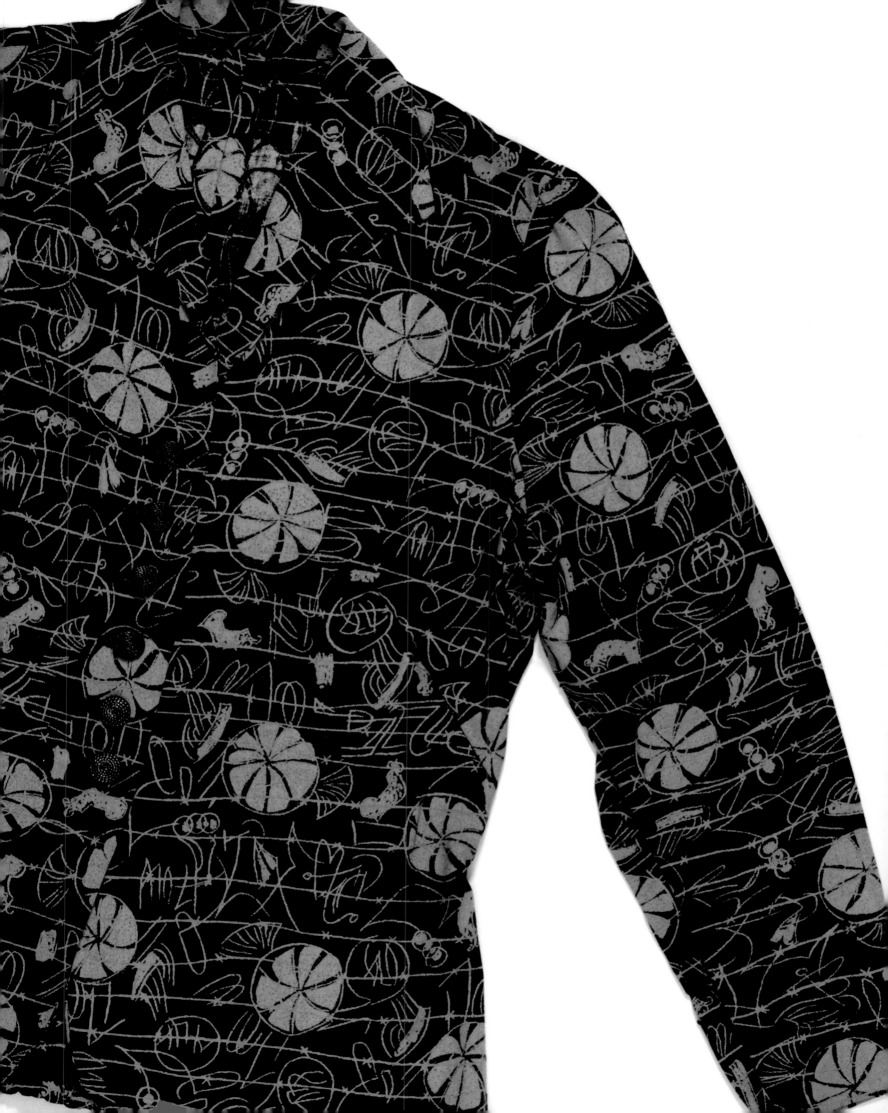

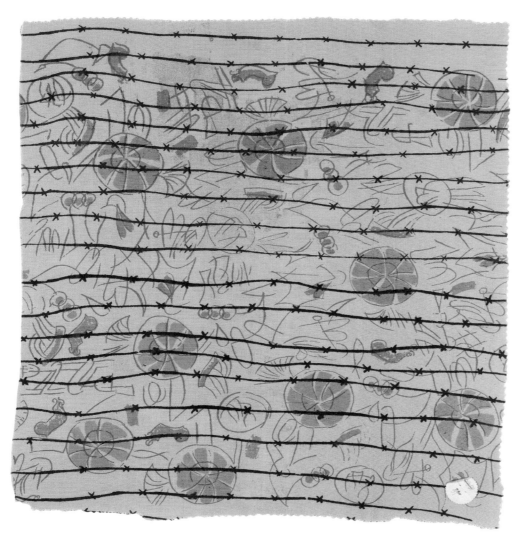

Barbed Wire c.1946
TEX 4.16
serigraphy in five colours
spun rayon
400 × 400mm
printed by ASCHER
The Ascher Collection

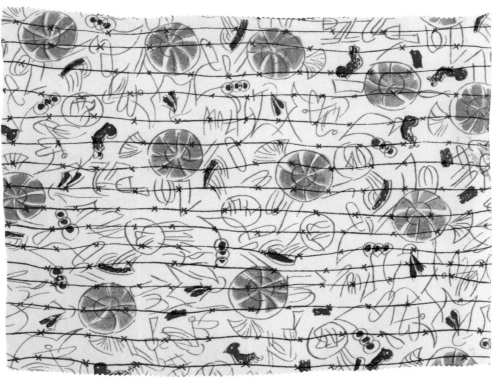

Barbed Wire c.1946
TEX 4.17
serigraphy in five colours
crepe rayon
340 × 440mm
printed by ASCHER
The Ascher Collection

In this design Moore has replaced the barbed wire (TEX 4) with the more whimsical piano keys as a device to run through the composition and break it into horizontal bands of motifs. The undulating rows are lyrical in mood as well as suggestive of the play of music. The forms depicted between the rows of keys harken back to Moore's surrealist drawings in the 1930s such as **Ideas for Metal Sculptures** (HMF 1362). The mysteriously marked clock face appears as part of a 1942 composition **Heads and Ideas** (right). At the same time, the gestures of the hands anticipate those of **King and Queen** 1952–53 (LH 350), for which he made several hand studies in the following years.

Piano is one of a number of patterns in which Moore particularly experimented with colour. The colours range from rich gold and lilac (TEX 5.8) to sombre khaki and mole brown (TEX 5.12) to startling pinks and purples (TEX 5.10) and lemon yellow and acid green (TEX 5.15). The variations in colour greatly affect the interplay of forms, with the piano keys or the clock and hand motifs alternating in prominence.

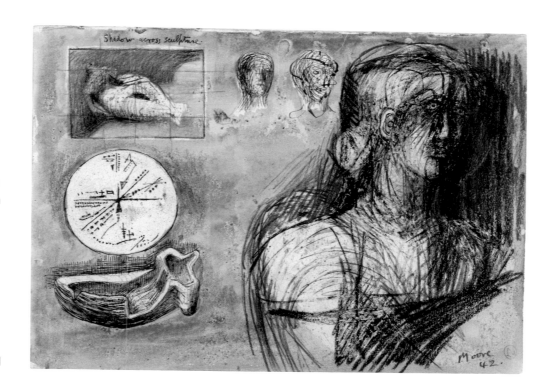

(above right)
Heads and Ideas 1942
HMF 2020
pencil, wax crayon, chalk, watercolour wash, pen and ink on cream medium-weight wove
178 × 254mm
signature: pen and ink l.r. *Moore/42*
inscription: pen and ink over pencil u.l.
Shadow across sculpture
Private collection, France

(right)
Textile Design for 'Piano' 1943
Possibly cut-down page from *Textile Design Sketchbook 3*
HMF 2125
pencil, wax crayon, coloured crayon, watercolour on cream medium-weight wove
216 × 242mm
signature (added later): l.l. *Moore/43*
Private collection, UK

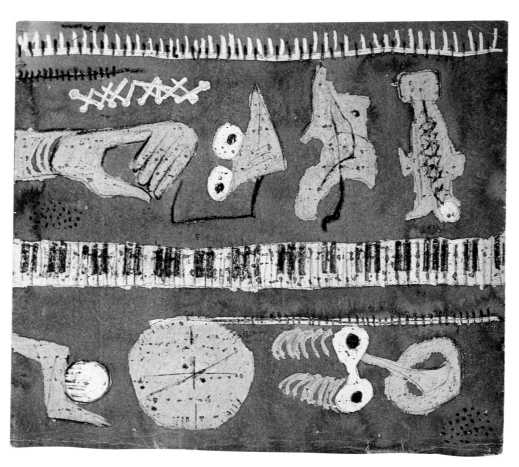

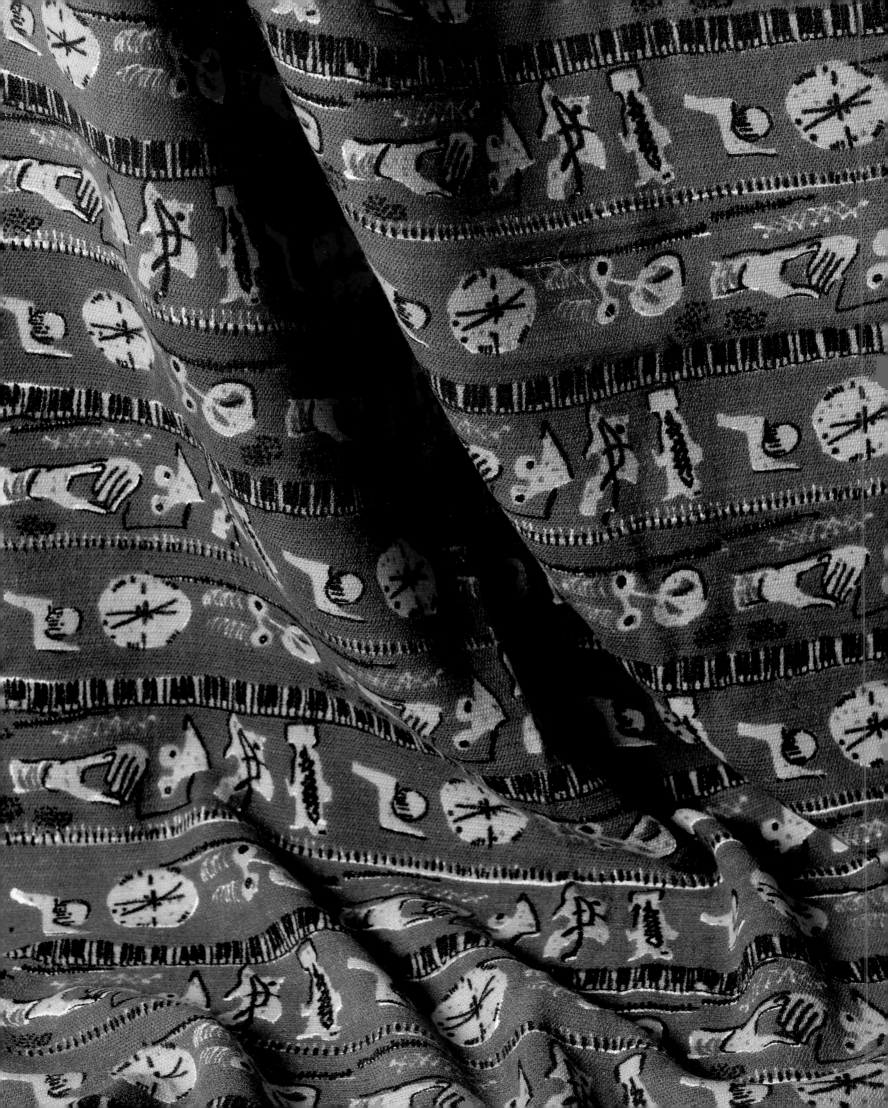

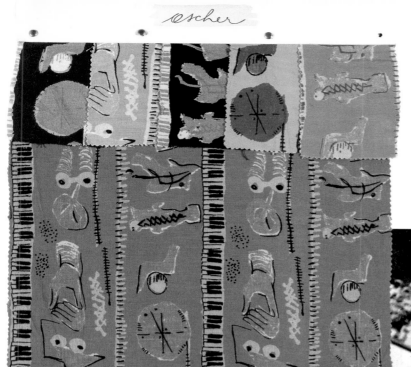

Piano 1947
TEX 5.8 (on sample band with 5.9; 5.7;
5.6; 5.4; 5.3)
serigraphy in five colours
rayon
455 × 385mm
printed by ASCHER
The Henry Moore Foundation:
acquired 1990

(opposite)
Piano 1947
TEX 5.2
serigraphy in six colours
wool
1910 × 940mm
printed by ASCHER
The Ascher Collection

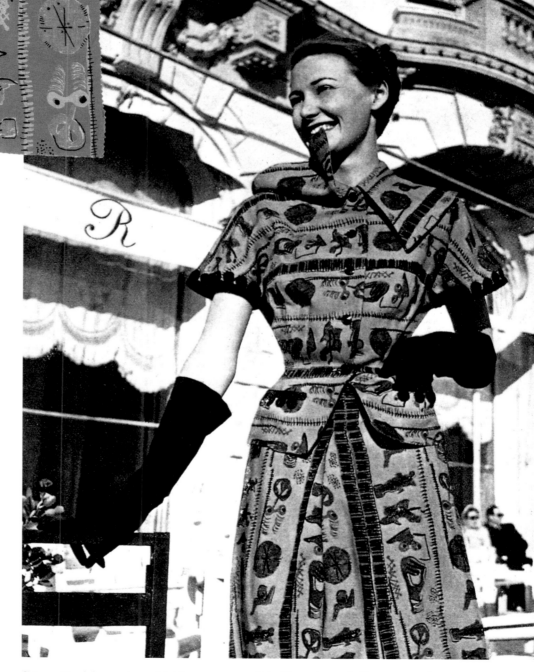

fig.31 Model wearing a Matita summer suit in **Piano** (TEX 5), Cannes, 1948.

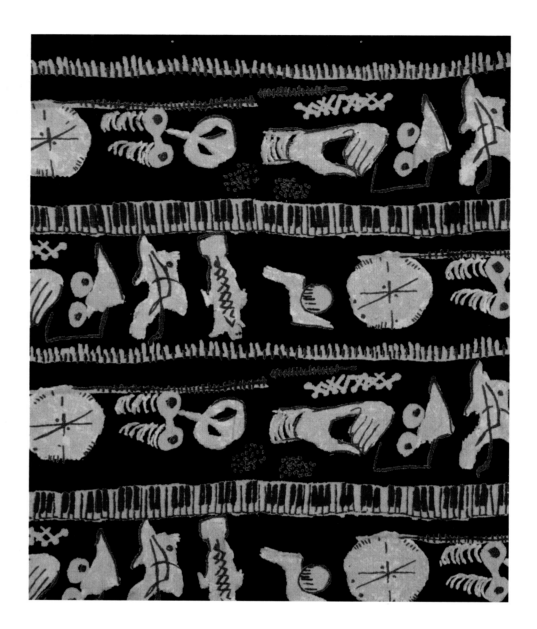

Piano 1947
TEX 5.12
serigraphy in seven colours
rayon
260 × 240mm
printed by ASCHER
The Ascher Collection

Piano 1947
TEX 5.10
serigraphy in four colours
rayon
400 × 365mm
printed by ASCHER
Victoria and Albert Museum, London

(right)
Piano 1947
TEX 5.3
serigraphy in five colours
wool
360 × 315mm
printed by ASCHER
The Henry Moore Foundation:
acquired 1990

(opposite)
Selection of colourways
of Moore's design, **Piano** (TEX 5).

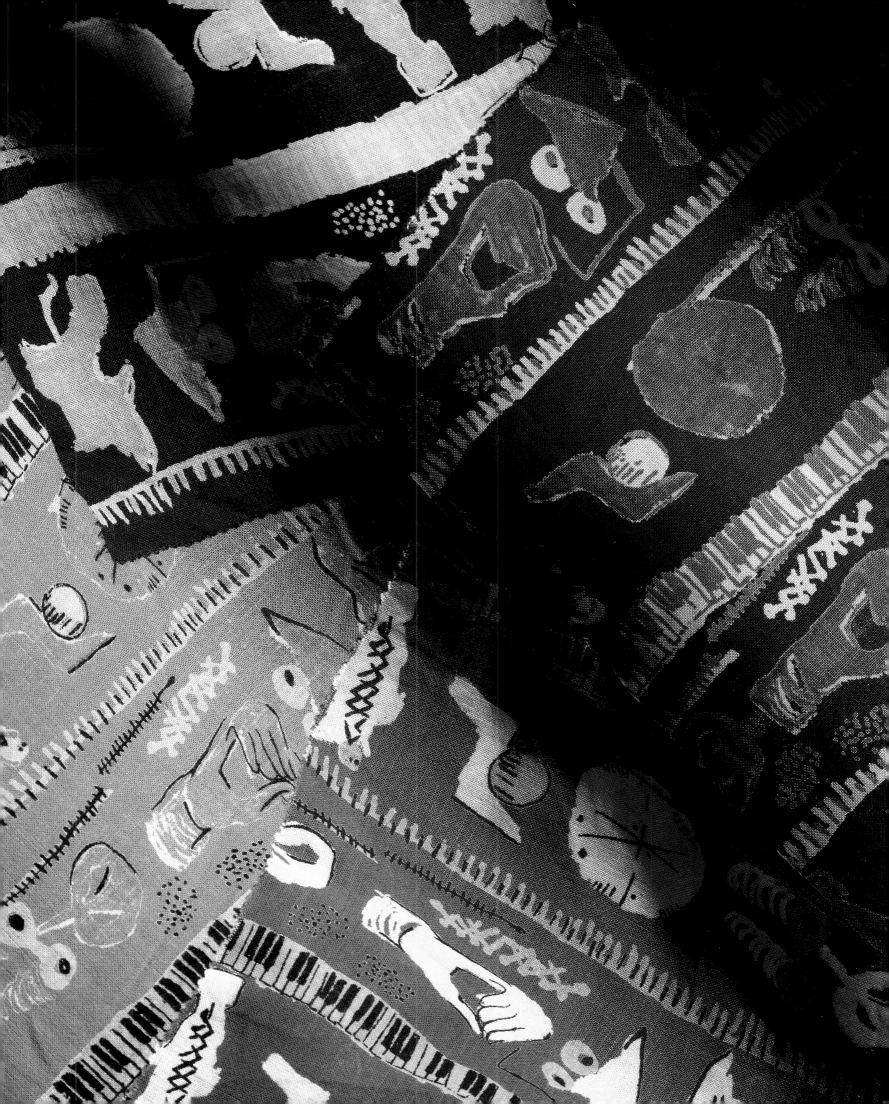

Reclining Figures is the closest of all Moore's textiles to his sculpture, and anticipates bronzes such as **Draped Reclining Figure** 1952–53 (LH 336) made for the Time/Life Building on Bond Street. But in the bronzes Moore's emphasis is on form – the three-dimensional weight and volume of the work, its physical mass in space. Here, the lines of the drapery begin by following the form of the figure, then completely dominate the composition by flowing into the background and linking the repeating pattern of figures together into one fluid rhythm. This effect is enhanced by the use of colour – from opposing reds and greens, to jarring red and magenta with an acid green, and even a positive/negative effect with the minimal scheme of only blue and white. This approach suits the idea of a fabric that can be worn, with the lines of the pattern also flowing around the person wearing the garment.

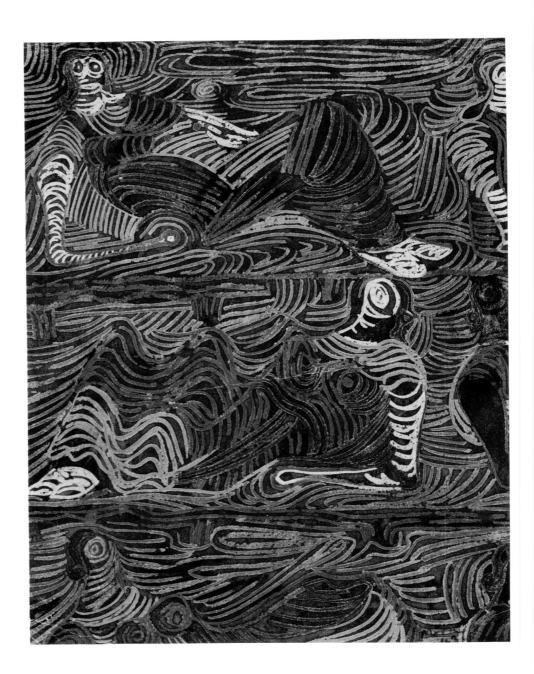

(right, above)
Textile Design for 'Reclining Figures' 1943
Page from *Textile Design Sketchbook 3*
HMF 2152
pencil, wax crayon, coloured crayon, watercolour on cream medium-weight wove
305 × 229mm
signature (added later): wax crayon l.r.
Moore/43
Private collection, UK

(right)
Reclining Figures 1944–46
TEX 8.3
serigraphy in two colours
cotton
485 × 510mm
printed by ASCHER
The Henry Moore Foundation:
acquired 1990

(right)
Reclining Figures 1944–46
TEX 8.1
serigraphy in six colours
cotton
360 × 530mm
printed by ASCHER
The Henry Moore Foundation:
acquired 1990

(below)
Reclining Figures 1944–46
TEX 8.2
serigraphy in six colours
cotton
1960 × 885mm
printed by ASCHER
The Ascher Collection

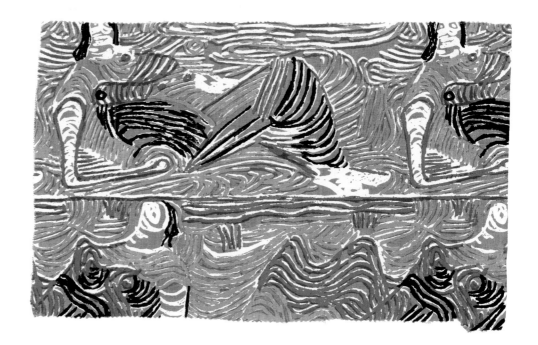

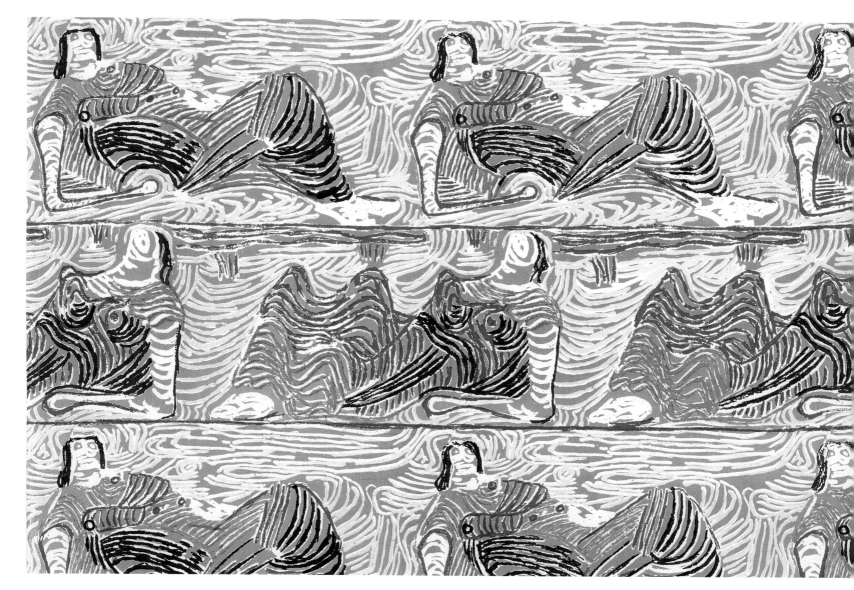

Heads was one of Moore's favourite textile designs; over the years curtains were made from this fabric for the sitting room, office and kitchen of Hoglands. There the rows of mask-like heads worked well with his eclectic collection of Cycladic heads, African and Oceanic masks, and stone masks that he carved in the 1930s. The two heads – one very abstract and the other resembling an African mask – also appear in another textile drawing, HMF 2124f (p.40). Although the original sketch depicts the pattern on a black background, for the fabric an off-white was chosen to lighten the overall effect with touches of black added to highlight the red motifs.

The reference to Picasso, particularly in the head on the right, is unmistakable. Picasso's etching *Sueño y mentira de Franco (8 janvier 1937)* also hung in the Hoglands kitchen opposite the curtains made from Moore's fabric. Moore first met the artist at his Paris studio in 1937 where he saw *Guernica* in progress; he was accompanied by the leading Surrealists André Breton, Paul Eluard, Max Ernst, Alberto Giacometti and Roland Penrose.

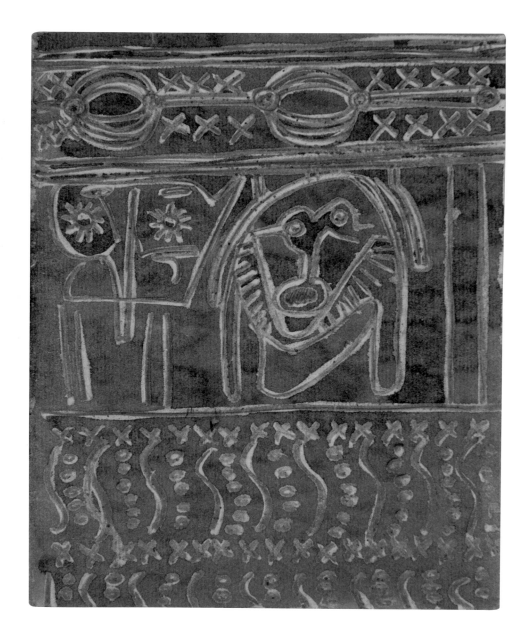

Textile Design for 'Heads' 1943
Page from *Textile Design Sketchbook 1*
HMF 2121
pencil, wax crayon, watercolour on cream medium-weight laid
204 × 165mm
The Ascher Collection

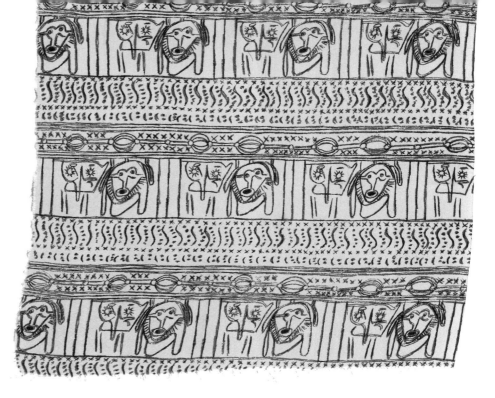

(right)
Heads 1945–46
TEX 9
serigraphy in three colours
rayon
540 × 590mm
printed by ASCHER
The Ascher Collection

(below)
Kitchen curtains in Hoglands with view to
garden, made from Moore's design, **Heads**.

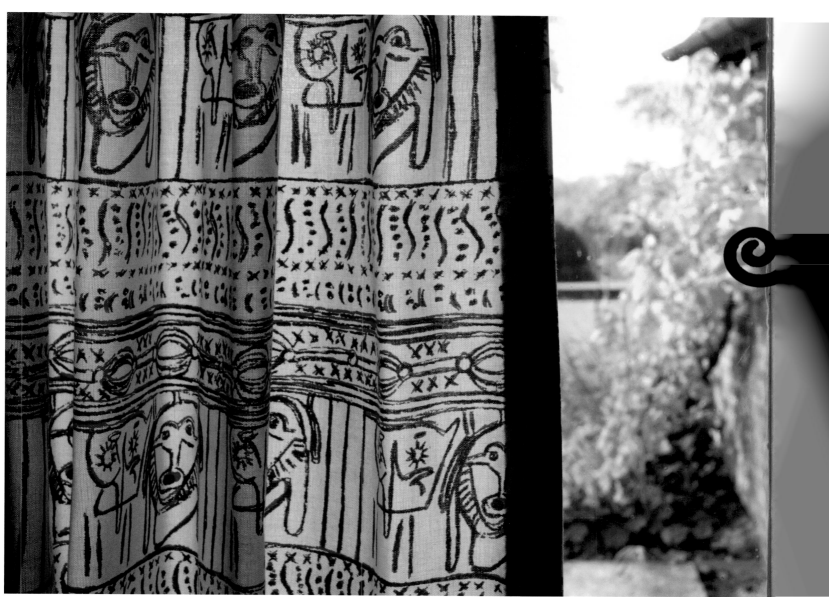

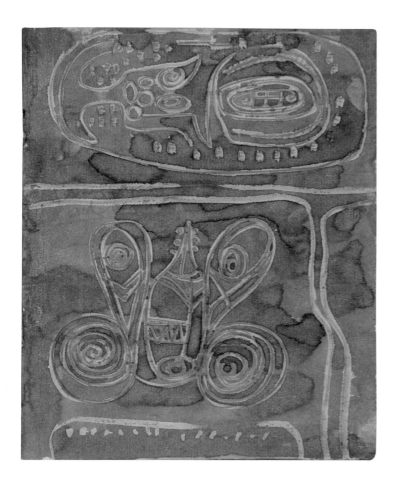
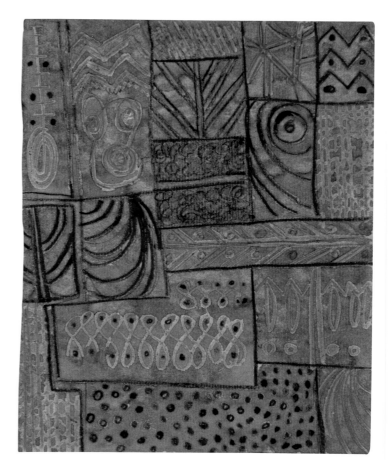

TEX 10
Caterpillar and Insect Wings

One of the more light-hearted textile designs, this patchwork of ideas includes motifs that have been selected from many different sources. While the interplay of rectangular forms is sketched out in HMF 2113 (above right), the scrollwork appears first in pencil in HMF 2114,[3] and again in vivid indigo blue in HMF 2148 (see p.46). The motif of free yet hard-edged intersecting lines is roughed out in HMF 2155 (see p.54). Variations on insect wings and ovals derive from HMF 2111 (see TEX 11) and 2112, while the twisting caterpillar crops up in HMF 2101 (see TEX 17) and HMF 2146 (see p.124). The schematic view of the caterpillar, with its face and each leg clearly visible and its 'S' shaped curve, has its origin in an illustration of a Chiricahua Apache painted leather poncho in *Indian Art of the United States*, by Frederic H. Douglas and René d'Harnoncourt.[4] Moore balanced the

complexity of the design with a simple two-colour scheme to produce a distinctively modern pattern overall.

3 See *Henry Moore: Complete Drawings*, vol.3, Lund Humphries, London 2001, p.176.
4 Museum of Modern Art, New York 1941 p.31.

(above left)
Textile Design for 'Caterpillar and Insect Wings' 1943
Page from *Textile Design Sketchbook 1*
HMF 2112
pencil, wax crayon, watercolour on cream medium-weight laid
204 × 165mm
inscription: pencil c.l. (...)/*red* (...)
The Ascher Collection

(above right)
Textile Design for 'Caterpillar and Insect Wings' 1943
Page from *Textile Design Sketchbook 1*
HMF 2113
pencil, wax crayon, watercolour on cream medium-weight laid
204 × 165mm
The Ascher Collection

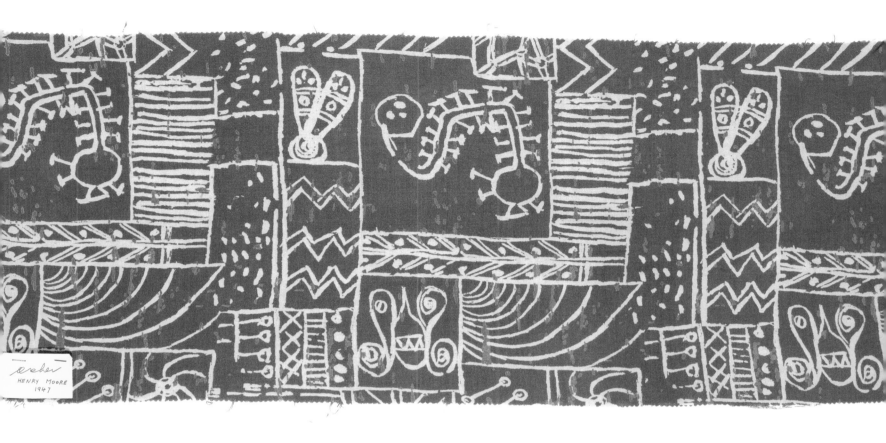

Caterpillar and Insect Wings 1947
TEX 10.1
serigraphy in three colours
rayon
370 × 925mm
printed by ASCHER
The Ascher Collection

(right)
Caterpillar and Insect Wings 1947
TEX 10.1
serigraphy in three colours
rayon bag
420 × 410mm
printed by ASCHER

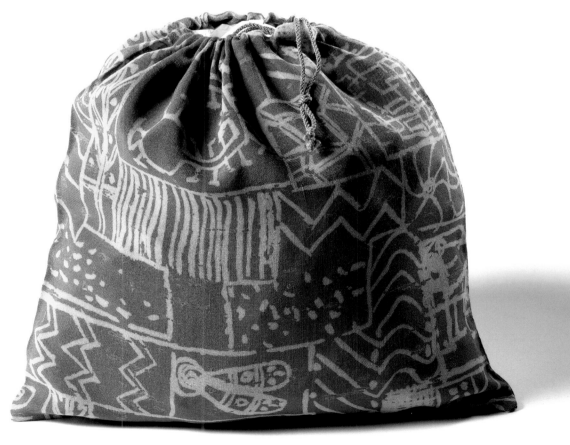

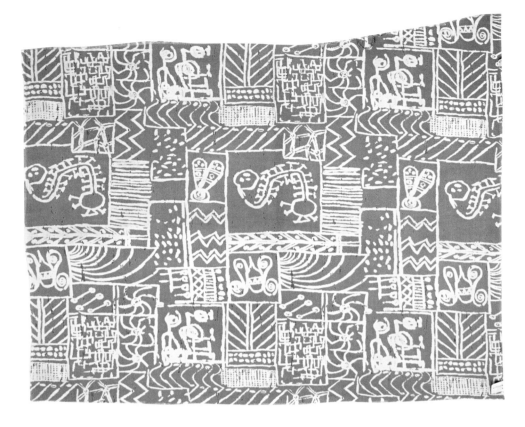

Caterpillar and Insect Wings 1947
TEX 10.2
serigraphy in three colours
rayon
805 × 940mm
printed by ASCHER
The Ascher Collection

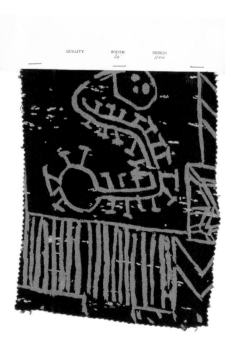

Caterpillar and Insect Wings 1947
TEX 10.4
serigraphy in three colours
rayon
180 × 270mm
printed by ASCHER
The Henry Moore Foundation:
acquired 1990

Caterpillar and Insect Wings 1947
TEX 10.2
serigraphy in three colours
rayon necktie
1300 × 85mm
printed by ASCHER
Private collection

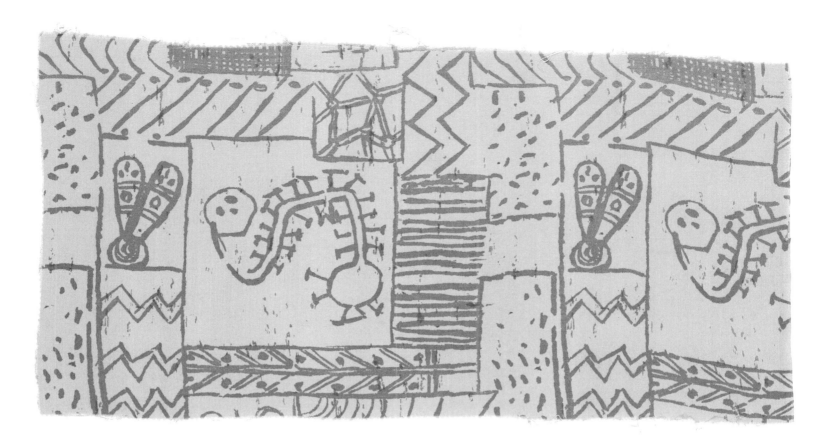

Caterpillar and Insect Wings 1947
TEX 10.6
serigraphy in three colours
rayon
330 × 650mm
printed by ASCHER
The Ascher Collection

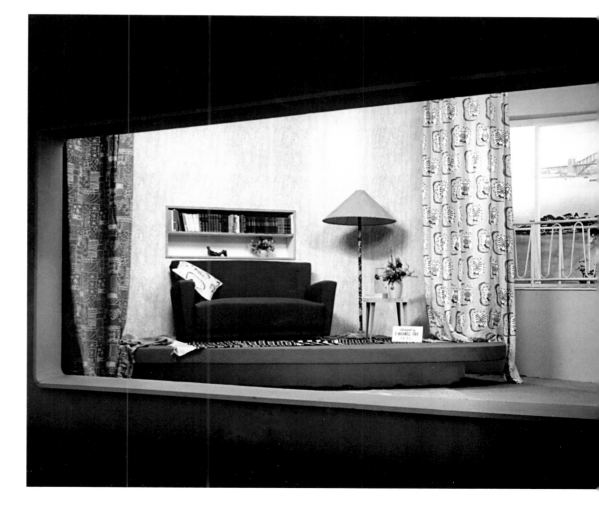

fig.32 Maxwell Fry's display for furnishings c.1950, with curtains made from Moore's **Caterpillar and Insect Wings** (left); Moore's bronze **Reclining Figure: Blanket** 1939 (LH 203) is on the shelf above the sofa.

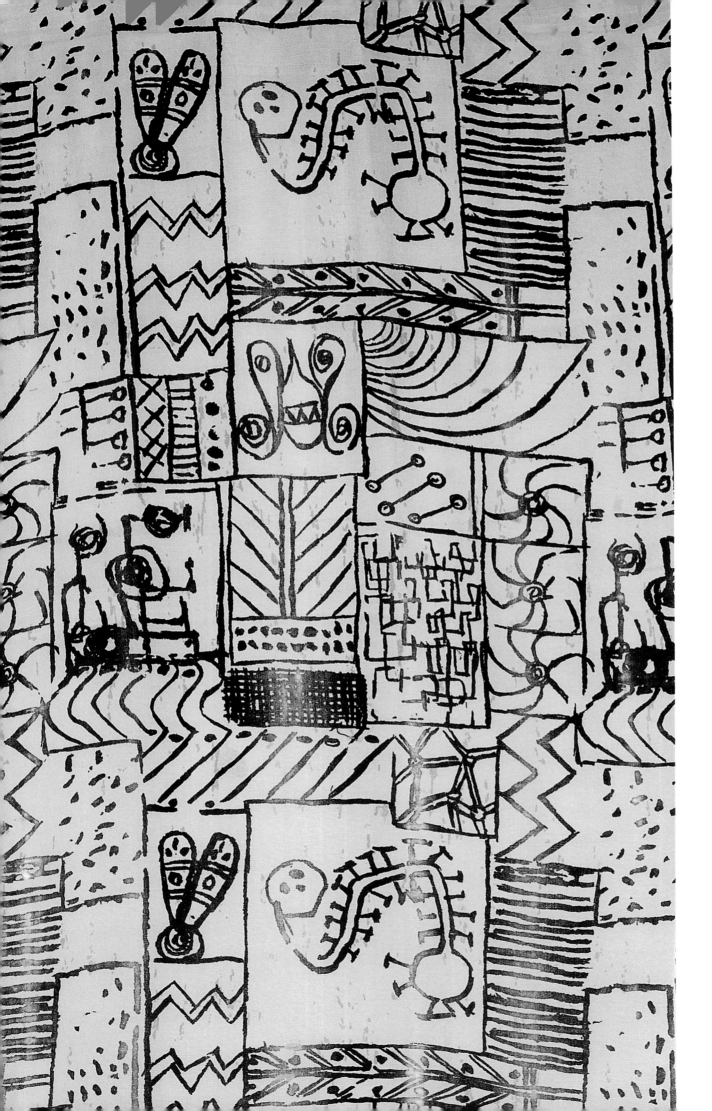

**Caterpillar and
Insect Wings** 1947
TEX 10.11
serigraphy in three
colours
spun rayon
1680 × 590mm
printed by ASCHER
The Ascher Collection

At a distance, **Insect Wings and Ovals** reads as broad horizontal bands of alternating colours. Yet within each row are the outlines of forms within forms, depicted with free, intertwining lines and circles. These are connected with quick dashes and circles that seemingly pin the rows together.

All known samples of this pattern were made up in rayon. Although the term rayon was coined in 1924,[5] high-performance rayons did not appear until the late 1930s, with the advent of hot-stretching and addition of larger amounts of zinc to the spin bath. Further modifications in 1947 meant that rayon fabrics could be mass produced, easily dyed and would retain their feel and texture for longer. Produced from naturally occurring polymers, rayon was neither a natural nor completely synthetic material, and had the unique capacity to imitate the texture and feel of silk, cotton, linen or wool. The technological advances in rayon made it a particularly modern fabric.

5 Versions of rayon existed as far back as the nineteenth century, when it was known as Chardonnay silk due to the efforts by the Duke of Chardonnay to imitate the production of silk by silk worms through processing wood pulp from mulberry trees. In 1894 British inventors patented a more practical method that became known as viscose rayon.

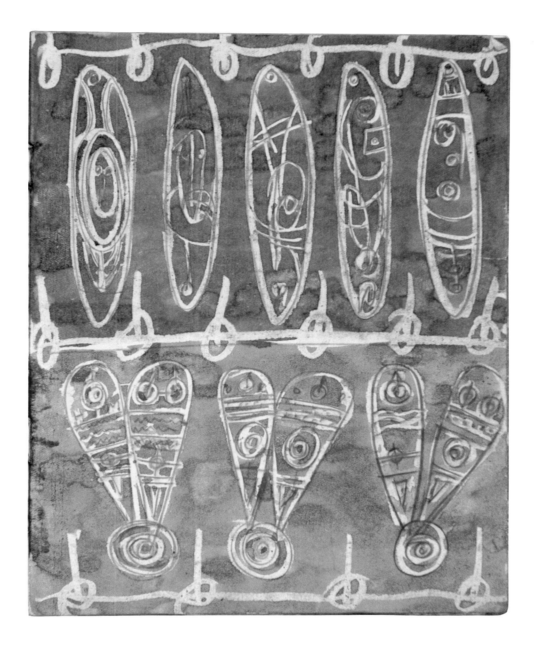

(right, above)
Textile Design for 'Insect Wings and Ovals'
1943
Page from *Textile Design Sketchbook 1*
HMF 2111
pencil, wax crayon, watercolour on cream medium-weight laid
204 × 165mm
The Ascher Collection

(right)
Selection of colourways of Moore's design, **Insect Wings and Ovals** (TEX 11).

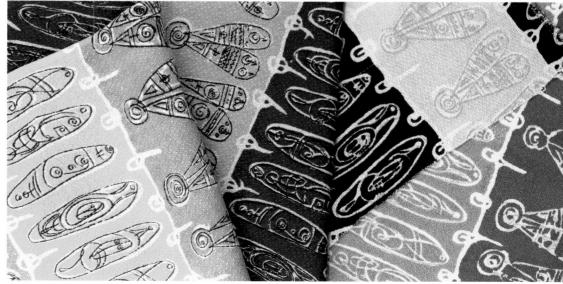

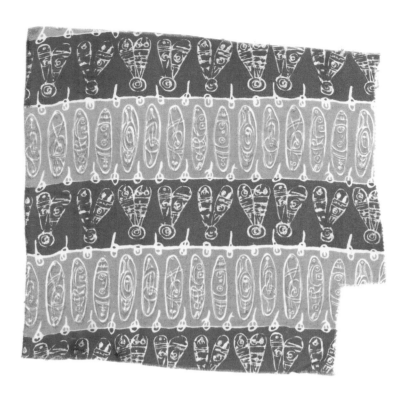

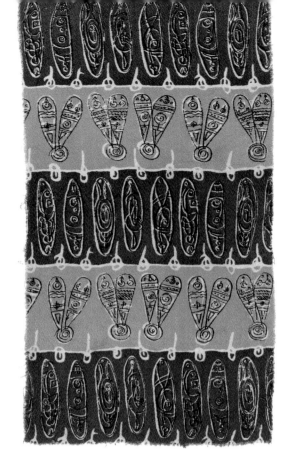

(above left)
Insect Wings and Ovals c.1947
TEX 11.1
serigraphy in four colours
spun rayon
190 × 270mm
printed by ASCHER
The Henry Moore Foundation: acquired 1990

(above right)
Insect Wings and Ovals c.1947
TEX 11.2
serigraphy in four colours
spun rayon
475 × 255mm
printed by ASCHER
The Henry Moore Foundation: acquired 1990

(below)
Insect Wings and Ovals c.1947
TEX 11.4
serigraphy in four colours
rayon
450 × 925mm
printed by ASCHER
The Ascher Collection

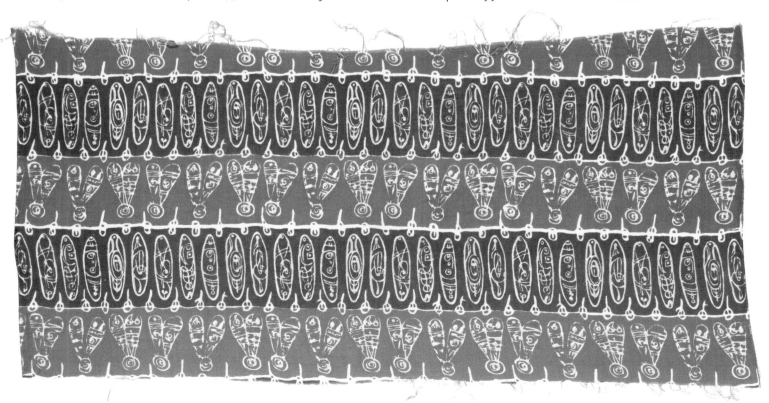

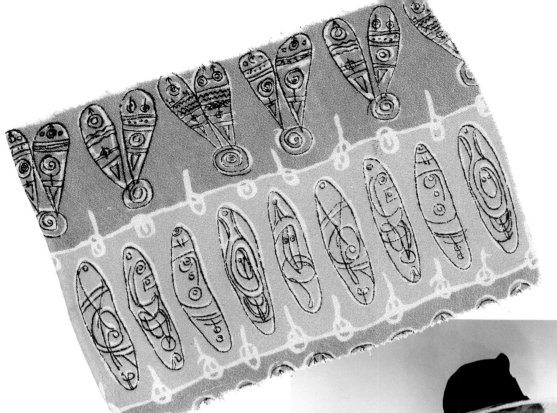

Insect Wings and Ovals *c.*1947
TEX 11.10
serigraphy in four colours
rayon
200 × 270mm
printed by ASCHER
The Henry Moore Foundation:
acquired 1990

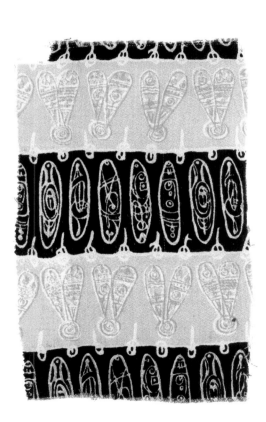

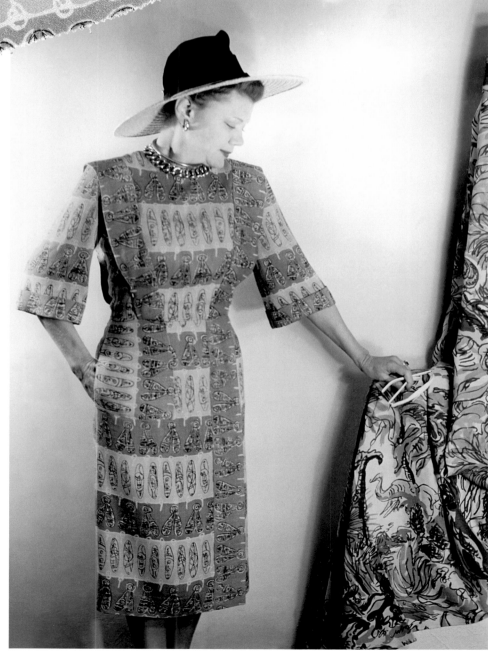

Insect Wings and Ovals *c.*1947
TEX 11.9
serigraphy in four colours
rayon
370 × 230mm
printed by ASCHER
The Henry Moore Foundation: acquired 1990

fig.33 Model wearing Ascher dress made from Moore's **Insect Wings and Ovals** *c.*1947.

 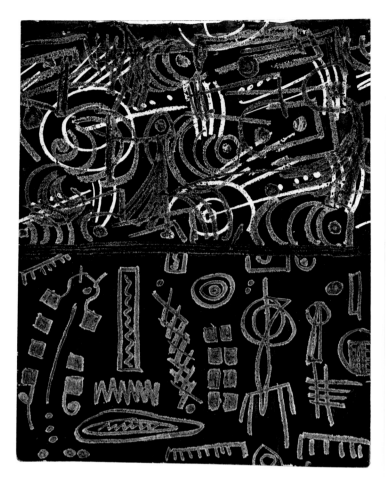

TEX 12

Treble Clef, Zigzag and Oval Safety Pins

Decades before Punk, twisted safety pins appear in Moore's work. As early as 1939, his drawing **Ideas for Sculpture** (HMF 1437) was inscribed '. . . safety pin magic table in odd setting'. In the drawing the safety pin traverses a table through which a plant grows from underneath.[6] Among the myriad sculptural ideas filling the page is a garden watering can that has metamorphosed into a human figure. These motifs reappear in the first pencil sketch for this textile design, HMF 2117. Here, the watering can at right is coupled with a rake at centre surrounded by abstracted flowers and an insect at left hovering above a stylised pond. In the final design, HMF 2149, the abstract motifs are jumbled together and further removed from any narrative or recognisable reading. Finally, in the textile pattern, the insect has lost any figurative characteristics whatsoever and has been reduced to a

double row of small squares with a squiggly line where its head used to be. Moore always believed that Surrealism and Abstraction need not be antithetical, and in this work he has managed to move from one approach to the other through a process of reduction. The result is one of the most modern textile designs of any artist in the post-war era.

6 See *Henry Moore: Complete Drawings*, vol.2, Lund Humphries, London 1998, p.236.

(above left)

Textile Design 1943
Page from *Textile Design Sketchbook 1*
HMF 2117
pencil on cream medium-weight laid
204 × 165mm
inscription: pencil u.l. *White & Black forms*
The Ascher Collection

(above right)

Textile Design for 'Treble Clef, Zigzag and Oval Safety Pins' 1943
Page from *Textile Design Sketchbook 3*
HMF 2149
pencil, wax crayon, coloured crayon, watercolour on cream medium-weight wove
305 × 229mm

Treble Clef, Zigzag and Oval Safety Pins

1946–47

TEX 12.1; 12.12 (Ascher samples)

serigraphy in three colours

rayon

187 × 210mm; 210 × 210mm

printed by ASCHER

The Henry Moore Foundation:

acquired 1990

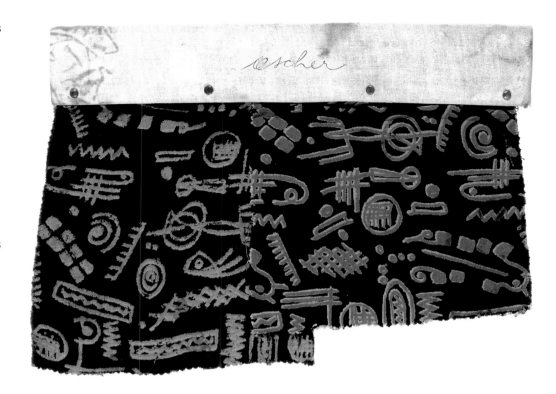

Treble Clef, Zigzag and Oval Safety Pins

1946–47

TEX 12.2

serigraphy in three colours

rayon

280 × 300mm

printed by ASCHER

The Ascher Collection

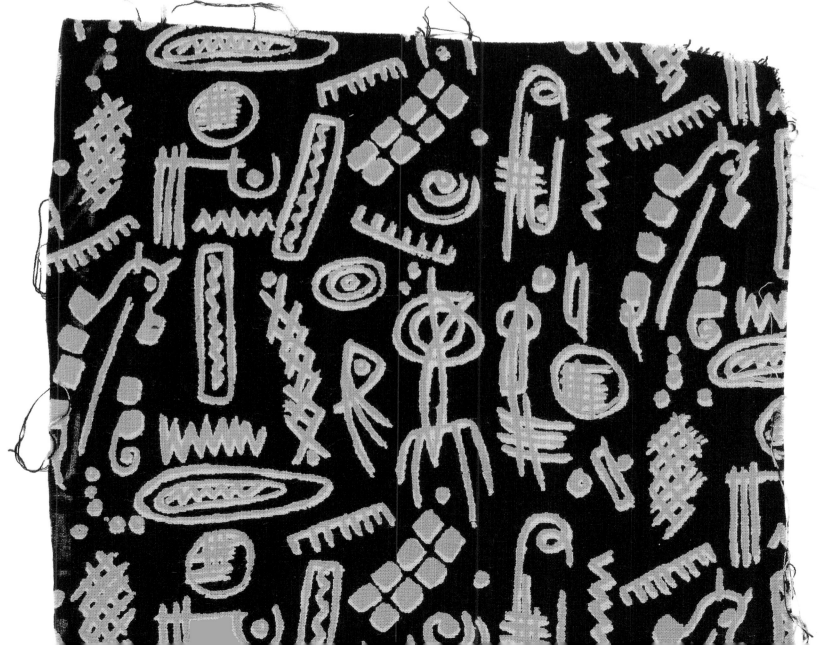

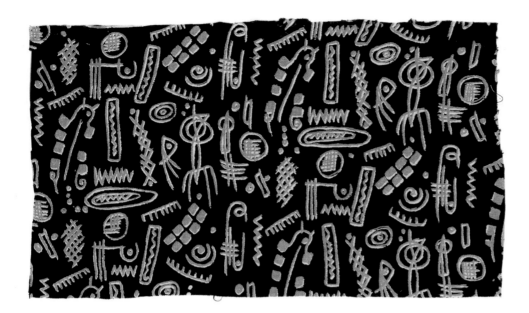

Treble Clef, Zigzag and Oval Safety Pins
1946–47
TEX 12.3
serigraphy in three colours
rayon
290 × 480mm
printed by ASCHER
The Ascher Collection

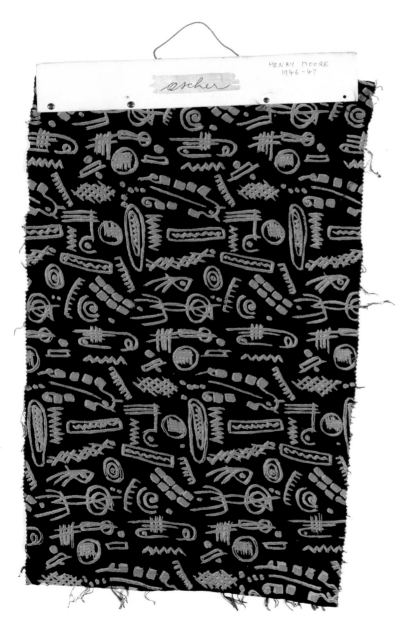

Treble Clef, Zigzag and Oval Safety Pins 1946–47
TEX 12.4
serigraphy in three colours
rayon
370 × 640mm
printed by ASCHER
The Ascher Collection

(opposite)
Curtains in Hoglands made from
Treble Clef, Zig Zag and Oval Safety Pins
(TEX 12.8), seen with Moore's bronze
Interior Form 1951 (LH 295a).

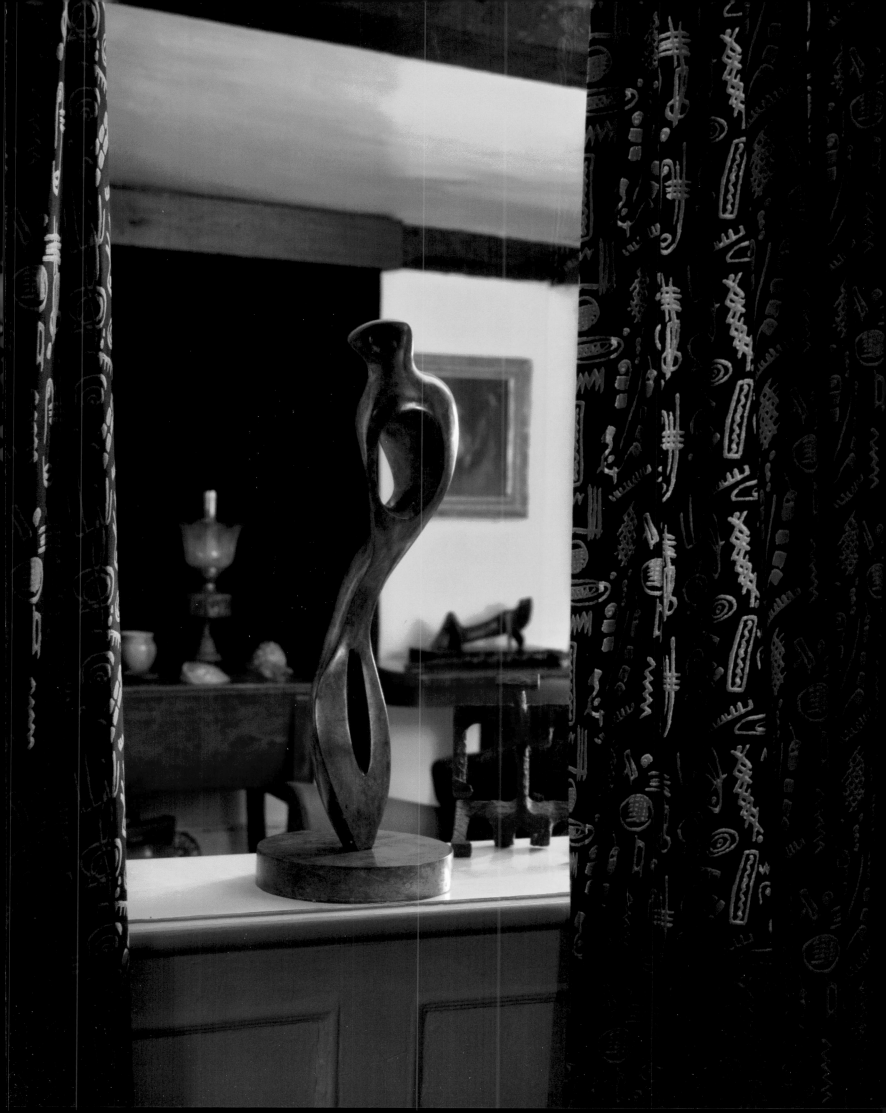

Treble Clef, Zigzag and Oval Safety Pins
1946–47
TEX 12.9
serigraphy in two colours
rayon
215 × 380mm
printed by ASCHER
The Henry Moore Foundation: acquired 1990

Treble Clef, Zigzag and Oval Safety Pins
1946–47
TEX 12.10
serigraphy in two colours
rayon
340 × 810mm
printed by ASCHER
The Henry Moore
Foundation: acquired 1990

Treble Clef, Zigzag and Oval Safety Pins
1946–47
TEX 12.16
serigraphy in four colours
rayon
255 × 435mm
printed by ASCHER
The Ascher Collection

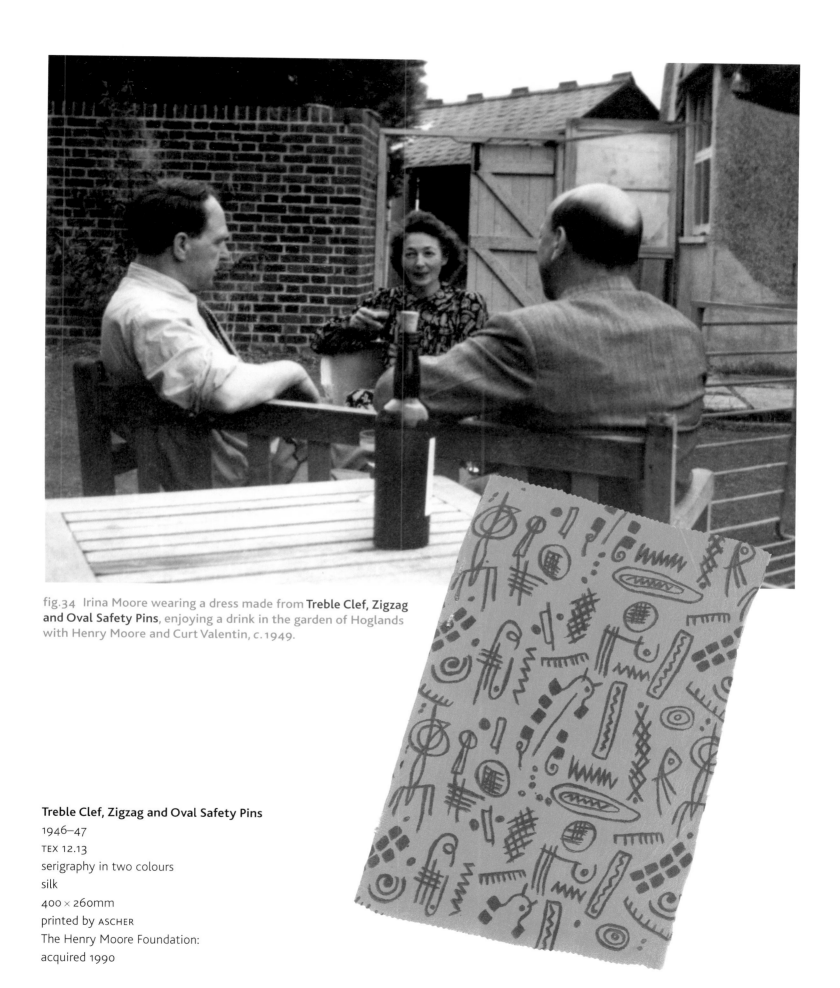

fig.34 Irina Moore wearing a dress made from **Treble Clef, Zigzag and Oval Safety Pins**, enjoying a drink in the garden of Hoglands with Henry Moore and Curt Valentin, c.1949.

Treble Clef, Zigzag and Oval Safety Pins

1946–47

TEX 12.13

serigraphy in two colours

silk

400 × 260mm

printed by ASCHER

The Henry Moore Foundation:

acquired 1990

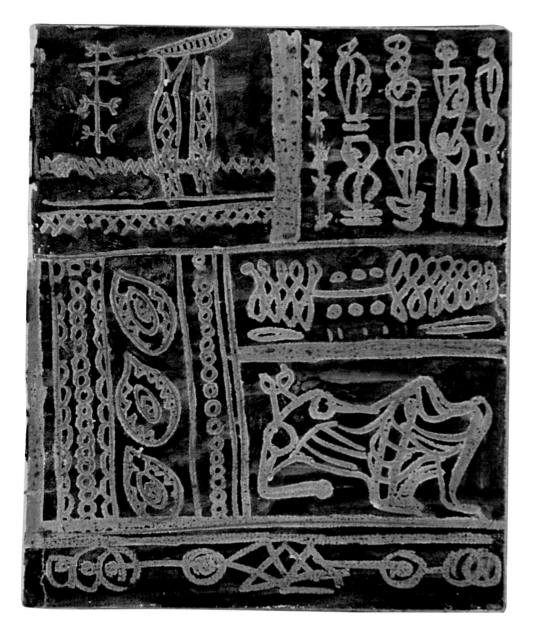

Textile Design for 'Four Standing Figures and One Reclining Figure' 1943
Page from *Textile Design Sketchbook 1*
HMF 2106
pencil, wax crayon, watercolour on cream medium-weight laid
204 × 165mm
The Ascher Collection

TEX 13
Four Standing Figures and One Reclining Figure

By the end of the Second World War Moore was paradoxically championed by Herbert Read as a pioneer of Modernism while being revered by Kenneth Clark as the leading British artist able to connect the past with the present. This continuity may be seen here in Moore's fundamentally humanist approach, re-examining the classicism of Ancient Greece in his use of drapery as well as figures standing in rows resembling the Caryatids of the Acropolis. Identification with Greece is further reinforced by the

colour scheme of grey or blue and white.

But the figures look forwards as well as back – the standing figures anticipate Moore's sculptural exploration of this theme in the early 1950s, while the reclining figure bears a strong resemblance to that of his initial maquette (LH 292b, see p.109), which ultimately led to the revolutionary bronze for the 1951 Festival of Britain. It was, Moore proclaimed, the first sculpture which was successfully opened out so that the spaces between the forms were of equal importance to the forms themselves.

(opposite, top)
Four Standing Figures and One Reclining Figure 1945–46
TEX 13.1
serigraphy in two colours
rayon
165 × 320mm
printed by ASCHER
The Henry Moore Foundation: acquired 1990

(opposite, bottom)
Four Standing Figures and One Reclining Figure 1945–46
TEX 13.3
serigraphy in two colours
rayon
185 × 420mm
printed by ASCHER
Victoria and Albert Museum, London

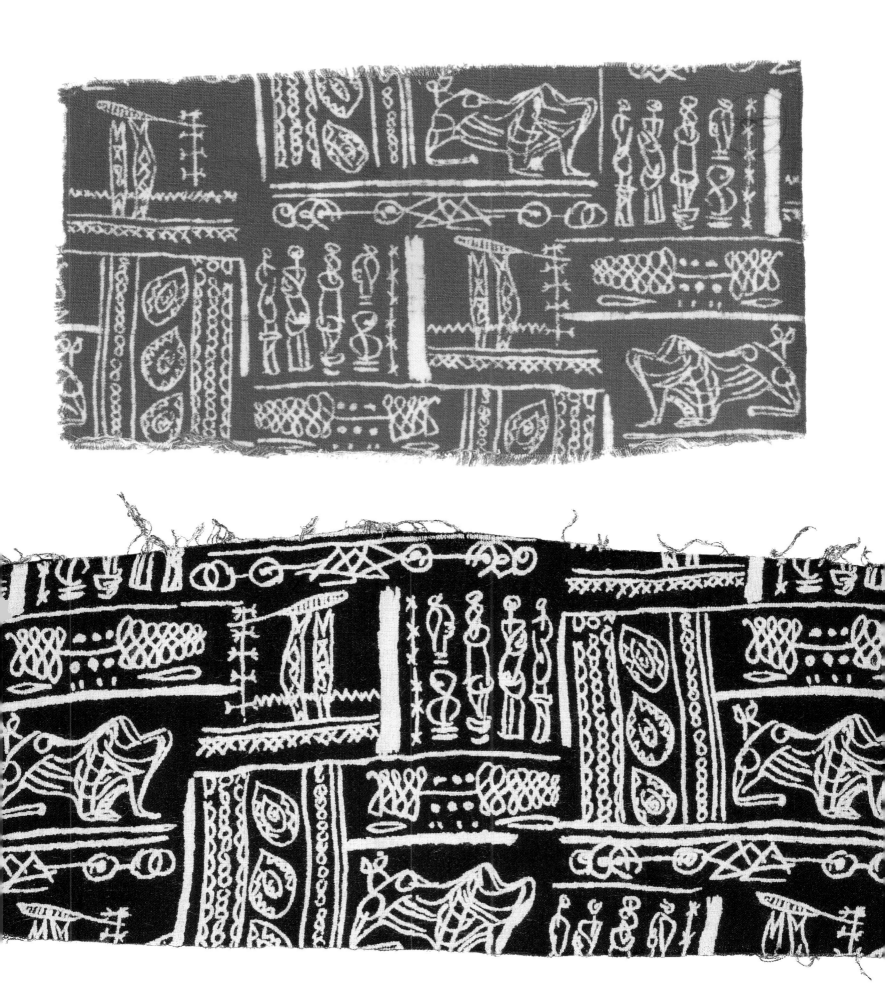

**Four Standing Figures and One Reclining
Figure** 1945–46
TEX 13.5
serigraphy in two colours
silk
280 × 560mm
printed by ASCHER
The Henry Moore Foundation:
acquired 1990

**Four Standing Figures and One Reclining
Figure** 1945–46 (TEX 13.5) with Moore's
bronze **Small Maquette No.2 for Reclining
Figure** 1950 (LH 292b), 21cm. The Henry
Moore Foundation: gift of the artist 1977

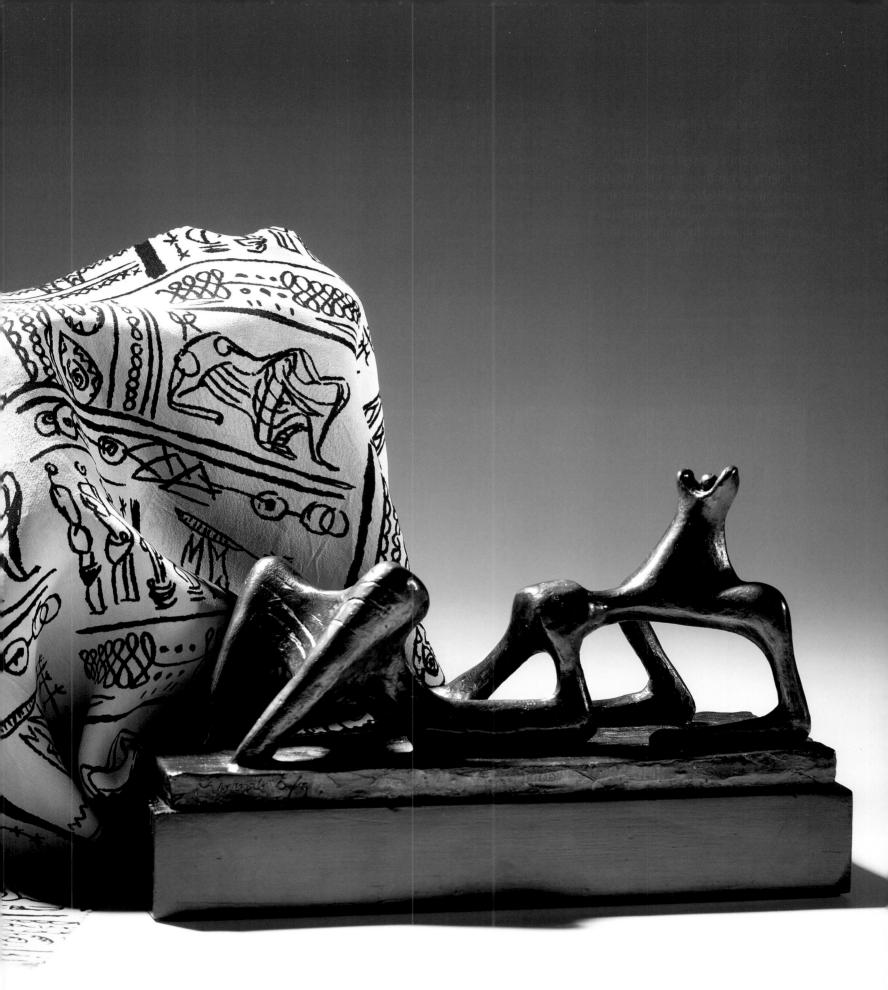

The appeal of this design is its simplicity and clarity, yet at the same time the motifs remain unrecognisable and somewhat mysterious, like an ancient indecipherable script. The origin of the symbols is unknown; some bear a resemblance to surrealist motifs in Moore's 1930s drawings, whilst others appear to be completely imaginary.

Unlike the deep red background he used in the drawing, Moore chose a background of white with varying colourways for the symbols. The squaring of symbols also appears in the more complex textile drawing HMF 2143 (see p.51), which was not put into production. This design was re-created without the squares, and set against the original deeply coloured background of the sketch, in TEX 19.

Textile Design for 'Clock Hands with Squares' 1943
Page from *Textile Design Sketchbook 3*
HMF 2151
coloured crayon, wax crayon, watercolour on cream medium-weight wove
305 × 229mm
signature (added later): pen and ink l.r.
Moore/43
Victoria and Albert Museum, London

(opposite)
Clock Hands with Squares c.1946
TEX 14.1; 14.2; 14.3 (Ascher samples)
serigraphy in three colours
cotton
360 × 285mm; 302 × 300mm; 347 × 277mm
printed by ASCHER
The Henry Moore Foundation:
acquired 1990

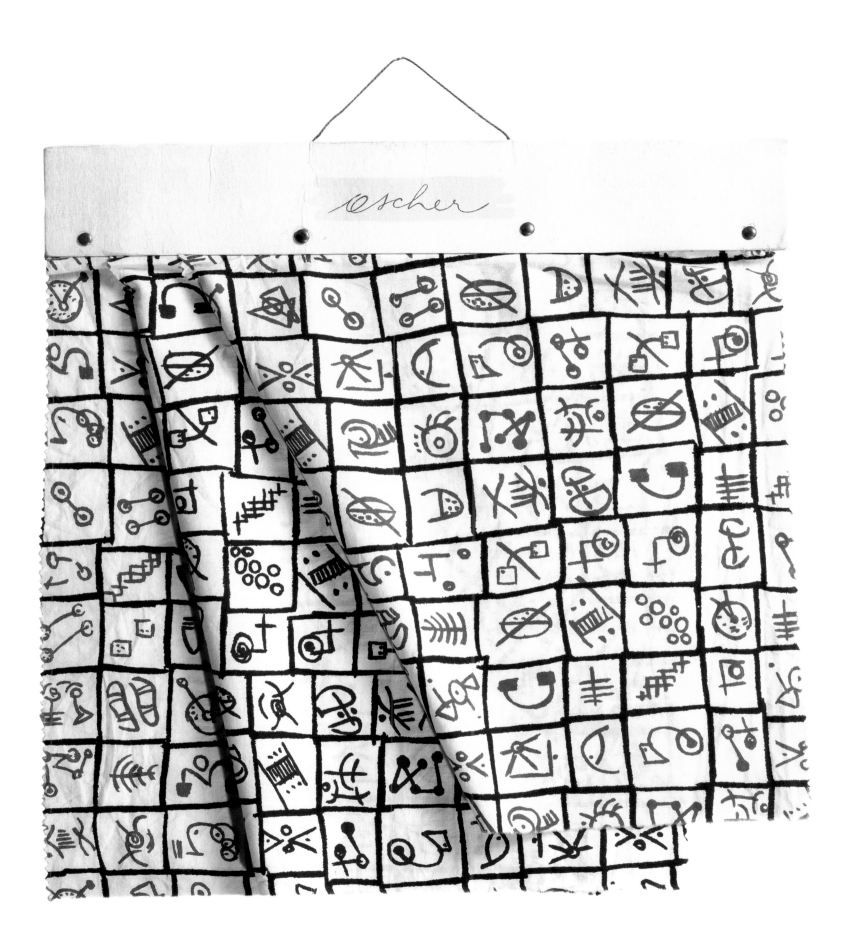

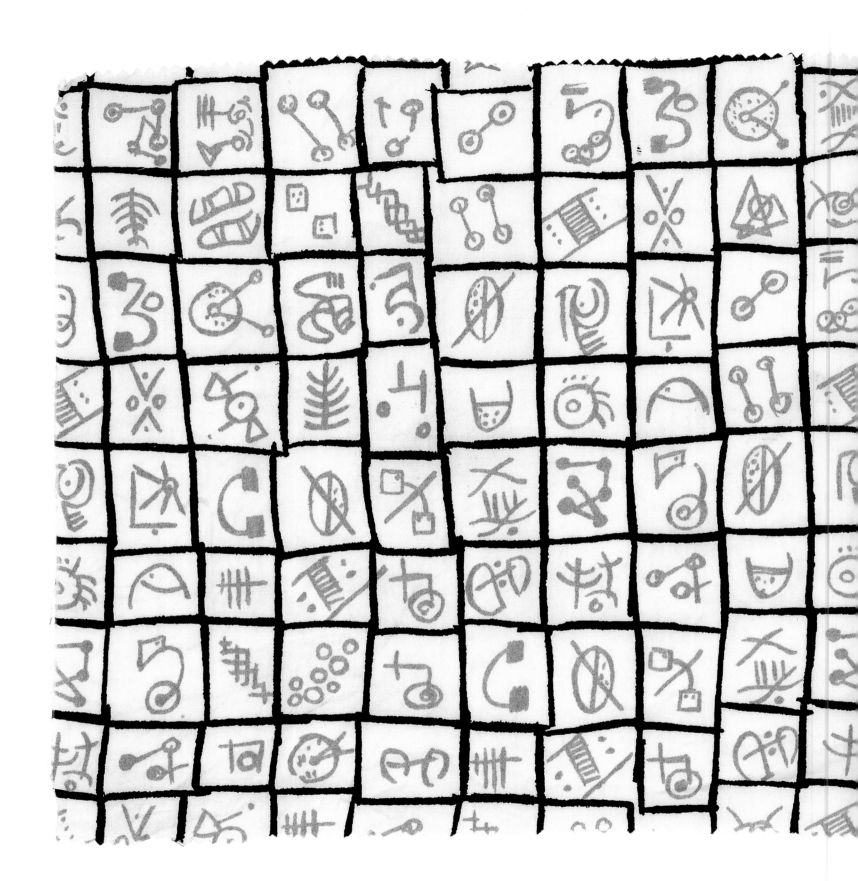

Clock Hands with Squares c.1946

TEX 14.4
serigraphy in three colours; cotton; 310 × 650mm
printed by ASCHER; The Ascher Collection

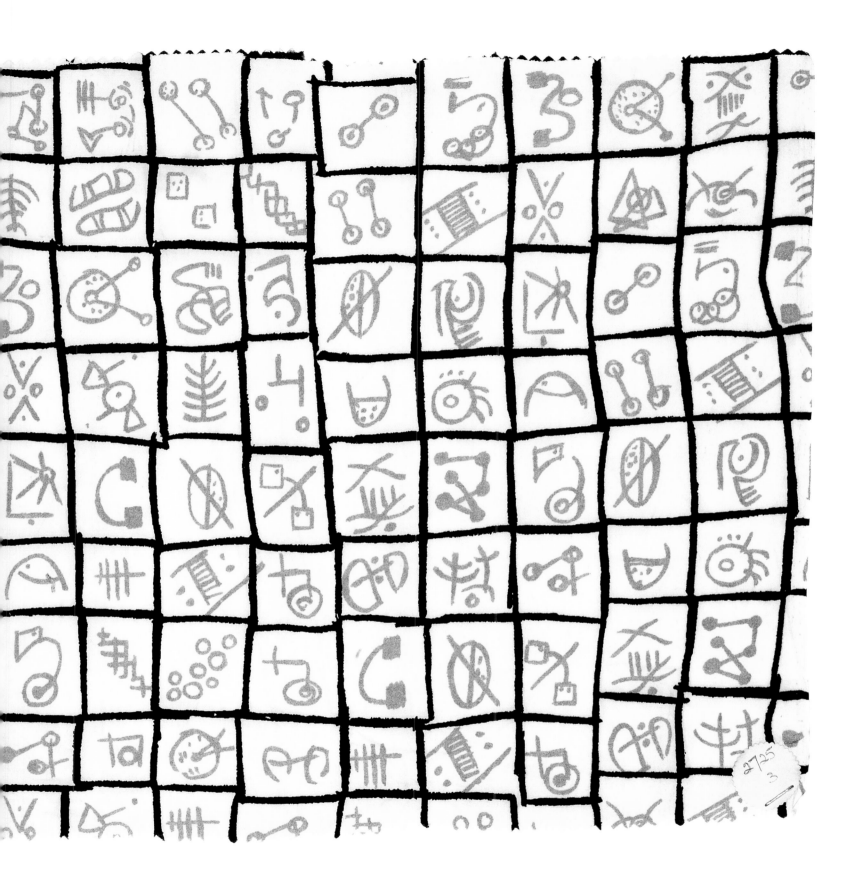

TEX 15

Four Heads, Half Figures and Animal

In October 1945 Zika Ascher wrote to Moore suggesting that he make some designs for children's textiles, requesting 'anything that would be familiar to children, or anything, though not familiar, that would appeal, such as the monkey and the elephant and the jollier types of birds like the penguin.'[7] Although we do not know of Moore's response, it could explain the appearance in this design of the brightly coloured tigers. But Moore and Ascher had more than children in mind; the pattern was produced in both rayon and silk for dress fabrics and also as a trial for a linoleum table top for the 1946 Victoria and Albert Museum exhibition *Britain Can Make It*.

The various elements of the design are united from several different drawings – the four profile heads and two half-figures comprise part of HMF 2121a, the tiger appears in HMF 2125a, the standing figure can be identified as the right figure from HMF 2151d (see TEX 1), while a recently discovered page from *No.2 Design Notebook*, HMF 2124j (see TEX 14), contains the single half-figure and abstract motif.

7 Letter from Ascher to Moore, 12 October 1945, The Henry Moore Foundation archive.

(above left)
Textile Design for 'Four Heads, Half Figures and Animals' 1943
Page from *No. 2 Design Notebook*
HMF 2121a
pencil, wax crayon, coloured crayon, ink wash, gouache on cream medium-weight laid
203 × 165mm
The Ascher Collection

(above right)
Textile Design for 'Four Heads, Half Figures and Animals' 1943
Page from *No. 2 Design Notebook*
HMF 2125a
pencil, wax crayon, coloured crayon, wash on cream medium-weight laid
203 × 165mm
The Ascher Collection

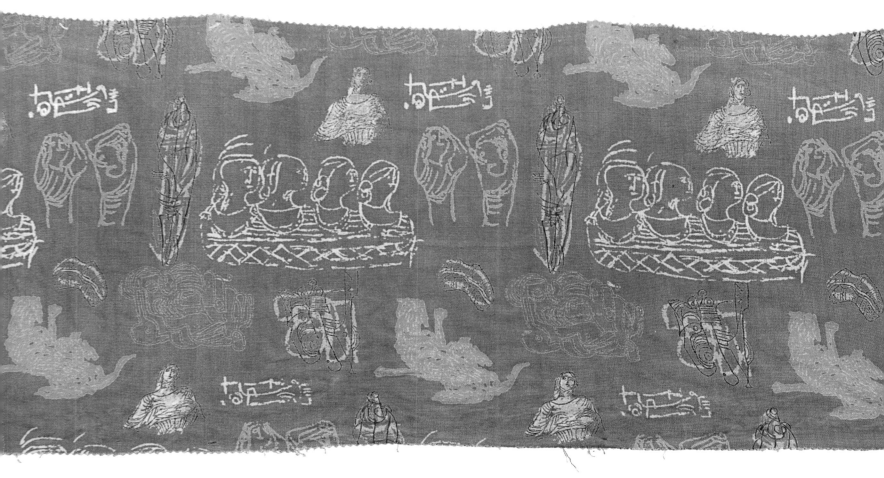

Four Heads, Half Figures and Animal
c.1946
TEX 15.7
serigraphy in seven colours
rayon
320 × 720mm
printed by ASCHER
The Henry Moore Foundation:
acquired 1990

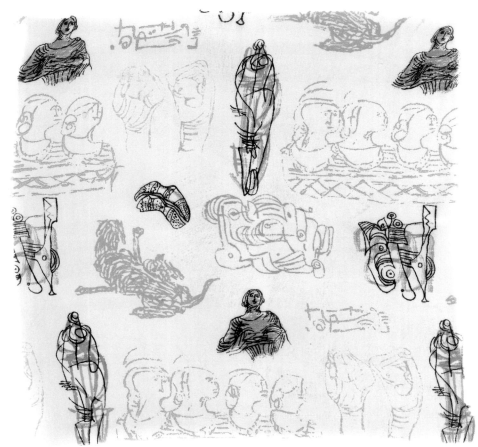

Four Heads, Half Figures and Animal
c.1946
TEX 15.17
serigraphy in seven colours
silk
300 × 300mm
printed by ASCHER
The Ascher Collection

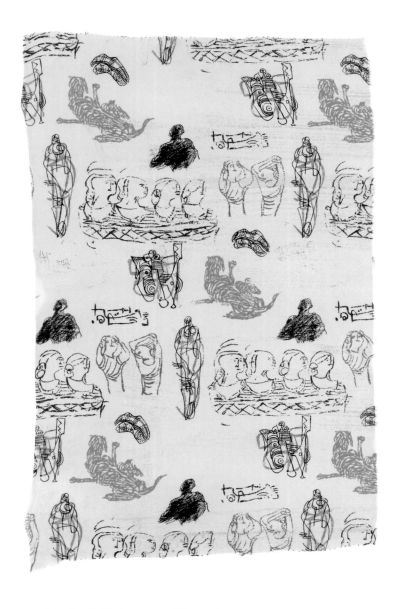

Four Heads, Half Figures and Animal
c.1946
TEX 15.18
serigraphy in six colours
silk
550 × 360mm
printed by ASCHER
The Henry Moore Foundation:
acquired 1990

Four Heads, Half Figures and Animal
c.1946
TEX 15.21
serigraphy in seven colours
rayon
330 × 515mm
printed by ASCHER
The Ascher Collection

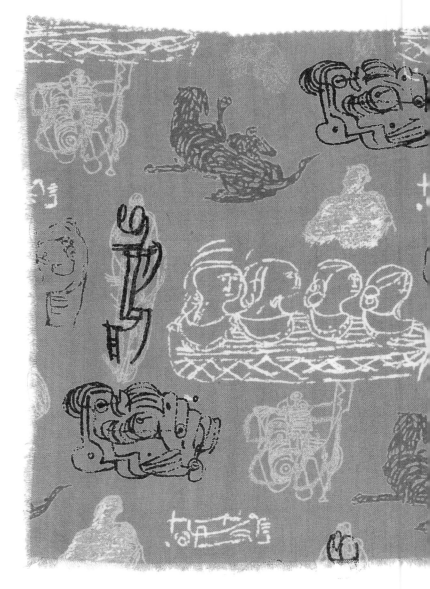

Four Heads, Half Figures and Animal
c.1946
TEX 15.24
serigraphy in seven colours
silk
440 × 370mm
printed by ASCHER
The Ascher Collection

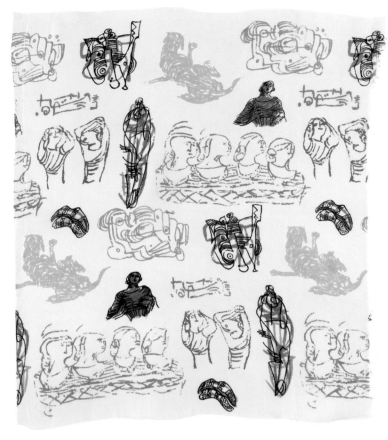

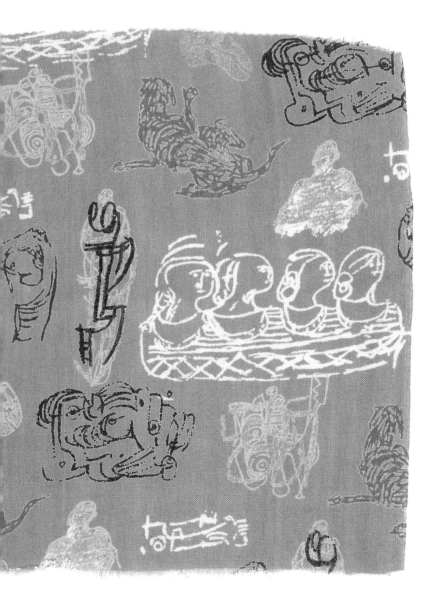

Four Heads, Half Figures and Animal
c.1946
TEX 15.25
plastic laminate created by Wareite Ltd.
from rayon in seven colours
305 × 305mm
printed by ASCHER
The Ascher Collection

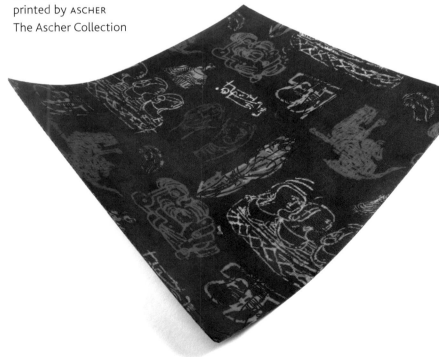

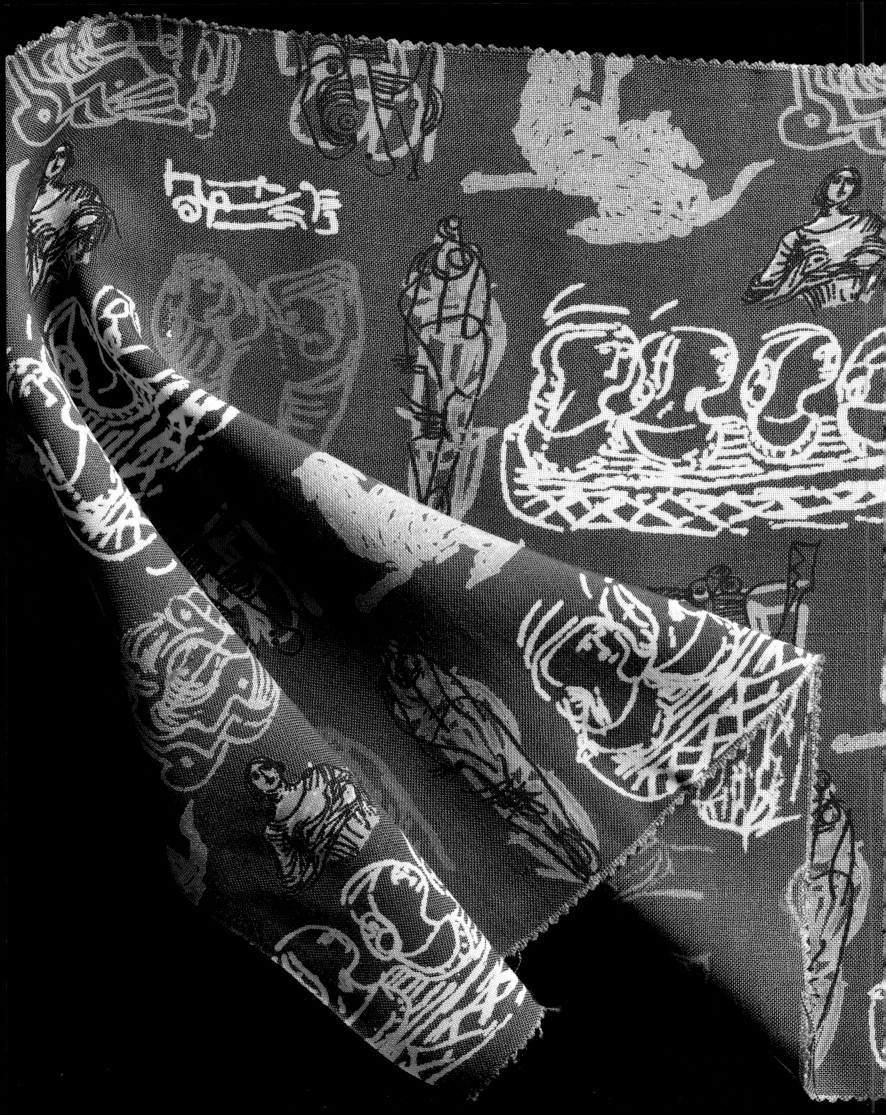

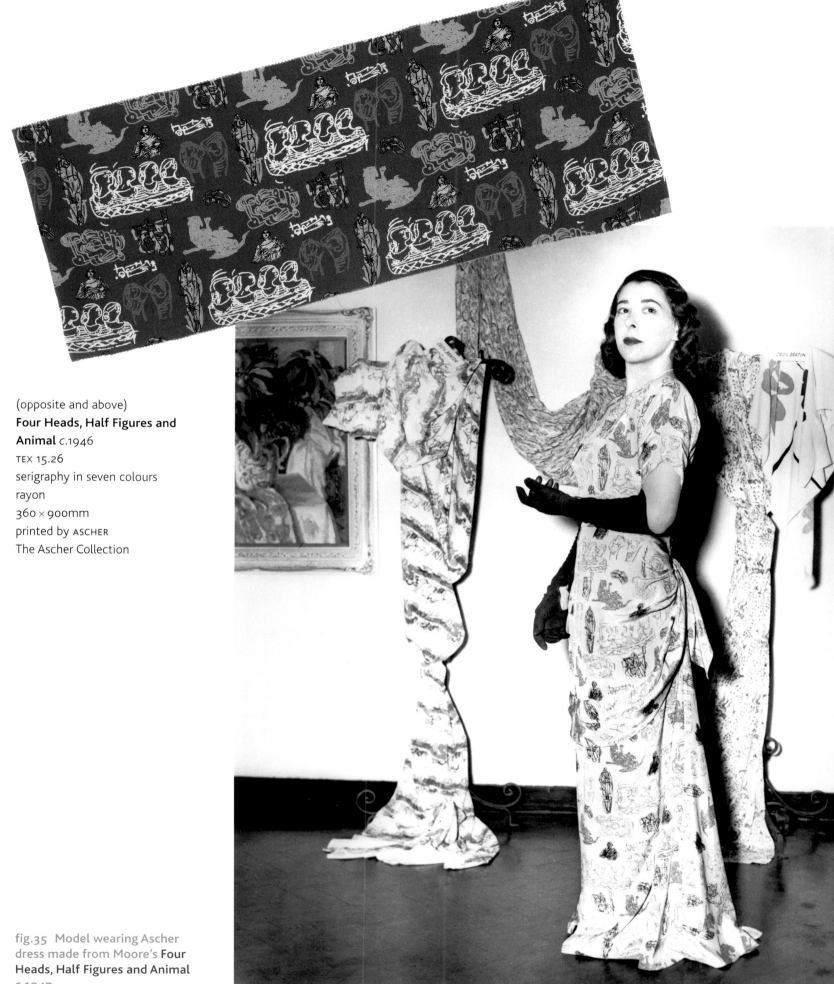

(opposite and above)
Four Heads, Half Figures and Animal c.1946
TEX 15.26
serigraphy in seven colours
rayon
360 × 900mm
printed by ASCHER
The Ascher Collection

fig.35 Model wearing Ascher dress made from Moore's **Four Heads, Half Figures and Animal** c.1947.

TEX 16
Abstract Design: Rectangles with Trains

Moore worked out several variations of this pattern in both rectangles against a solid background for clarity, and flecked so that the shapes merge with the overall design. Upon closer inspection, the 'trains' are actually an elaborate array of eighteen different ideas. Some of the rectangles are truncated into squares whilst others, abbreviated, create even further variations.

Textile Design for 'Abstract Design of Rectangles' 1943
HMF 2130
coloured crayon, wax crayon, watercolour
190 × 259mm
signature: pen and ink l.r. *Moore/43*

The general effect echoes that of Moore's drawings a decade earlier, such as **Ideas for Relief** 1933–35 (HMF 1066),[8] in which rows of rectangles contain linear designs that touch on both the fluid forms of the Surrealists and the hard-edged linear motifs of the Constructivists.

8 See *Henry Moore: Complete Drawings*, vol.2, Lund Humphries, London 1998, p.108.

(opposite)
Abstract Design: Rectangles with Trains
c.1946
TEX 16.1; 16.7
serigraphy in five colours; serigraphy in six colours
crepe rayon; rayon
320 × 245mm; 440 × 370mm
printed by ASCHER
The Henry Moore Foundation: acquired 1990

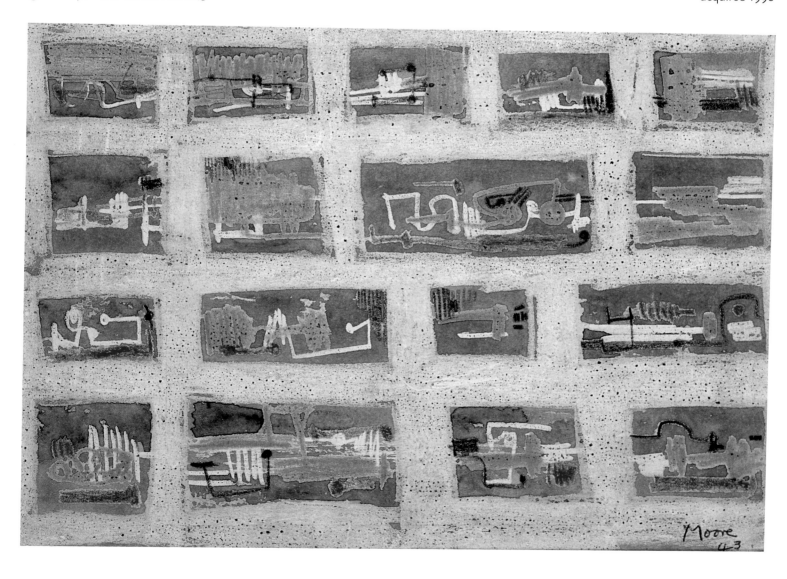

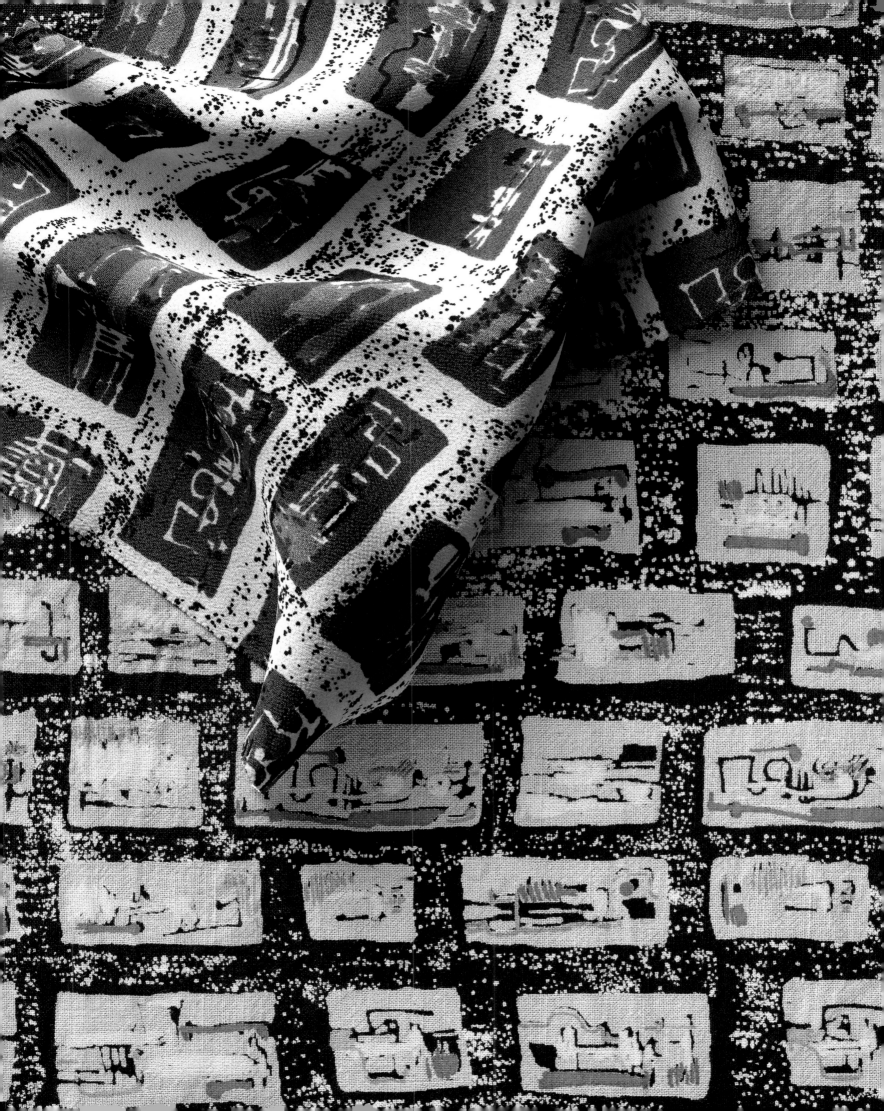

(above)
Abstract Design: Rectangles with Trains
c.1946
TEX 16.2; 16.5
serigraphy in six colours
artificial silk
315 × 245mm; 70 × 500mm
printed by ASCHER
The Henry Moore Foundation:
acquired 1990

(below)
Abstract Design: Rectangles with Trains
c.1946
TEX 16.6
serigraphy in six colours
crepe silk
250 × 450mm
printed by ASCHER
The Ascher Collection

(opposite)
Abstract Design: Rectangles with Trains
c.1946
TEX 16.3
serigraphy in six colours
silk
360 × 370mm
printed by ASCHER
The Ascher Collection

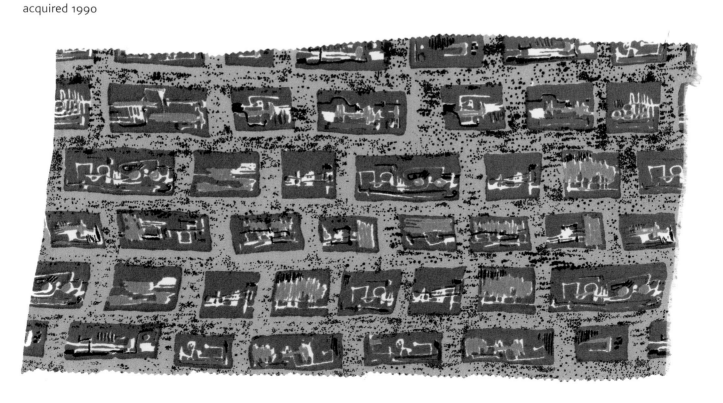

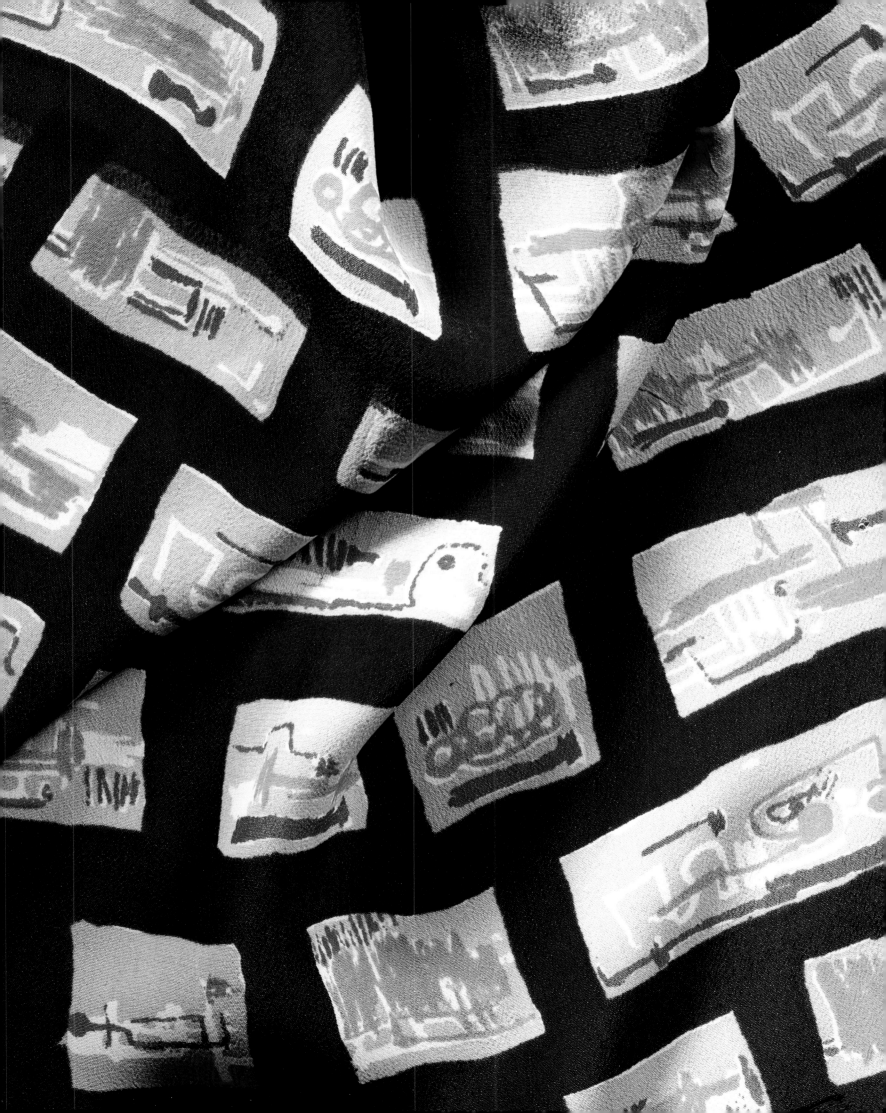

This design is one of few Moore textiles predominantly printed in cotton. The British cotton industry was disastrously affected by both World Wars. During the First, a ban on foreign export led to Japan developing its own competitive cotton industry, and during the Second, the British industry was deliberately scaled down in an effort to organise the home front. Rationing of clothing began in 1941, and was compounded by Utility regulations strictly imposed in 1943 which further limited apparel and were not withdrawn until 1952. Lack of modern textile machinery such as ring spindles and automated looms meant that by 1959 the British cotton industry's input into the world market, which at one time had been nearly one third, was reduced to just 5 per cent.

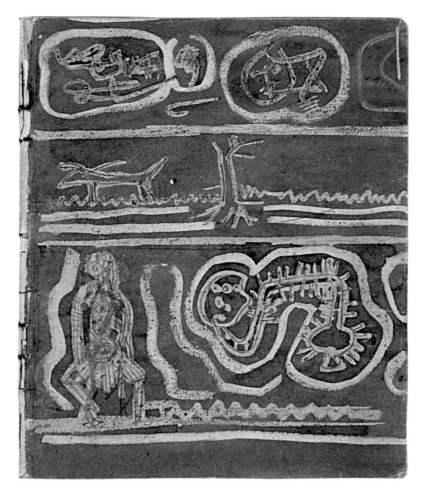

(above)
Textile Design for 'Seated Figures and Caterpillars' 1943
Page from *Textile Design Sketchbook 1*
HMF 2101
pencil, wax crayon, watercolour on cream medium-weight laid
204 × 165mm
The Ascher Collection

(right)
Textile Design 1943
HMF 2146
pencil, wax crayon, watercolour wash
200 × 226mm
signature (added later): ballpoint pen l.r. *Moore/43*
inscription: pencil u.c. *Finart yellow*
Annely Juda Fine Art, London

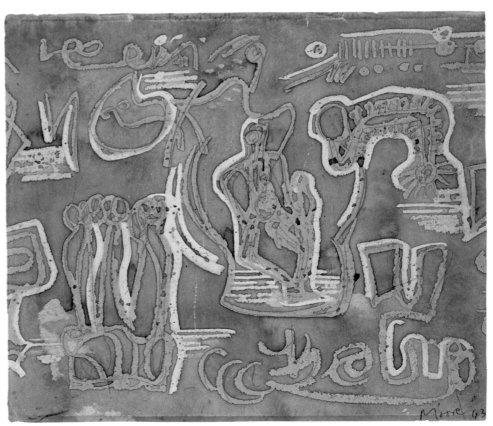

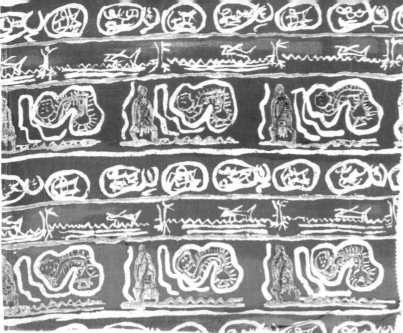

(above)
Seated Figures and Caterpillars c.1946
TEX 17.1
serigraphy in four colours
cotton
440 × 500mm
printed by ASCHER
The Henry Moore Foundation:
acquired 1990

(right)
Seated Figures and Caterpillars c.1946
TEX 17.2
serigraphy in two colours
cotton
290 × 420mm
printed by ASCHER
The Ascher Collection

Moore's interest in gnarled roots and the bare branches of winter trees is well known, but here graceful coils of ferns and sweeping palm fronds are intertwined. The origin of the motif underlies Moore's fascination with metamorphosis, for these natural forms began as studies of seated figures, still discernible in the turquoise crayon outline in the first sketch, HMF 2144a. In HMF 2144b, the lines have become free of any recognisable subject, while in 2144c the plant forms are recognisable.

The fabric itself also undergoes a transformation. From one of the most clearly organic patterns, a web of sweeping lines in vivid colours dominates any possible identification of potential content to the point of becoming the equivalent in textiles of an abstract expressionist painting. It is the gestural freedom of the depiction of colour and line that are paramount. One can imagine Moore's vigorous drawing technique; there is nothing tentative here.

Textile Design 1943
HMF 2144
wax crayon, watercolour wash, pen and ink
on cream medium weight wove
220 × 170mm
The Ascher Collection

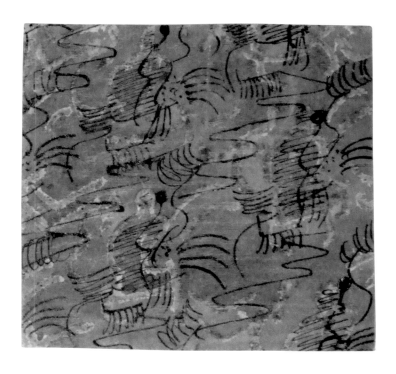

(below)
Textile Design: Palm Branches
1943
HMF 2144b
165 × 150mm
wax crayon, watercolour wash,
pen and ink

(bottom)
Textile Design
HMF 2144b (verso)
wax crayon, watercolour wash,
pen and ink
The Ascher Collection

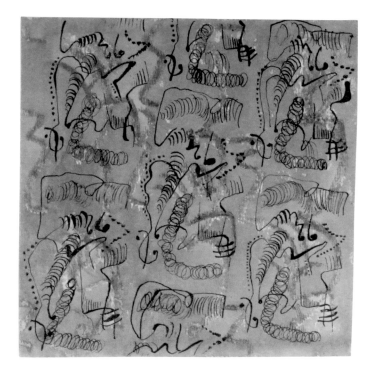

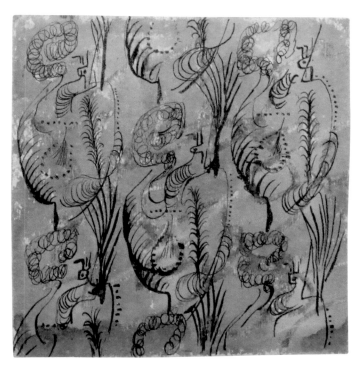

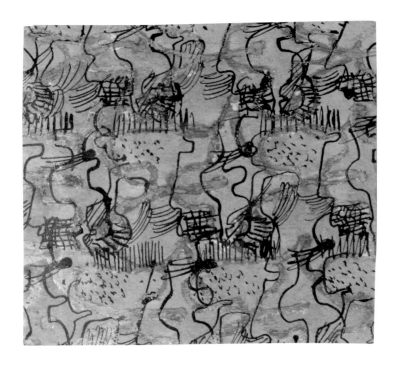

(top)
Textile Design: Seated Figures
1943
HMF 2144a
wax crayon, watercolour wash,
pen and ink
160 × 165mm

(above)
Textile Design: Palm Branches
HMF 2144a (verso)
wax crayon, watercolour wash,
pen and ink
The Ascher Collection

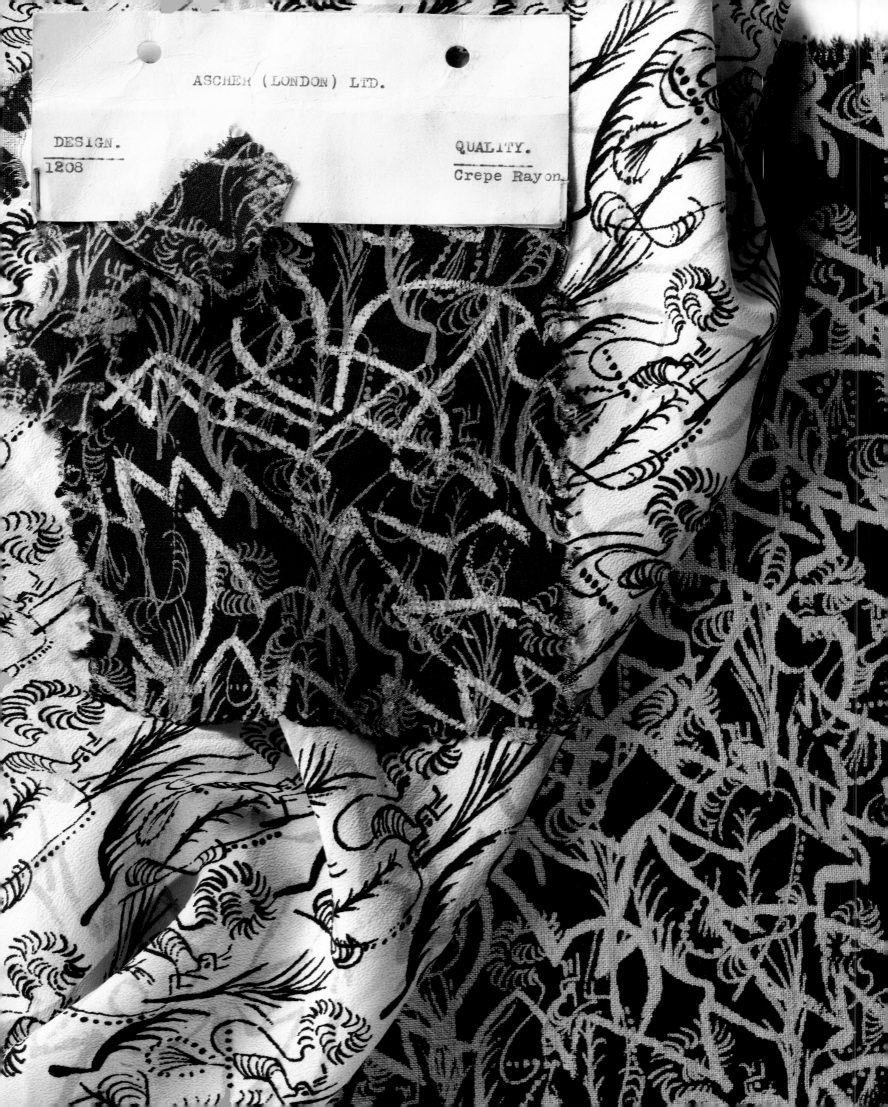

ASCHER (LONDON) LTD.

DESIGN.
1208

QUALITY.
Crepe Rayon.

Fern Leaves and Palm Branches c.1946
TEX 18.9
serigraphy in three colours
silk
240 × 250mm
printed by ASCHER
The Ascher Collection

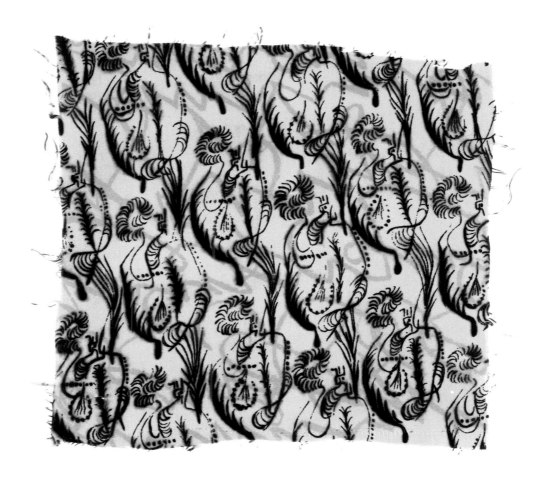

Fern Leaves and Palm Branches c.1946
TEX 18.10
serigraphy in three colours
silk
260 × 245mm
printed by ASCHER
The Ascher Collection

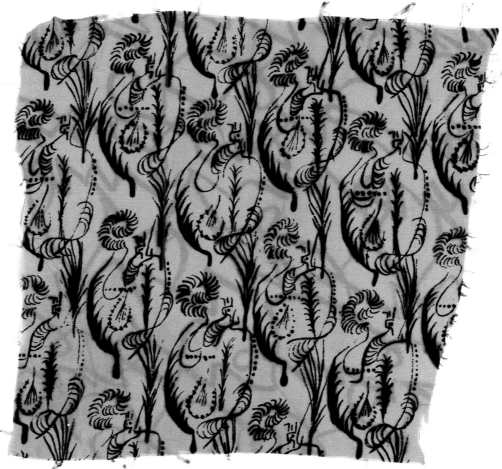

(opposite)
Original Ascher swatch and various
colourways in crepe rayon and artificial silk
of **Fern Leaves and Palm Branches** (TEX 18).

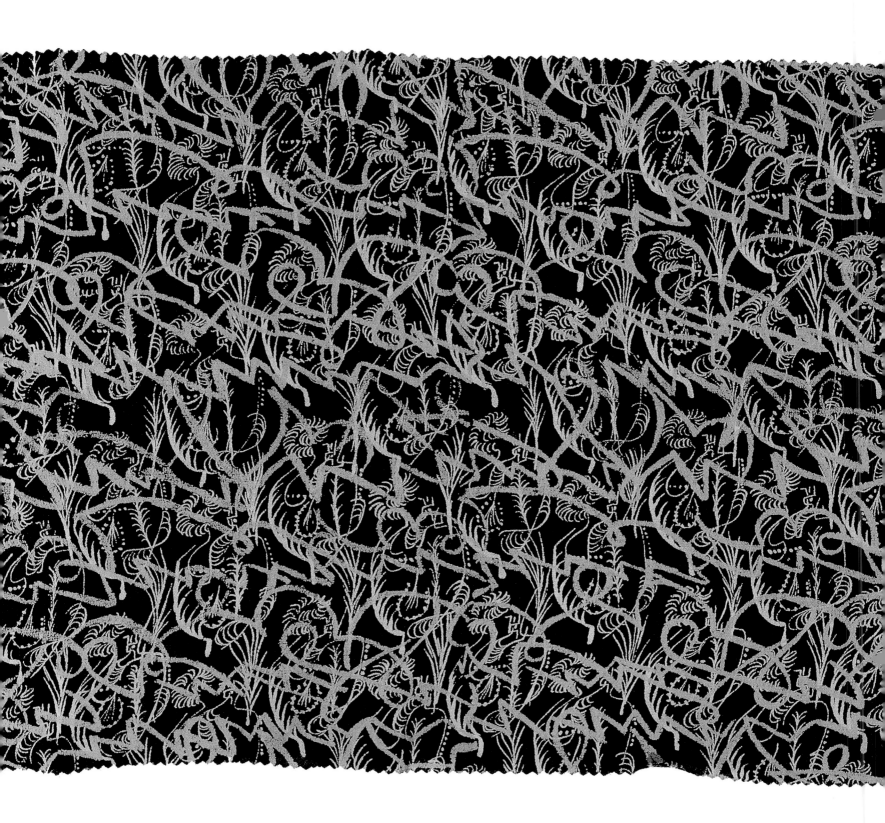

Fern Leaves and Palm Branches c.1946
TEX 18.14
serigraphy in three colours
crepe silk
355 × 895mm
printed by ASCHER
The Ascher Collection

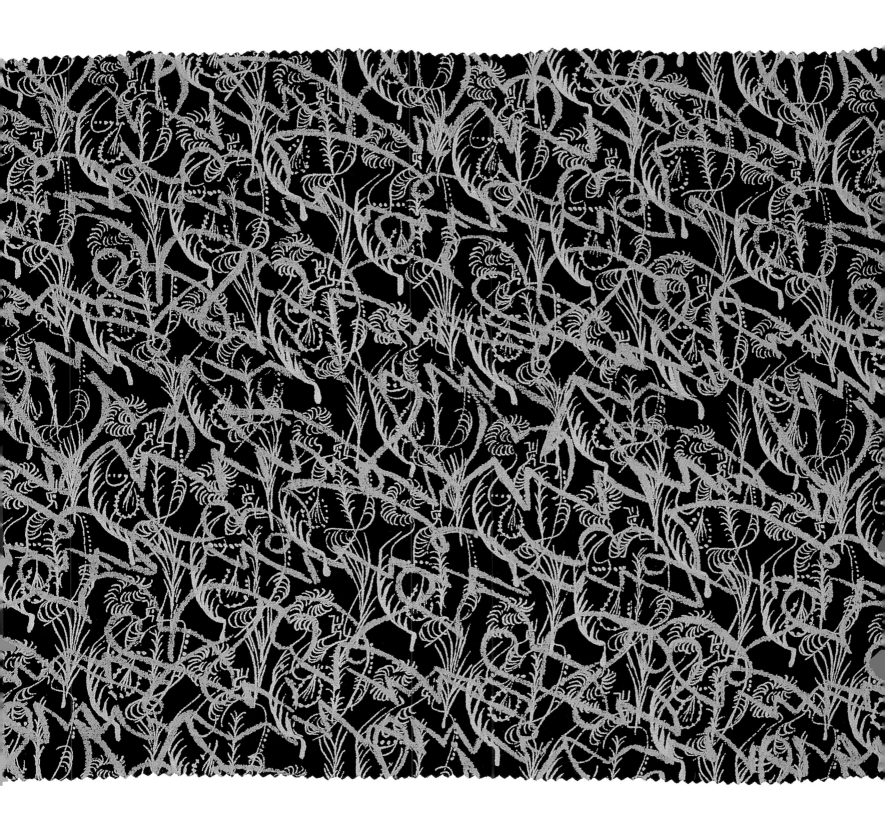

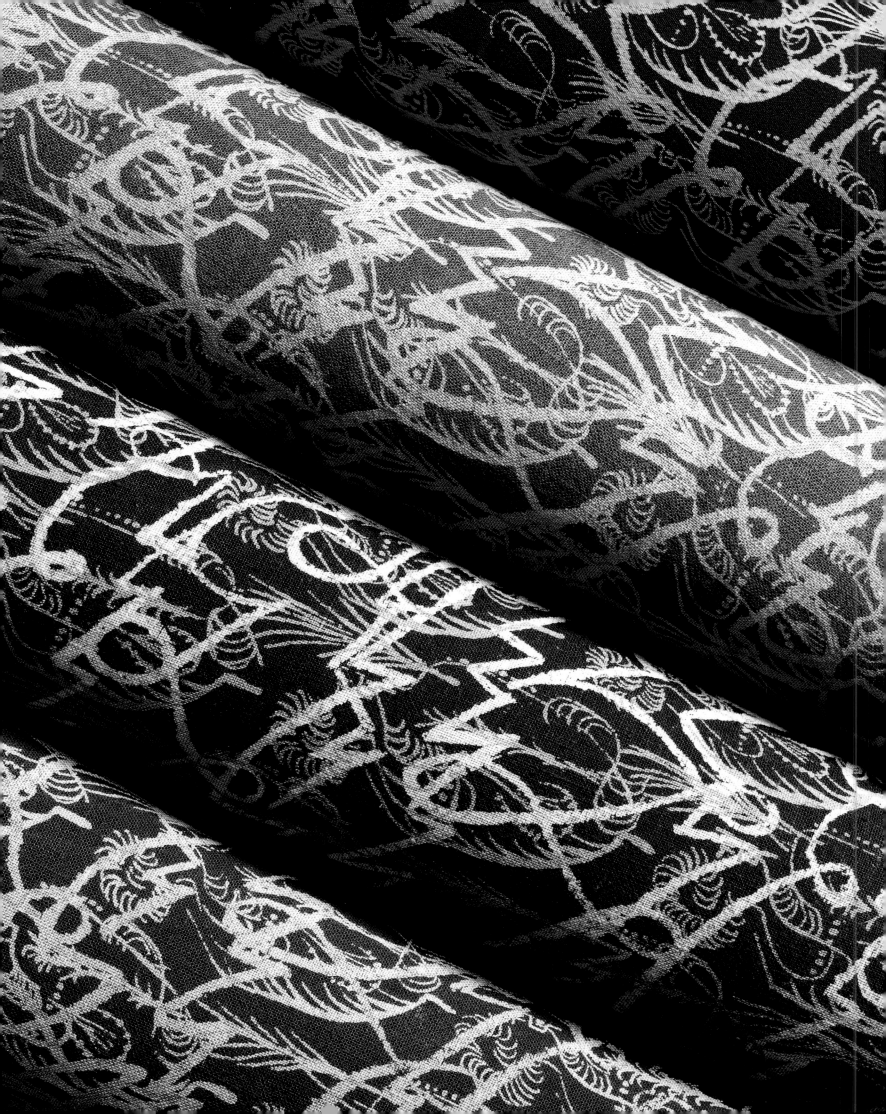

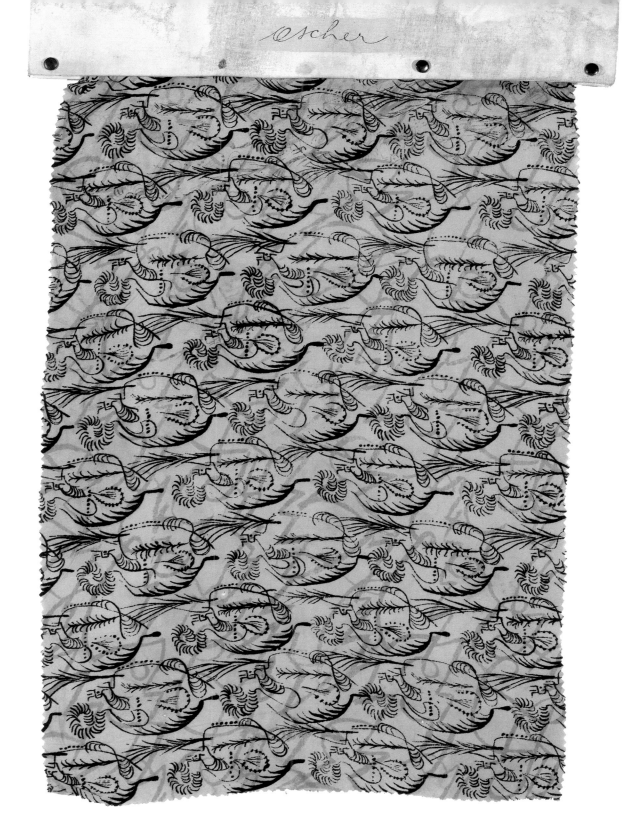

**Fern Leaves and Palm
Branches** c.1946
TEX 18.22
serigraphy in three colours
silk
320 × 470mm
printed by ASCHER
The Ascher Collection

(opposite)
Fern Leaves and Palm Branches c.1946
TEX 18.14; 18.20; 18.13; 18.17
serigraphy in three colours and four colours
crepe silk, rayon, cotton, rayon
355 × 895mm; 390 × 370mm; 270 × 280mm;
321 × 370mm
printed by ASCHER
The Ascher Collection

Somewhere between the mystery of prehistoric runes and the familiarity of modern cufflinks lies the key to decoding these symbols. Some are recognisable from Moore's early carvings, such as his first large elmwood reclining figure (LH 175), in which the navel is depicted using an oval traversed by a straight line. This shorthand abstraction relates both to the Constructivists in its geometric purity, but also to something more esoteric, less tied to any particular time or place.

A version of TEX 14, here the symbols, printed in various permutations, are kept either in black or white while the background is tried in various colours, from muted grey, ochre or tan to deep red and blue. Without the framework of the black sections, the symbols seemingly float in the field of colour, yet are strictly retained within their linear boundaries as characters in a script.

(right)
Textile Design: Figures and Symbols 1943
Page from *No.2 Design Notebook*
HMF 2124j
203 × 165mm
wax crayon, watercolour wash, pen and ink, brush and ink on cream medium-weight laid
The Ascher Collection

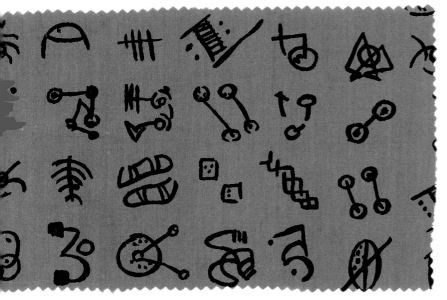

(left)
Clock Hands c.1946
TEX 19.4
serigraphy in two colours
cotton
145 × 225mm
printed by ASCHER
The Ascher Collection

(opposite)
Various colourways of **Clock Hands** c.1946 TEX 19.5; 19.6; 19.7; 19.1 (above) The Henry Moore Foundation: acquired 1990; TEX 19.2 (below) serigraphy in two colours cotton printed by ASCHER The Ascher Collection

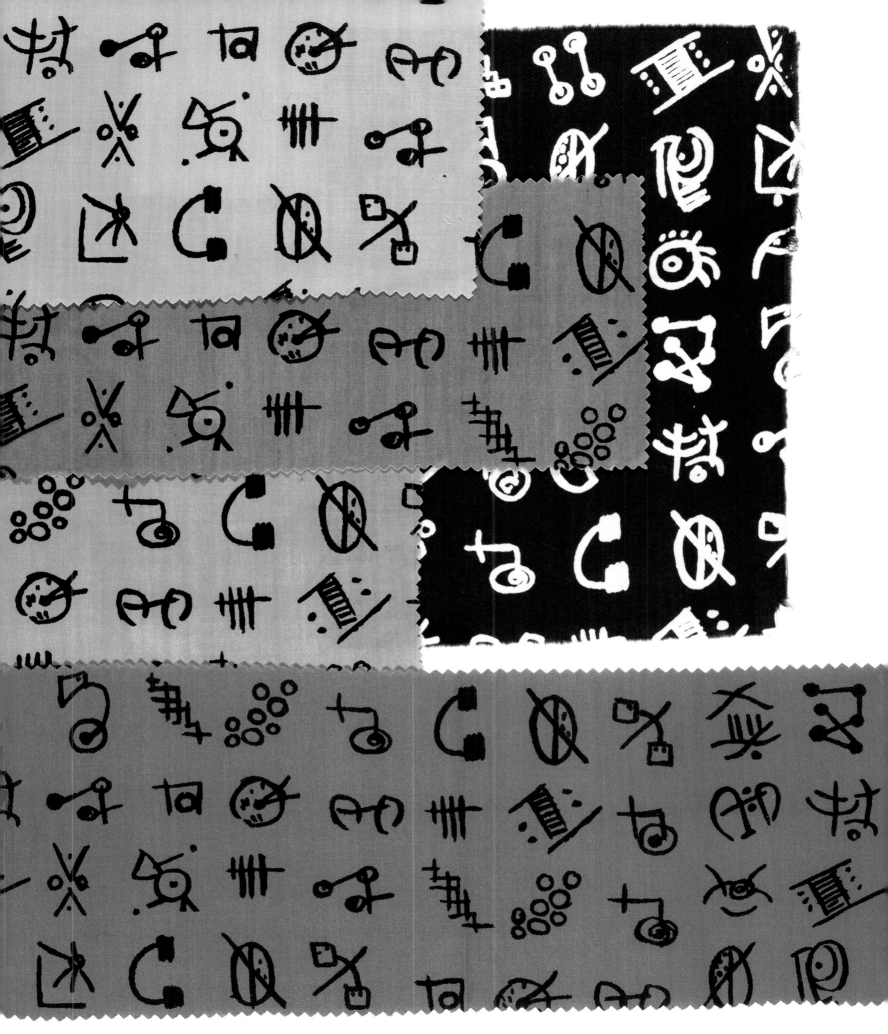

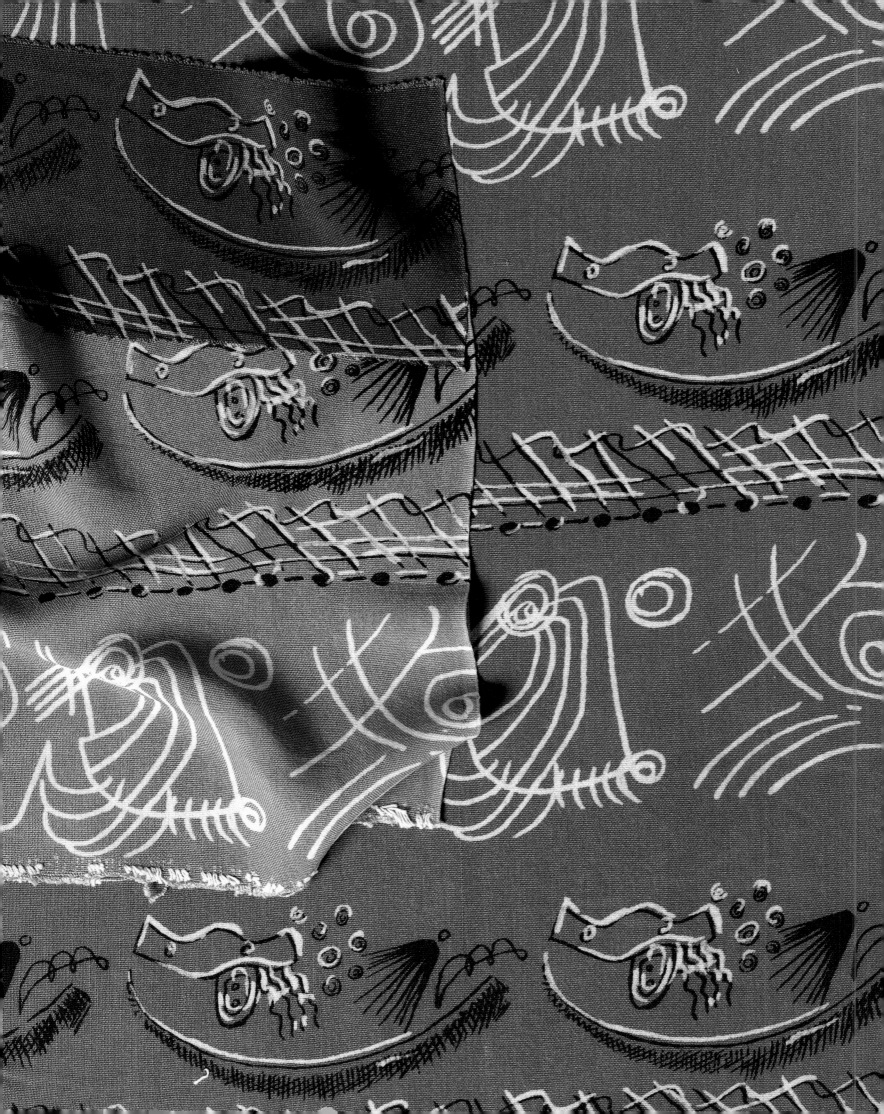

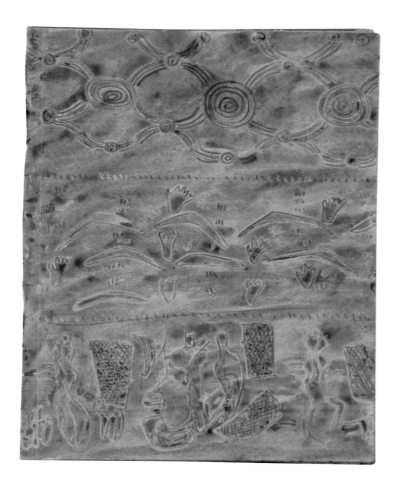
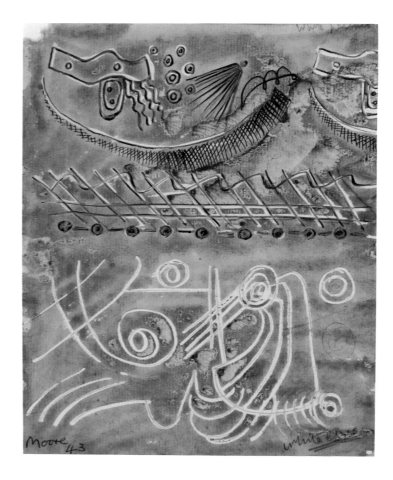

Known as 'Eyebrows' for many years, this design's original title 'Sealife' was discovered on a tag pinned to a sample fabric during the cataloguing of the Ascher collection in 2006. This makes sense of the drawing HMF 2124k, which is signed to orientate the image with the arches pointing upwards like waves, and the bubbly squid-like amorphous shapes floating to the surface.

The first sketch is more complex – HMF 2107 has an algae-coloured wash, with the water divided into three strata: the pool's surface with rings expanding and connecting to one another; plant life and coral – this time with the arches pointing downwards; and finally an array of imaginative sea creatures with multiple legs resembling octopi. The life forms – both plant and animal – are not really identifiable, but elements of a Surrealistic compilation in which the sea provides the medium for transformation.

(above left)
Textile Design 1943
Page from *Textile Design Sketchbook 1*
HMF 2107
pencil, wax crayon, watercolour on cream medium-weight laid
204 × 165mm
The Ascher Collection

(above right)
Textile Design: Sealife 1943
Page from *No. 2 Design Notebook*
HMF 2124k
pencil, wax crayon, watercolour wash, gouache, pen and ink on cream medium-weight laid
203 × 165mm
inscription: pencil u.r.c. *white* (illegible); l.r. *white lines*
signature: ballpoint pen l.l. *Moore/43*
The Ascher Collection

(opposite)
Sealife c.1946
TEX 25.7; 25.6; 25.1
serigraphy in four colours
rayon
125 × 215mm; 280 × 410mm; 590 × 450mm
printed by ASCHER

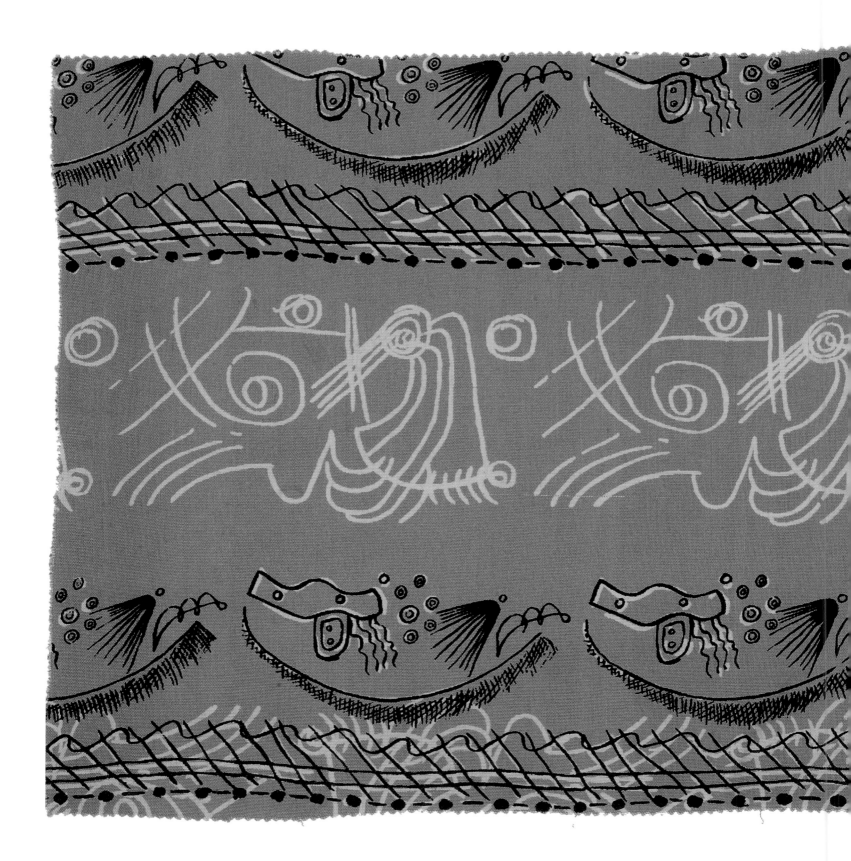

Sealife c.1946

TEX 25.4

serigraphy in four colours; rayon; 410 × 870mm

printed by ASCHER

The Ascher Collection

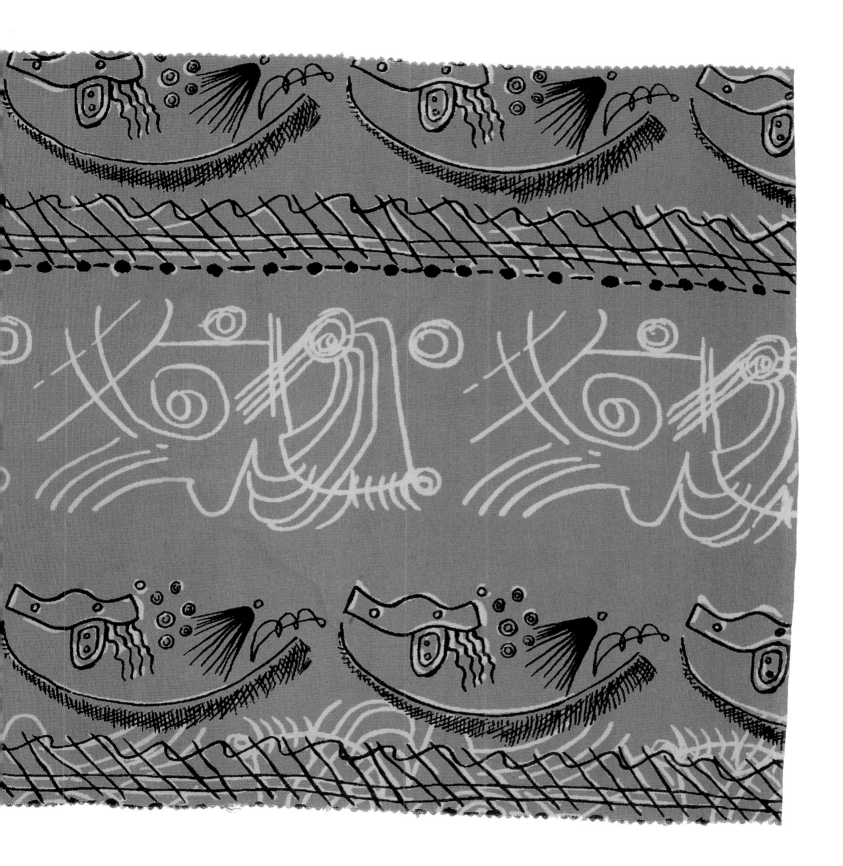

This is the design about which there is the least information; the only extant sample of the fabric measures a mere 24 centimetres square. No records of it exist in the Ascher archive, although it is undoubtedly an Ascher fabric. This sample was acquired directly from Zika Ascher himself, among many other Ascher fabrics designed by Moore that were selected for the Foundation's collection in 1990 by David Mitchinson. He recalled that during his visit to Casa Maria, Ascher's house in the middle of Hampstead Heath in London, Ascher disappeared into a spiral stairwell hidden behind a grand piano in the ballroom, which led into an enormous basement filled with artist-designed fabrics, including many by Moore.

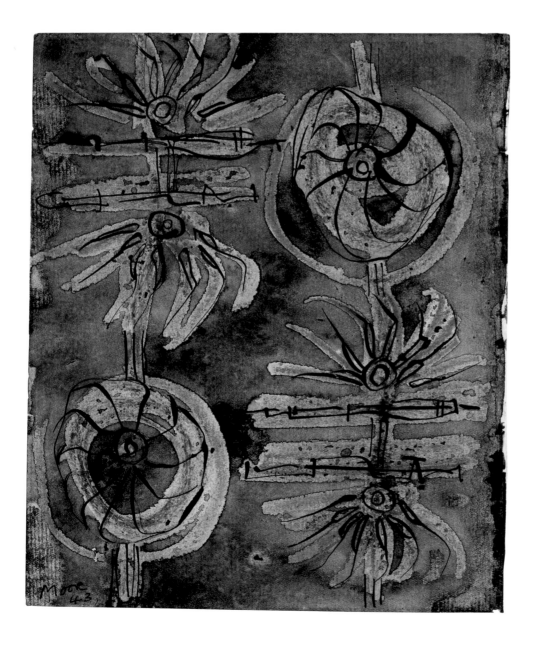

Textile Design for 'Fruit and Flowers' 1943
HMF 2145
pencil, wax crayon, watercolour, chalk, pen and ink
203 × 165mm
signature: pen and ink l.l. *Moore/43*
The Henry Moore Foundation: acquired 2008

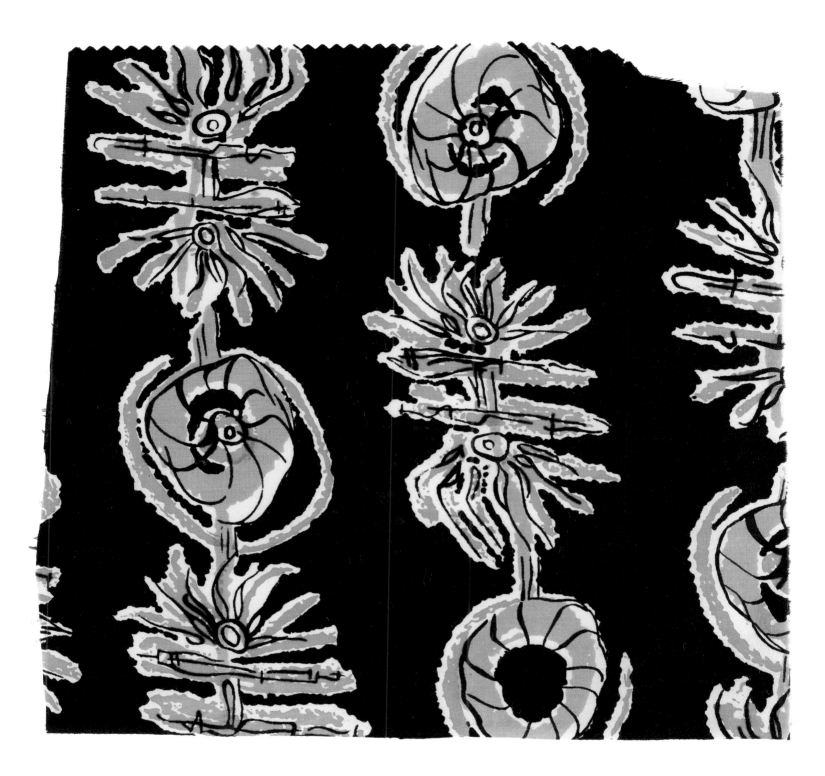

Fruit and Flowers c.1946
TEX 26
serigraphy in four colours
cotton
240 × 240mm
printed by ASCHER
The Henry Moore Foundation:
acquired 1990

Although there is no known extant drawing for **Zigzag**, Moore's vibrant orange-red design for the textile was reproduced on the cover of the Institute of Contemporary Arts catalogue *Painting into Textiles*. This catalogue was distributed as an insert in the 1953 No.11 issue of *The Ambassador: The British Export Magazine for Textiles and Fashions*, a trade magazine run by Hans and Elspeth Juda, who helped organise the exhibition. The simplicity of the design lent itself to being printed in the flatbed screen process rather than by hand (see TEX 22). Henry and Irina Moore had this fabric made up in grey-brown, black, rust and white as both curtains and bedspreads for their home, Hoglands.

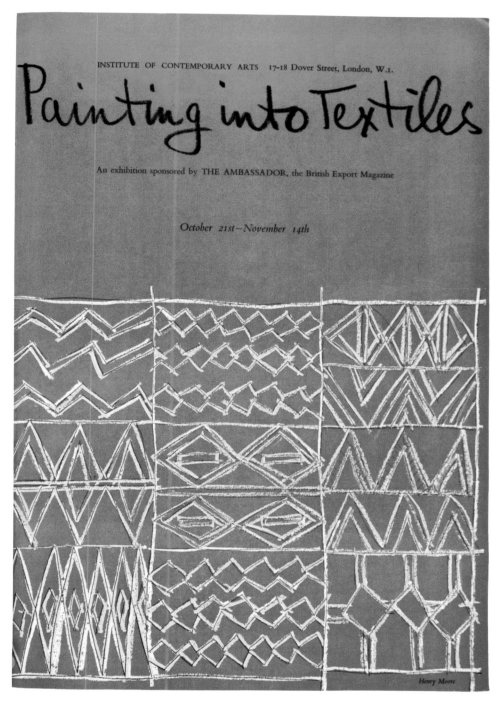

fig.36 *Painting into Textiles*, Institute of Contemporary Arts, London, with Moore's drawing for **Zigzag** (TEX 23) on the cover.

(opposite)
Zigzag 1954
TEX 23.1
serigraphy in four colours
rayon sateen
1880 × 1080mm
printed by David Whitehead Fabrics
The Henry Moore Foundation:
acquired 1990

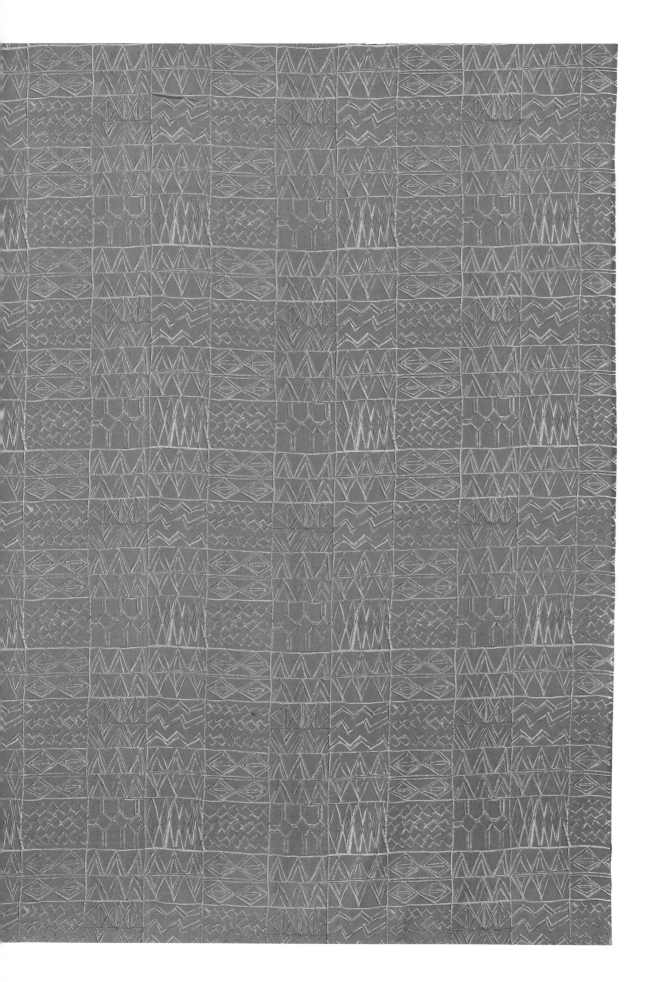

Zigzag 1954
TEX 23.2
serigraphy in four colours
rayon sateen
2470 × 1215mm
printed by David Whitehead
Fabrics
The Henry Moore Foundation:
acquired 1990

(opposite)
Zigzag 1954
TEX 23.1
serigraphy in four colours
rayon sateen
1880 × 1080mm
printed by David Whitehead
Fabrics
The Henry Moore Foundation:
acquired 1990

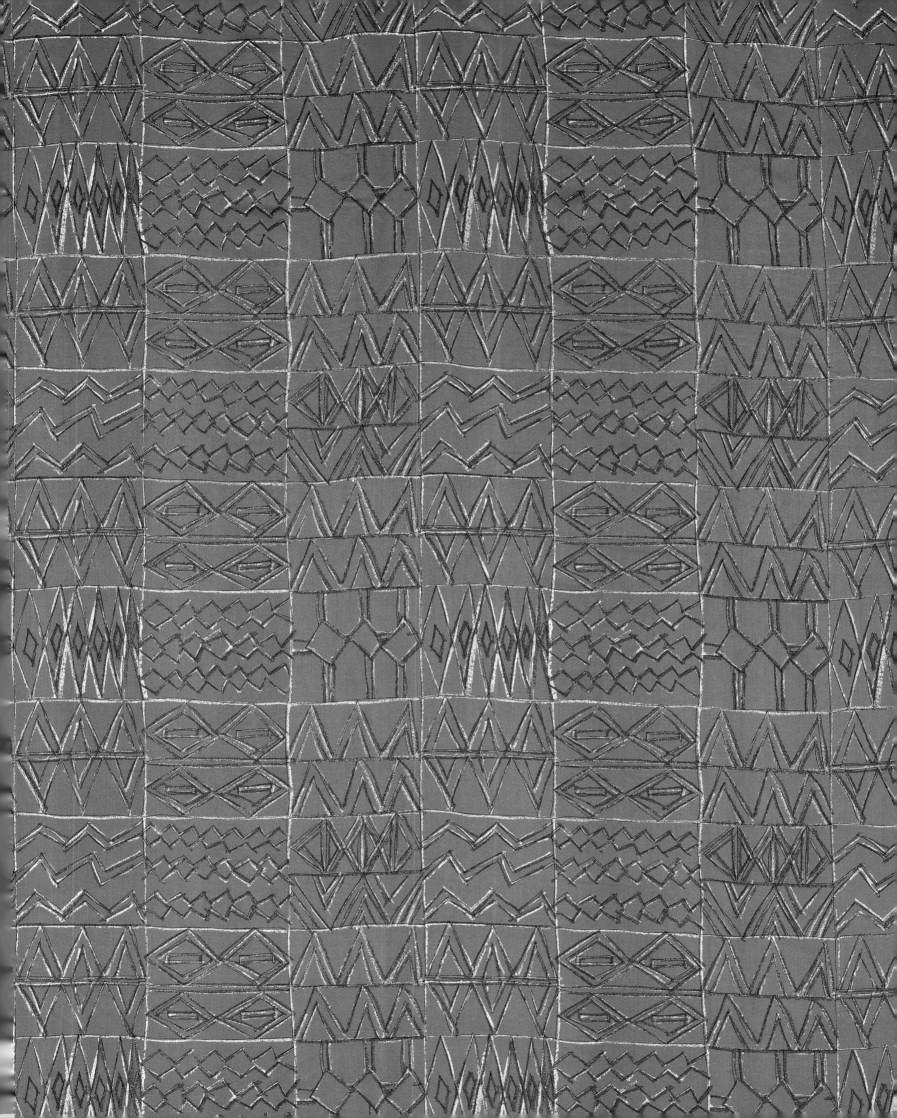

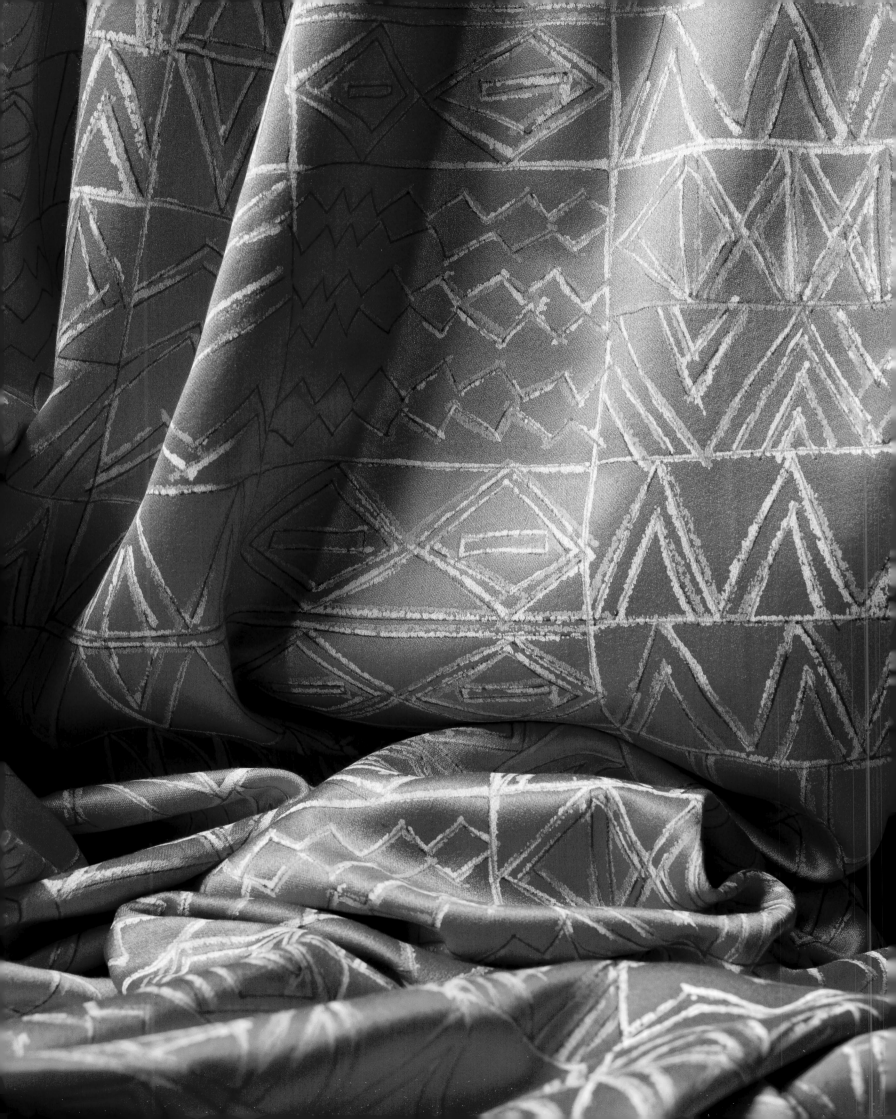

Unlike Ascher's hand-printed fabrics, David Whitehead Fabrics may have printed Moore's textiles using a semi-automated process, in which the lengths of fabric were fed mechanically beneath a series of flat printing screens. This method was faster than hand printing, but slower than fully automated rotary screenprinting. It was a less expensive and less labour-intensive process than printing by hand, yet retained a painterly effect in the fabric. This was in line with the philosophy 'the cheap need not be cheap and nasty', as espoused by the company's director John Murray in 1948.[9] Murray left the organisation in 1952 and was replaced by Tom Mellor, who – inspired by the 1953 exhibition *Painting into Textiles* held at the Institute of Contemporary Arts – produced two of Moore's designs for fabrics (see TEX 23) as well as others by Donald Hamilton Fraser, Cawthra Mulock, John Piper, William Scott and Paule Vézelay.

9 Fully mechanised flat-screen printing was introduced in 1957. See Lesley Jackson, *20th Century Pattern Design: Textile and Wallpaper Pioneers*, Mitchell Beazley, Octopus Publishing Group, London 2002, p.103.

(opposite)
Zigzag 1954
TEX 23.2
The Henry Moore Foundation:
acquired 1990

Triangles and Lines 1954
TEX 22
serigraphy in six colours
rayon sateen
2330 × 1200mm
printed by David Whitehead Fabrics
The Henry Moore Foundation

Wall panels

fig.37 Moore (far right) on the jury for the textile design competition 'Try Your Hand' 1946. From second on left: Audrey Withers, editor of *Vogue*; Anne Scott-James, editor of *Harper's Bazaar*; Graham Sutherland; fashion journalist Lesley Blanch and Zika Ascher (centre).

Moore designed four large-scale wall panels that were proofed by Ascher between 1947 and 1949 on woven cotton or linen. Unlike the other fabric designs, these were not done in repeat but as bold single images that could be hung on the wall as one would display a work of art. Furthermore they were editioned, so in concept as well as in function these panels were very unlike the more utilitarian dress or furnishing fabrics. The edition was limited, like a signed lithograph or etching. In fact, Moore had simultaneously just begun what would become a prolific activity in printmaking; he created only four prints by 1946, but by the end of his career his graphic works numbered over seven hundred.

In 1948 the Lefevre Gallery held an exhibition of just four works: two of the Moore panels alongside two panels by Henri Matisse[1] – two of the most eminent artists of the post-war era were showing how textiles could change the face of art. From 1949 to 1950 the panels were exhibited on tour throughout the United States by the Museum of Modern Art, New York. Ivon Hitchens wrote: 'The bare walls of the house of the future will call for a modern counterpart of the ancient tapestries and painted hangings. It is possible that your method of reproduction may be the first to answer this need by lending itself to a limited number of copies of large scale designs intended as wall coverings.'[2]

At the same time that these panels were created, Moore served as judge for 'Try Your Hand', a textile competition initiated by Ascher in 1946 to encourage new talent.[3] Entrants had to be under twenty-five years of age, or had to have served in the war or in essential war-work. An overwhelming ten thousand designs were submitted, and sifted through by Moore, alongside Zika and Lida Ascher, Graham Sutherland and the fashion journalists Lesley Blanch, Ann Scott-James and Audrey Withers. As with the panels, none of the designs was in repeat.

1 Matisse exhibited his *Océanie-La Mer* and *Océanie-Le Ciel*.
2 Cited in Valerie D. Mendes and Frances M. Hinchcliffe, *Ascher: Fabric, Art Fashion*, Victoria and Albert Museum, London 1987, p.41.
3 This success led later to 'The Ascher Award', an international textile design competition in 1966.

(opposite)
Details of wall panels **Head** (TEX 28) and
Three Seated Figures (TEX 27)
The Henry Moore Foundation: acquired 1990

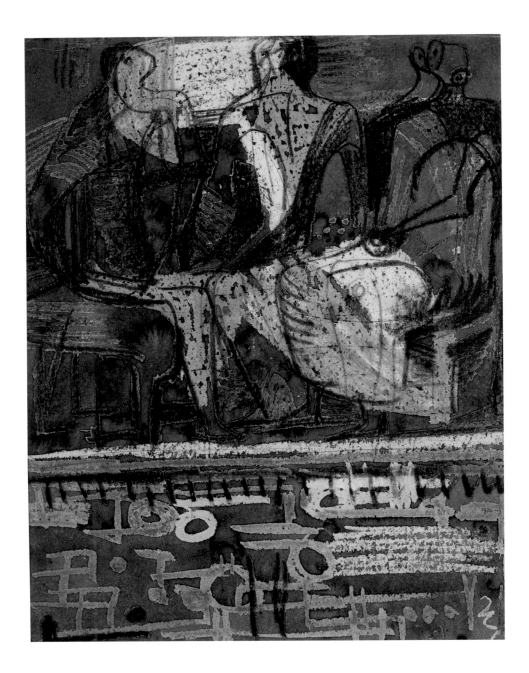

fig.38 **Three Seated Figures** (TEX 27).

Textile Design for 'Three Seated Figures'
1943
Page from *Textile Design Sketchbook 3*
HMF 2152a
pencil, wax crayon, coloured crayon, wash
on cream medium-weight wove
305 × 229mm

(opposite)
Three Seated Figures
TEX 27
serigraphy in ten colours
textured cotton
1600 × 1200mm
printed by ASCHER
The Henry Moore Foundation:
acquired 1990

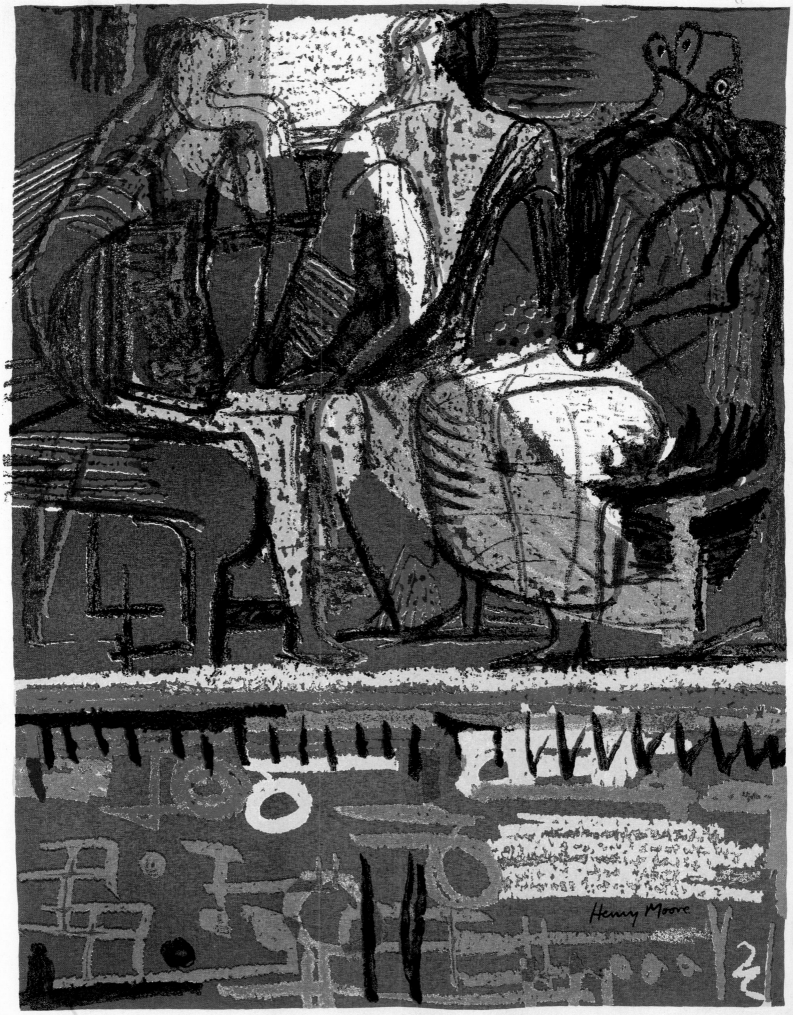

18/65

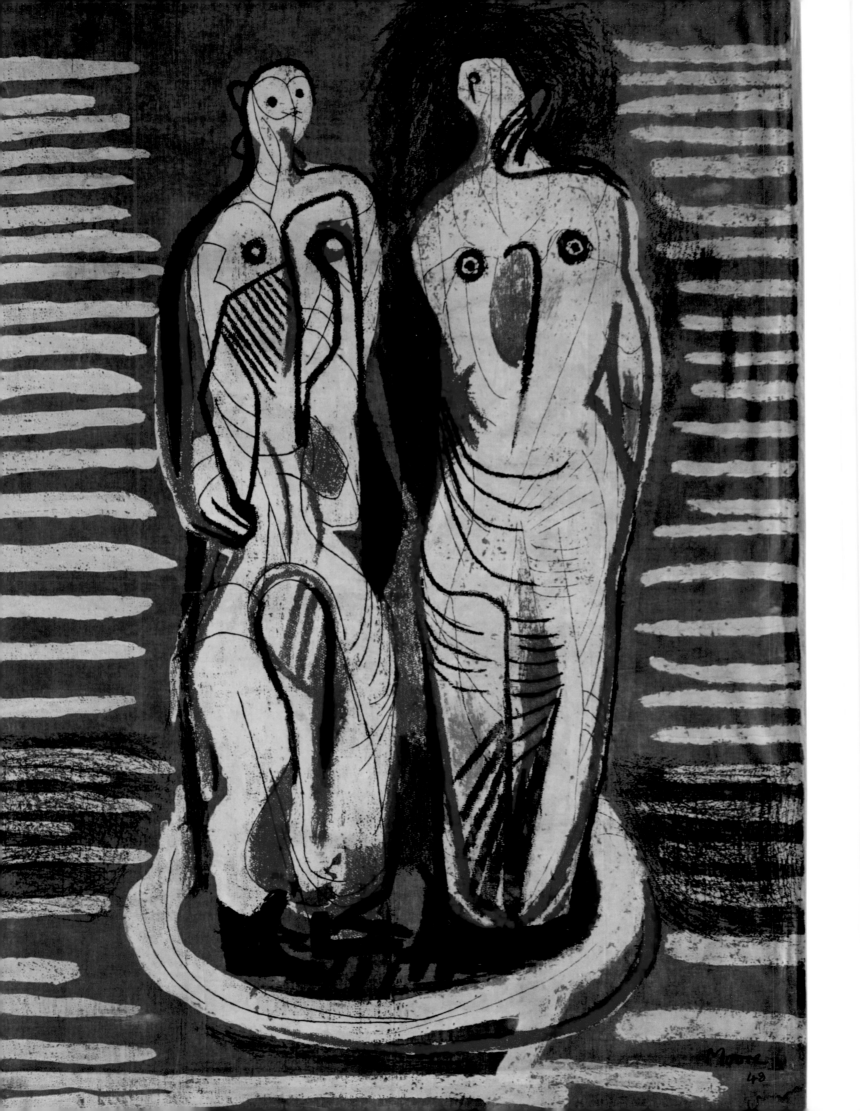

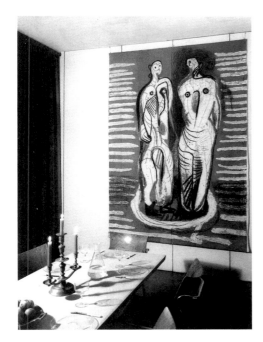

fig.39 Moore's wall panel **Two Standing Figures** (TEX 20) photographed at the end of a dining table for *Building*, December 1948 in which Erno Goldfinger referred to them as 'part of the proceedings'.

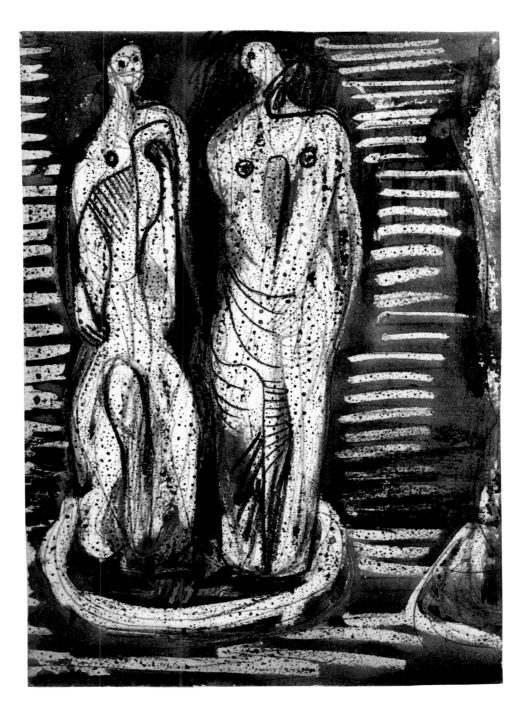

(opposite)
Two Standing Figures 1948
TEX 20
serigraphy in five colours
linen
2570 × 1825mm
printed by ASCHER
The Henry Moore Foundation:
acquired 1990

Two Standing Figures: Drawing for Linen Panel 1947–48
Page from *Rocking Chair Notebook*
HMF 2396
pencil, wax crayon, coloured crayon, watercolour wash on cream medium-weight wove
251 × 178mm
Private collection, Italy

fig.40 **Head** (TEX 28).

Textile Design for 'Head' 1943
Page from *Textile Design Sketchbook 2*
HMF 2127a
pencil, wax crayon, coloured crayon,
watercolour on cream medium-weight
wove
254 × 178mm
The Ascher Collection

(opposite)
Head
TEX 28
serigraphy in five colours
woven cotton
1815 × 1270mm
printed by ASCHER
The Henry Moore Foundation:
acquired 1990

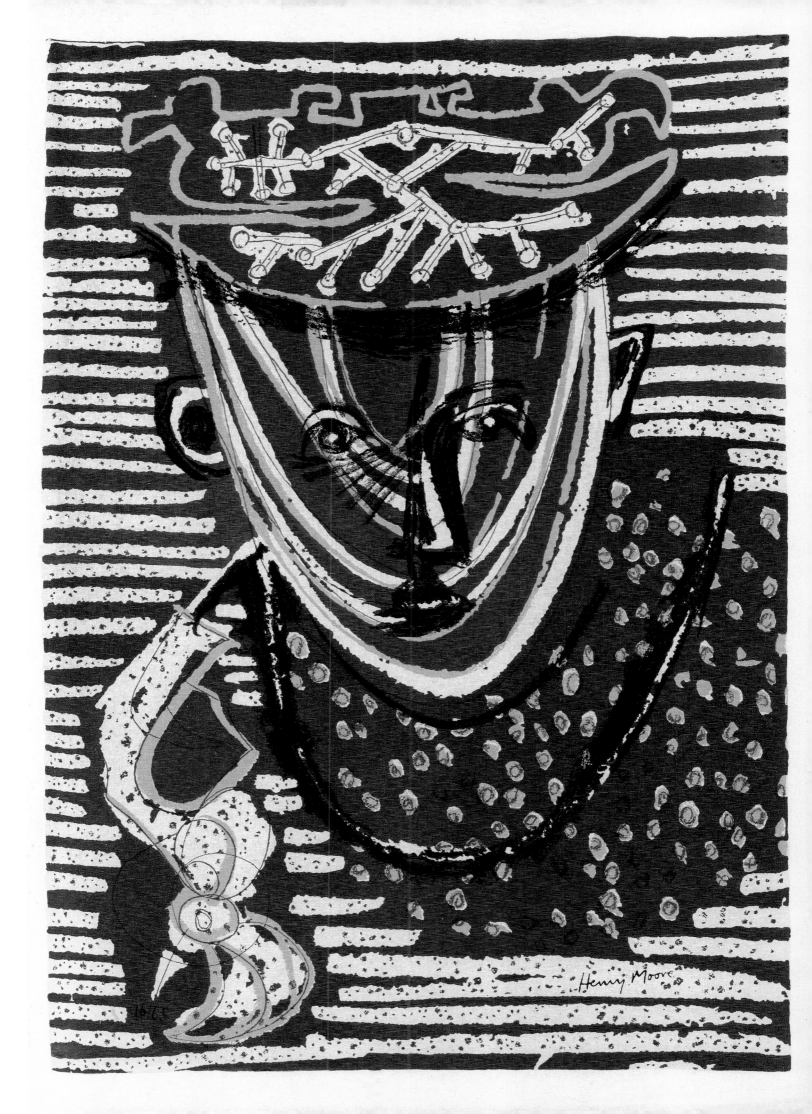

Textile Design 1943
HMF 2151b
pencil, wax crayon, coloured crayon,
watercolour
203 × 165mm
Triple Gallery, Berne

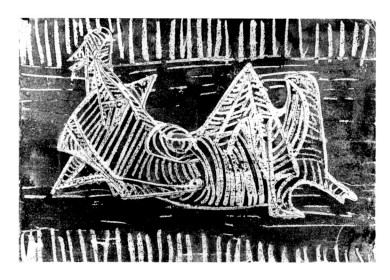

Reclining Figure: Drawing for Linen Panel 1947–48
Page from *Rocking Chair Notebook*
HMF 2395
pencil, wax crayon, watercolour wash on cream medium-weight
wove
178 × 251mm
Private collection, Italy

fig.41 **Reclining Figure** (TEX 21)
photographed in a domestic setting
alongside an African mask for *Building*,
December 1948.

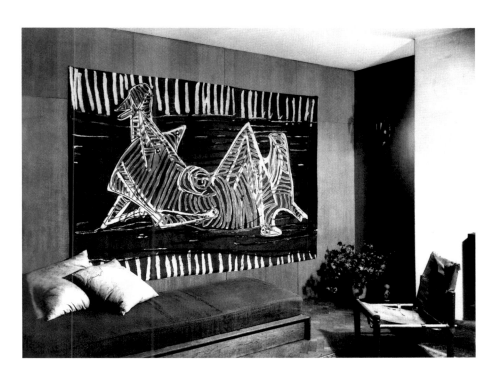

(opposite)
Head
TEX 28
The Henry Moore Foundation:
acquired 1990

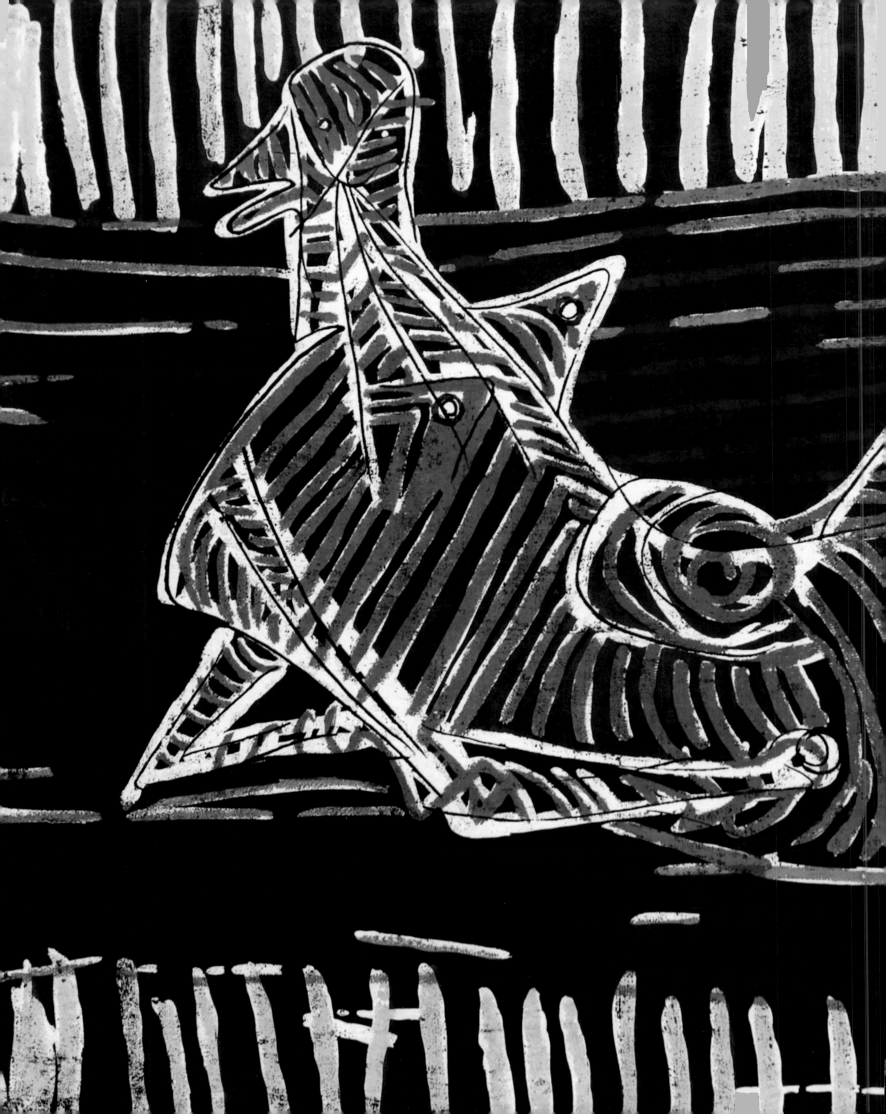

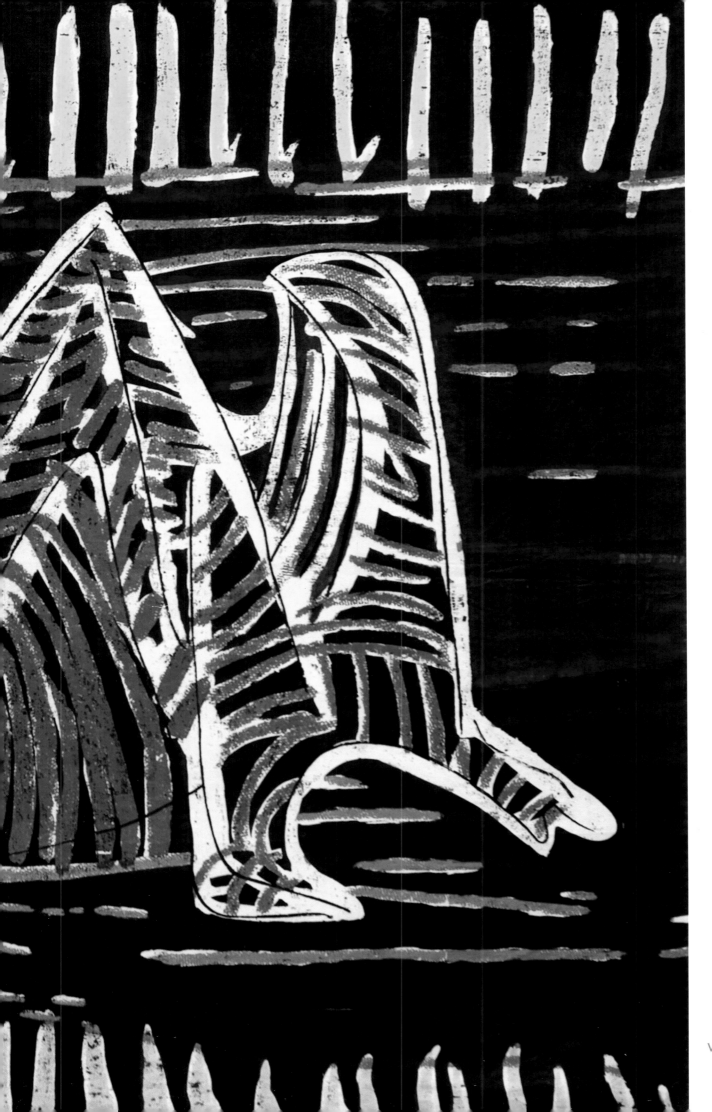

Reclining Figure
1949
TEX 21.1
serigraphy in five
colours
linen
1830 × 2870mm
printed by ASCHER
The Henry Moore
Foundation:
acquired 1990

Related publications

Francesca Galloway, *Post-War British Textiles*, Robert Marcuson Publishing Services for Francesca Galloway, London 2002

Ngozi Ikoku, *The Victoria and Albert Museum's Textile Collection: British Textile Design from 1940 to the Present*, Victoria and Albert Museum, London 1999

Lesley Jackson, *20th Century Pattern Design: Textile & Wallpaper Pioneers*, Mitchell Beazley, London 2002

Sue Kerry, *Neo-Classicism to Pop: Part II Twentieth Century Textiles*, Francesca Galloway, London 2007

Valerie D. Mendes and Frances M. Hinchcliffe, *Ascher: Fabric Art Fashion*, Victoria and Albert Museum, London 1987

Alan Peat, *David Whitehead Limited: Artist Designed Textiles 1952–1969*, Oldham Museum and Art Gallery, 1994

Geoffrey Rayner, Richard Chamberlain and Annamarie Stapleton, *Artists' Textiles in Britain 1945–70; A Democratic Art*, Antique Collectors' Club in association with The Fine Art Society and Target Gallery, London 2003

Mary Schoeser and Celia Rufey, *English and American Textiles from 1790 to the Present*, Thames and Hudson, London 1989

Selected Moore publications

Roger Berthoud, *The Life of Henry Moore*, Giles de la Mare, London 2003

Ann Garrould (ed.), *Henry Moore: Complete Drawings*, vol.3 1940–49, The Henry Moore Foundation in association with Lund Humphries, London 2001

Ann Garrould and Valerie Power, *Henry Moore Tapestries*, The Henry Moore Foundation in association with Lund Humphries, London 1998

David Mitchinson, *Celebrating Moore: Works from the Collection of the Henry Moore Foundation*, Lund Humphries, London 2006

David Mitchinson, *Hoglands: The Home of Henry and Irina Moore*, Lund Humphries, London 2007

Alan Wilkinson (ed.), *Henry Moore: Writings and Conversations*, Lund Humphries, London 2003

Recent exhibition catalogues

Henry Moore uma Retrospectiva, essays by Aracy Amaral, Anita Feldman Bennet, Rafael Cardoso, David Mitchinson and Margaret Reid, Pinacoteca do Estado de São Paulo, Paço Imperial, Rio de Janiero, and Centro Cultural Banco de Brasil, Brasília 2005

Henry Moore Epoch und Echo: Enlische Bildhauerei im 20.Jahrhundert, essays by Christa Lichtenstern and Ian Barker, Swiridoff for Kunsthalle Würth 2005

Henry Moore: War and Utility, essays by David Mitchinson and Roger Tolson, Imperial War Museum, London 2006

Henry Moore, essays by Anita Feldman Bennet, Maria Lluïsa Borràs and Toby Treves, Fundació La Caixa, Barcelona 2006

Henry Moore Sculptuur en architectuur, essays by Anita Feldman Bennet, Suzanne Eustace and Jan van Adrichem, Terra for Kunsthal Rotterdam, 2006

Henry Moore und die Landschaft, essays by Anita Feldman Bennet, Katja Blomberg, Beate Kemfert and Irene Tobin, Haus am Waldsee Berlin and Opelvillen Rüsselsheim, Dumont Literatur und Kunst Verlag, Köln 2007

Moore at Kew, text by Anita Feldman and Suzanne Eustace, Kew Publishing, London 2007

Henry Moore et la Mythologie, essays by David Mitchinson, Anita Feldman, Thierry Dufrène and Musée Bourdelle with Paris Musées, Paris 2007

Photographic credits

Caterpillar and Insect Wings 1947 (TEX 10.6)